GREAT MOMENTS IN THE THEATRE

Benedict Nightingale

GREAT MOMENTS IN THE THEATRE

OBERON BOOKS
LONDON

WWW.OBERONBOOKS.COM

First published in 2012 by Oberon Books Ltd

521 Caledonian Road, London N7 9RH

Tel: +44 (0) 20 7607 3637 / Fax: +44 (0) 20 7607 3629

e-mail: info@oberonbooks.com

www.oberonbooks.com

Reprinted in 2012, 2013

A catalogue record for this book is available from the British Library.

PB ISBN: 978-1-84943-233-7

E ISBN: 978-1-84943-744-8

Cover design by James Illman

Printed and bound by MPG Books Limited,
Victoria Square, Bodmin
Cornwall, PL31 1EB

For Anne, with love

Many thanks to Tim Teeman, who commissioned the originals of many of these pieces when he was Arts Editor of *The Times*, and to Alex O'Connell, who continued to publish them at a time when space was shrinking. Thanks also to James Hogan, who commissioned this book; George Spender, who edited it; to my agent, Christopher Sinclair-Stevenson; to my wife Anne, who did all the supporting; and to the many actors, writers, directors and musicians who made my career as a theatre critic a continuous joy.

CONTENTS

PREFACE

What's meant by a 'great' moment in theatre? In my book, and by 'my book' I mean both my head and this volume, it embraces a variety of definitions. Great theatre can move you, exhilarate you, delight you with its wit, double you up with laughter, churn you, horrify you, deepen you, transport you and your imagination to other worlds, tell you fascinating things about your and others' society, culture, history, drama and, indeed, theatre. It can even perform that exercise in intellectual pugilism so often invoked by high-minded professionals: challenge you. It can be excellent or unforgettably bad or strikingly in between. It can doubtless be cathartic, whatever that means, and very occasionally it can be magical, whatever *that* means.

But even if the 'cathartic' arousing and/or purging of pity and terror is an elusive idea, the cause of endless debate in academia and endless confusion everywhere else, I know what 'magical' is, at least for me. I felt it way back in 1964 when, as an apprentice critic for *The Guardian*, I was sent to a so-called theatre in Salford to review that great (oh no, that word again) British actress Barbara Jefford in a touring production of Racine's *Phèdre*.

I say 'so-called' because the theatre was actually a shabby old cinema, with disintegrating seats and, somewhere at the back of quarter-filled stalls, a urinal which every few minutes flushed so loudly that an ugly whooshing noise carried through the audience and, no doubt, onto the stage. The place couldn't have been more unfriendly to classical drama if it had tried, and it was trying very hard. Yet Jefford and her anguished Phèdre didn't merely blaze. Something strange and almost unworldly happened. There was a connection between actors and audience, stage and spectators, that went beyond a close or even intimate rapport. We were rapt. It was magical.

I've not made that one of my 'great moments' because the details of the production have evaporated. My review, which would anyway have been carried only in *The Guardian*'s northern editions, is dust. The 'theatre' itself is probably now a small supermarket or a coffee bar, complete with loos that flush silently. But my book includes two other events that left me and, as far as I could tell, those around me feeling as if we were linked in some mysterious secular communion. One occurred in the 1990s at the

National Theatre, one in the 1980s on Broadway, of all glitzy places. Oh yes, and perhaps there's yet another, also included here: the opening of a now-famous musical, this time at the Barbican in the 1980s. All helped to clinch my belief that the theatre has a potency and therefore an importance denied to any electronic medium.

Among other things, it's a gymnasium in which we can rediscover and exercise that underused muscle, the imagination. By way of emphasising this, I've included work that depends at least as much on visual invention as on words: Complicite's *Mnemonic*, Robert Lepage's *Far Side of the Moon*. But there obviously are also very many times, indeed the overwhelming majority of times, when the dramatist's script and the actors' words are dominant – and you still leave feeling that your imagination has been creatively stretched.

Times, too, when you sense this happening even though you weren't there. I witnessed many of the 'great moments' in this book, and reviewed most of those, among them the world premiere of Harold Pinter's *Homecoming* in Cardiff; but I'm not old enough to have seen the first night of Shakespeare's *Hamlet* or even those of Coward's *Private Lives* and Clifford Odets's *Waiting for Lefty*. To evoke David Garrick's breathtaking Hamlet or Edmund Kean's even more astonishing Shylock you have to rely on contemporary accounts of their acting. Fortunately, these are often long and precise, more so than today, when reviews are abundant but disappointingly short and therefore lacking in the detail you get from a Lichtenberg, whose letters and diaries analysed Garrick's Hamlet. True, performances are sometimes televised or filmed, which is a help; but, as I indicate later, you have only to compare Laurence Olivier's Othello as it hammily materialised on celluloid with memories of the Olivier Othello that mesmerised theatre audiences to see how inadequate recordings are.

Here, I should probably offer some ritual apologies. There are unfortunate omissions in this book as well as what I believe to be defensible inclusions. Where are some of the major Europeans – Schiller, Strindberg, Pirandello, Horváth, Dürrenmatt, Frisch, Sartre and the Anouilh whose *Poor Bitos* thrilled me when I was a boy? Why have South America and Australia disappeared from the theatrical map? Where's Asia, for Heaven's sake? Where are English-language contemporaries I've admired and enjoyed – Mike Leigh, Steven Berkoff, Neil LaBute, and the Rowan Atkinson whose imitation of a man trying to stay awake in a church service showed me that the cliché, 'rolling in the aisles', could be a literal truth?

Where's *War Horse*, with its pioneering puppetry? Where's Congreve's *The Way of the World*, Barker's *Waste* and Christopher Hampton's *Tales from Hollywood*, a play that, transposed to television, got a genuinely great performance from Alec Guinness as a distraught Heinrich Mann. Come to that, where's Guinness?

Indeed, the habits of a near-lifetime as a reviewer impel me to raise still more critical doubts. Why the number of 'great moments' that you'll find in this volume? I'd originally intended to include 100, though for no better reason than that it sounded as right as, say, Classic FM broadcasting its listeners' 100 favourite tunes or a newspaper listing the 100 richest people in the world. Then I suddenly found I'd slightly exceeded that supposedly magical or allegedly 'round' number and, like someone making his will, didn't want to cut out any of my best beloved. So I stopped counting and suggest you do too. Anyway, who but a mathematical nerd can be bothered to count as far as 100, let alone beyond it?

Then again, should this book be so relentlessly chronological? Isn't there a more interesting pattern to be found in what is, I suppose, a *de facto* theatrical history? Well, on rereading items I wrote at very different times – Burbage's *Hamlet* after Butterworth's *Jerusalem*, for instance – I've been surprised to see how many significant plays and shows had difficult births, whether because of the reviewers' short-sightedness, the theatre's limitations, the audience's prejudices or the doubts of their own creators and producers. That's not a pattern, but it is a recurrent phenomenon, theme and lament, though not one that has changed the book's relentless chronology.

So too bad if I've erred. These are the 'great moments' that seemed irresistibly to elbow their way onto my laptop. Some I wish I'd seen – a terrific performance, a stirring dramatic achievement, a highly controversial event – because they mattered to our forebears and/or have proved influential enough to matter to us today. Those I've tried to reconstruct. But many, as I say, I did see. Either way, you'll find examples of great actors at their best. You'll find examples of just about every genre of drama and theatre, if not quite Polonius's tragical-comical-historical-pastoral. You'll find occasional memories of famous fiascos. After all, how could anybody who saw Barbara Windsor gallantly battle her way through Lionel Bart's *Twang!!* not include that bizarre opening in Manchester 1965?

And though the prime emphasis is on British theatre, for reasons that include the surely indisputable truth that my life in the upper circle, pit

and stalls has coincided with the most exciting period in our theatrical history since the Jacobean era, there are forays abroad, mainly to America, where I've also worked as a critic. I've enjoyed the remembering, the re-imagining and, not least, the sheer fun of it all. I hope you do too.

THE ORESTEIA

The Great Dionysia, the spring festival devoted to the wine-god, had already lasted two or even three days. There had been processions, sacrifices, speeches, awards, libations, a parade of war orphans, dance and song in the enormous O, or 'orchestra', in front of the wooden 'skene' inside which actors were preparing for a long day. Then, early the next morning, a figure appeared upon that very building. He was Agamemnon's watchman and about to see beacons proclaiming that his master had returned home after leading the Greeks to victory at Troy. Aeschylus's *Oresteia* had started to unfold before the 15,000-odd citizens and visitors crowded on semi-circular benches in the theatre on the southern slope of Athens's Acropolis.

As a boy, Aeschylus had reputedly seen Dionysus in a dream and been told by him to become a tragedian. Now he was sixty-seven, Athens's greatest dramatist, and once again triumphing in a contest that was being waged by three men whose tetralogies had been selected for performance by the city's senior magistrate. The prize was probably little except prestige, but that would have satisfied Aeschylus, who hadn't appreciated losing to the rising Sophocles ten years earlier. He died two years afterwards, perhaps when an eagle dropped a tortoise on his head, having written some ninety plays, of which seven survive, prime among them the three tragedies we call *The Oresteia*.

The play that followed them, a raucous 'satyr' called *Proteus*, is lost, but it's hard to see what it could have added to a trilogy that Swinburne called 'the greatest achievement of the human mind'. And, yes, the story of Agamemnon's murder by his wife Clytemnestra, her killing by their son Orestes, and his arraignment by Furies before an Athenian jury on a rock ten minutes' walk from the theatre itself has ramifications today. It's about the triumph of justice, democracy, civilisation over blood-feud and revenge.

The trilogy clearly also made quite a spectacle. According to an ancient biography, Aeschylus 'stunned his audience with brilliant visual effects – paintings and machines, altars and tombs, trumpets, ghosts and Furies'. Indeed, the twelve- or fifteen-man chorus that played Theban elders in

Agamemnon and servants in *Choephori* so terrified the spectators as snake-haired Furies in the third play, *Eumenides*, that pregnant women reputedly had spontaneous miscarriages. It also danced and sang and, like the three male actors who shared the speaking roles, wore painted masks of rags hardened with plaster and topped by wigs.

As Peter Hall's 1981 revival of *The Oresteia* showed, masks can be extraordinarily expressive, seeming to change expression according to the words projected through their open mouths. And though most scholars believe that Aeschylean acting was relatively dignified – one actor, Mynniskos, accused a successor of performing 'like a monkey', presumably meaning he over-elaborated and vulgarised his gestures – the aim was clearly to convey and provoke strong feeling. After all, how could the man playing Agamemnon's war-trophy Cassandra, who breaks the tension created by a long silence to speak, sing, wail out prophecies of impending cataclysm, not be using all his voice and body to express extreme anguish?

Mounting a satiric battle between the ghosts of Aeschylus and Euripides in his *Frogs* in 405, Aristophanes paid oblique tribute to the former's weight and power, both of which were badly needed at a time when Athens was losing its war with Sparta. Certainly, *The Oresteia* was Aeschylus's own magisterial tribute to the enlightened city in whose ranks he'd fought the Persians at Marathon. The Furies prosecute Orestes for matricide on the Areopagus. Apollo, who has browbeaten Orestes into killing Clytemnestra, defends him. With the jury split, Athene herself gives the casting vote, acquitting Orestes and ensuring that a hard-won wisdom prevails.

Meanwhile many questions – moral, social, political, theological – have materialised. Is Clytemnestra's murder of Agamemnon justified by his earlier sacrifice of their daughter Iphigenia, as she claims? Surely not, especially as she's taken the slimy Aegisthus as her lover, compromising her motives. But does Agamemnon's killing justify her son's murder of her? Can Orestes avenge his father, as has been divinely demanded, without committing a terrible crime? What happens when one definition of *dike*, the right, is in conflict with another? Orestes is the special case who challenges the inflexibility of law, and he gets the special treatment he deserves from a new institution: Athens's jury-system.

The courtroom battle achieves this, admittedly in ways that sometimes seem bizarre nowadays. The Furies represent the old matrilineal deities for whom a mother's murder is unpardonable, and Apollo is one of the gods who replaced them around 2,000 BC, Olympian deities who sanctioned

a male hegemony in Athens. Indeed, Apollo argues that matricide barely matters, since women are pods, 'nurses' to men's seed. Yet Aeschylus gave the Furies some unassailable arguments and they convince half a jury of free and equal citizens. And the play's last words are of reconciliation. The Furies transmute into Eumenides, kindly ones, and, closeted in a cave below the Areopagus, become the city's protectors. There's mercy as well as law, reason as well as instinct, and the possibility of security for mothers *and* fathers, respect for marriage *and* kinship. Democratic, civilised Athens prevails – as did Aeschylus at the Great Dionysia some 2,500 years ago.

HAMLET

There's a moment in Virginia Woolf's *Orlando* where the title-character joins a motley London throng and finds himself moved to tears by a distraught black man, clearly Shakespeare's Othello, waving his arms and speaking with 'dazzling agility of tongue' before suffocating a white woman on a bed. That would presumably have been Richard Burbage, whose obituarist wrote in 1619 that 'a whole world' which lived in him had died, including 'the grieved Moor', 'kind Lear' and 'young Hamlet'. So one may also imagine Orlando mingling with the groundlings standing in the Globe's pit or paying a few pence to join the better-off seated in the tiers above – and seeing Burbage's Hamlet quake and shake at a ghost who was very likely played by Shakespeare himself.

What kind of Hamlet was Burbage? Since detailed description of individual performances is lacking, scholars argue about the nature of Elizabethan acting, some thinking it was pretty formal, some relatively naturalistic, some a blend of both. Whatever the wider truth, Burbage clearly tackled a striking variety of roles. He was the son of the actor who had built London's first important playhouse, and himself doubtless went on stage as a boy, taking female parts before playing lead after lead for the Lord Chamberlain's Men, later the King's Men: the hugely successful company that he, Shakespeare and others founded in 1594.

So Burbage, who was born in 1568, would have played Romeo at the age of twenty-eight and the octogenarian Lear at thirty-eight. He was presumably also wicked Richard III, witty Benedick, agonised Brutus and grave Prospero. Here was an extremely versatile actor, forced to perform in a theatre that held over 2,000 spectators yet more at home with subtleties of language and feeling than his rival Edward Alleyn, who first played Marlowe's Tamburlaine and evidently commanded that dramatist's 'mighty line'. And it was Burbage who created the most complex character of all, one who must be sorrowful, bitter, courteous, aggressive, self-doubting, sardonic and able to switch from sophisticated verse to colloquial prose in a twinkling: 'young Hamlet'.

As Hamlet, Burbage also delivered an acting lesson – a manifesto, almost – that surely reflected his own practice. If he was a highly stylised

actor himself, would he have commanded the players who visit Elsinore to avoid town-crier rhetoric, mannered gestures and overblown emotion? Actors were to speak 'trippingly on the tongue', 'suit the action to the word, the word to the action', and never 'o'erstep the modesty of nature'. They were not to pander to groundlings, most of whom 'are capable of nothing but inexplicable dumb-shows and noise', but avoid excesses that 'make the judicious grieve'. That's a bit rude about much of the Globe's own audience, but it shows what Shakespeare got from Burbage and, conversely, what Burbage expected of and got from Shakespeare. We tend to think that Shakespeare created his characters in an imaginative limbo. No. Burbage was Shakespeare's business partner, fellow-actor and, since he left him money in his will, close friend – and helped to shape the plays by showing him what was theatrically possible.

Burbage was clearly intelligent, deft, measured, but more. The only description we have of his acting comes from the occultist Simon Forman, who saw him as Macbeth and reported he 'fell into a great passion of fear and fury' on observing Banquo's ghost. And his anonymous obituarist wrote that he'd often 'seen him leap into the grave', which presumably means that he did something as Hamlet that's sanctioned only by what scholars call the 'bad quarto', a version of the play mangled by actors with questionable memories. He jumped into Ophelia's grave and, mad with jealous rage, fought Laertes beside or even upon her corpse.

The picture grows of a complete and surprisingly modern actor. That same obituarist recalled that even his fellow-actors thought Burbage was actually dying 'whilst he but seemed to bleed'. And let's remember how impressed Hamlet was when he saw the Player King bleeding emotionally – 'all his visage wanned, tears in his eyes, distraction in 's aspect, a broken voice' – in response to the prince's demand for a 'passionate speech' about the stricken Hecuba. Burbage was the king of England's leading players, and he too was clearly able to inhabit character and to do so in circumstances we now know weren't friendly to private thought or deep personal emotion.

One of the lessons actors have learned from the replica of the Globe Sam Wanamaker created on London's South Bank is that the 'private', the 'personal', or any intimate interaction can barely have existed in 1601. Acting on a stage thrust out amid the groundlings, sharing daylight with spectators perched in half-circles high above, performers had to acknowledge their audience to a degree they didn't after the English drama disappeared behind the proscenium arch in 1660. When Mark

Rylance played Hamlet at the Globe in 2000 'to be or not to be' wasn't just anguished introspection. It was in effect an intense debate with those watching him: should I be or not be? Did Burbage, too, accomplish that while staying firmly in character? I suspect so.

EASTWARD HO!

This was the 'city comedy' that landed Ben Jonson and George Chapman – a third collaborator, John Marston, probably fled London – in prison for insulting James I and his Scottish retinue. Indeed, it nearly left both men with sliced-off ears and noses as punishment for *lèse-majesté*. But it's a pity that nowadays *Eastward Ho!* is remembered mainly for that threat. The Royal Shakespeare Company's revival of the play in 2002 left many critics feeling that its four centuries of neglect was a disgrace – and that it would be satisfying to exhume the dramatists and give each an extra pair of nostrils as a reward for the satiric skill they brought to the business of sniffing out skulduggery in Jacobean London.

Though scholars argue about which dramatist wrote what sections, it's tempting to see Jonson as the dominant partner, since his best-known comedies, *Volpone* and *The Alchemist*, exude a similar glee in deception. He would surely have relished the play's more scoundrely characters: Sir Petronel Flash, who absconds with the dowry of Gertrude, the goldsmith's daughter he's married and then sent packing to a castle that doesn't actually exist; the crooked sea captain Seagull, who has promised to take Flash to Virginia, where the chamberpots are made of gold and adoring natives shower English immigrants with treasure; the gruesomely malevolent usurer Security, who is simultaneously fleecing Sir Petronel and being cuckolded by him.

Even by Jonson's standards, it's an extreme case of nits biting fleas that are nibbling leeches that are bleeding curs. So far, so good. Generalised satire was acceptable in 1605. But not only had the authors of *Eastward Ho!* failed to get permission from the Lord Chamberlain for a production that was performed by one of the boy companies popular at the time: their play contained gibes at the men whom James had brought from Scotland with him and, to English dismay, was preferring. Between his arrival in London in April 1603 and the end of 1604, the new king had created an astonishing 1,161 knights, many Scottish and paying for the privilege.

The play's most offensive passages were probably cut by the time it was printed, but some survived and others may be identified from a copy of

11

an acting script. Seagull says that there are 'only a few industrious Scots' in Virginia, adding that he wishes 'a hundred thousand of them' were there, since that would be ten times better than their presence in England. Again, Flash is shipwrecked on the Thames, lands up on the Isle of Dogs, thinks he's in France, and accosts two gentlemen, one of whom recognises him. 'I ken the man weel, he's one of my thirty pound knights,' he says in an accent that was obviously unmistakable and possibly mimicked James's own.

It was one of those new knights, Sir James Murray, who complained of the play, precipitating the dramatists' arrest. The insults to the Scots he doubtless thought bad enough, but he was surely also offended by a passage in which the conversation turns to the court itself, a place where it's said to be necessary to pander to the presiding lord's lackeys, among them 'my worshipful rascal, the groom of his close-stool'. There was indeed a court officer called The Groom of the Stool, a man responsible among other things for the health of the royal anus, and in 1605 he was Sir John Murray, Sir James's brother.

The imprisoned dramatists petitioned their aristocratic contacts and eventually were released, whereupon Jonson threw a banquet at which his mother announced she'd have poisoned him and herself if he'd been convicted. Whether or not she meant it, that doughty lady certainly knew her turbulent son's appetite for trouble. After killing an actor in a duel, Jonson had been branded on the thumb, perhaps with a T for Tyburn, where he risked being hanged. A play he'd written with Thomas Nashe, *The Isle of Dogs*, is now lost, but in 1597 it had sent him to prison and hauled before the Privy Council, where he was accused of purveying 'very seditious and scandalous matter', probably because he had satirised important individuals, even the Queen herself. In 1603 his tragedy about the Emperor Tiberius's favourite, *Sejanus*, had brought him before the same council, this time arraigned both for 'treason', presumably because the play's treatment of imperial corruption hit nerves in high places, and for 'popery'. But he successfully answered his accusers, as he would those who suspected him of complicity in the Gunpowder Plot of November 1605. The Catholic Jonson, it seems, knew several conspirators and, conceivably, their intentions.

His personal life was murky, but *Eastward Ho!* isn't. It's robustly, raucously funny about folly and pretension as embodied by the spivvish Flash and, even more, by his socially ambitious wife. 'I am a lady still,' wailed Amanda Drew's Gertrude in her fake-genteel lisp in the RSC's revival, rolling on the floor in distress at her knight's betrayal yet finding comfort in the fact that she's not just an ordinary 'shitizen'. Jonson was dangerous and endangered. He was also hilarious.

THE CID

Thank goodness Shakespeare was oblivious to Aristotle's 'rules', as generations of oppressive critics called the archaic decrees they ruthlessly imposed on living dramatists. It's possible to defend the Bard from the accusation that his work lacks 'unity of action', meaning that little can be excised without damaging a play as a whole. But what of 'unity of time', which comes from the philosopher's throwaway remark that tragedy tries to confine itself to 'a single revolution of the sun', and 'unity of place', which he didn't mention at all? *Hamlet, Lear, Antony and Cleopatra* abjectly fail those tests: which is why even Voltaire, writing a century after Pierre Corneille's *The Cid* had been hammered for sins that included flouting Aristotle's *Poetics*, derided Shakespeare for 'barbarous irregularities'.

The irony was that Corneille himself called the unities 'an absolute and indispensable necessity' and packed the plot of his masterpiece, *The Cid,* into a preposterously short time-frame. Consider what happens within 24 hours in and around Seville. The father of the chivalrous Rodrigo, alias The Cid, forces his son to avenge the insults he's received from the father of Rodrigo's beloved, Ximena. Rodrigo kills the old man in a duel, goes off to defeat the Moors in a battle, returns to fight and win another duel, and is rewarded by the King with the hand of that emotionally very confused and divided lady, Ximena.

'I leave you to judge whether this has been a very busy day', sneered Georges de Scudéry, Corneille's fellow-dramatist in the pamphlet that began the French theatre's most famous controversy. Scudéry wasn't disinterested. He clearly envied *The Cid*'s unparalleled popular success. He declared that this had gone to the head of Corneille, then a socially awkward thirty-one-year-old from provincial Normandy. In Scudéry's view, the 'vulgar effluvia of the pit' was invading the theatre boxes, creating absurd enthusiasm for a play that had a 'worthless' plot, abused Aristotle's rules, and was poorly written, with 'virtually all its beauties stolen'. Moreover, it gave an 'atrocious example', since the heroine was an 'unnatural daughter' who ought to be struck dead by a thunderbolt rather than left 'basking in the royal pardon'.

Poor Corneille. He was desperately wounded, and replied that the play had been performed before the Queen at the Louvre and at the palace of Louis XIII's chief minister, Cardinal Richelieu. Moreover, he had shown the Cardinal a copy of his acknowledged inspiration, a play the Spanish dramatist Guillén de Castro had derived from a thirteenth-century poem immortalising both Rodrigo and Ximena. But worse trouble was to come. *The Cid* was delivered to Richelieu's recently created Académie Française, which was busy ensuring that he and the King exercised as much control over culture as over everything else. And its opinion was decidedly unsympathetic.

'For fear of violating the rules of art the author has preferred to sin against human nature,' the Académie wrote of Corneille's attempt to cram several years into twenty-four hours, somewhat inconsistently adding that Aristotle's 'judicious' rule decreed a twelve-hour time-frame, sunrise to sunset. Again, Corneille poorly understood the 'no less essential unity of place'. But the Académie's prime objection was that the play lacked decorum. True, the historical Cid had ended up marrying Ximena, but 'there are some truths that are monstrous or that we must suppress for the good of society'. Corneille should have changed the story or, better, not dramatised it at all.

Corneille never got over the attack, stopping writing for three years, continuing to answer his critics into old age, and producing work that lacked the exuberant energy of *The Cid*. One would like to say he won the war, because the play was soon published in other languages, remains a staple of the Comédie-Française and, though its verse doesn't easily transmute into English, has been successfully staged at the National Theatre in a lively translation by Ranjit Bolt. Dilemmas involving honour and duty may no longer obsess us, but the play's basic subjects haven't dated. Don't we still try to reconcile desire and morality, will and justice, like characters with passions that are sometimes as intense as those that fire the masterwork of Corneille's successor, Racine's *Phèdre*?

Still, that war took time fully to win. Racine adapted well to those 'rules', but they intimidated many other European dramatists and did immeasurable damage to their creativity. Not until Dr Johnson robustly pointed out that audiences who could imagine they were watching Antony in Alexandria could as easily imagine they were watching him months later in Rome did the unities of time and place lose their potency in Britain. The irony was that the embattled Corneille had made a similar point twenty-

three years after *The Cid*, but diffidently, apologetically, even forlornly. Couldn't playwrights be allowed some leeway, he asked? Couldn't they do a little violence to time and place? Couldn't 'the imaginations of the spectators' be allowed to flow? Well, couldn't they?

TARTUFFE

I t was the first performance of the version of Molière's *Tartuffe* that has survived to this day. It was also a huge success. According to the journalist Antonin Robinet, 'curiosity like nature abhors a vacuum', which was why people fought for admission, crying 'I'm suffocating' and risking being smothered in their anxiety to see a play that had caused such a stir and scandal. That production, with Molière himself playing the gullible patriarch who falls victim to a religious hypocrite, took a record 2,860 livres that day and, as the Palais-Royal register showed, went on to play for forty-three performances, which was far more often and profitably than any other new Molière comedy.

But thanks to the hostility of France's religious extremists, it wasn't the play Molière had originally written. Even before he brought an early version to Versailles in 1664, when and where the dramatist was helping to organise a long and lavish festival for Louis XIV, a secretive and highly influential sect called the Compagnie du Saint-Sacrement had vowed to suppress what they called 'the wicked comedy of *Tartuffe*'. And what followed was a long war waged by the society's members and sympathisers against Molière and an admiring but cautious king.

Louis spoke well of the play, had an embryonic version played as part of the festival, but didn't yet allow its public performance, something that emboldened those who saw Molière's portrait of the hypocritical Tartuffe as an attack on piety and the Church. A vicar called Pierre Roullé published a grateful tribute to the 'Most Glorious King in All the World' which demanded both the stake and hell fire for the dramatist, calling him 'the most notably impious creature and libertine who ever lived throughout the centuries'. The King was angered by such unwanted praise, but still said that an 'extremely diverting' and well-intentioned play might mislead those unable to distinguish between sincere devotion and 'a vain ostentation of good works'. Hence a ban that dismayed Molière, who had scheduled *Tartuffe* for his new season at the Palais-Royal.

Still, the King encouraged private performances of the play, himself inviting the Papal Legate, Cardinal Chigi, to a reading of *Tartuffe* and

permitting his brother, the official 'protector' of Molière's company, to hold a staging in his house. Meanwhile, the dramatist's pleas and petitions had their effect. Louis demonstrated his support by becoming protector of a company he renamed the Troupe du Roi. And when Molière produced a longer, softer version that sought to meet pious objections, a play now pointedly retitled *L'Imposteur* appeared at the Palais-Royal in August 1667.

But its troubles weren't over. Louis was away on a military campaign in Flanders and his substitute, president of the parliament and a secret member of Saint-Sacrement, banned subsequent performances, declaring it wasn't the business of comedians to tackle matters of Christian morality and placing guards at the theatre's doors to ensure his orders were obeyed. Days later the Archbishop of Paris issued a decree threatening anyone who performed, read or heard *Tartuffe* with excommunication. But the king listened to Molière, who had left for Flanders with yet another petition, standing godfather to his child, defying the Church by staging a private performance for the Prince de Condé and sanctioning the public showings of the play we now know.

For by 1669 *Tartuffe* had changed still further. Instead of the credulous Orgon virtually giving Tartuffe his wife and worldly goods at the end, as seems to have happened in the first version, an emissary from the Sun King appeared as a *deus ex machina* to expose and arrest a more obviously villainous imposter. A light comedy about gullibility had become a satire on hypocrisy. Molière had cut Tartuffe's more holy-sounding lines and even changed his costume from clerical to secular – 'small hat, long hair, a wide collar, a sword and lace' – to propitiate what he saw as the true hypocrites: men that his preface to the published script accused of misinterpreting a moral play and misleading the fanatical, squeamish and devout alike.

He took oblique revenge in *Don Juan*, where the libertine's 'final abomination' is the 'fashionable vice' of playing the hypocrite. But the war against Molière continued even after his death. Though he was a practising Catholic, two priests refused to give him the last rites after he collapsed while playing the title-character in his *Le malade imaginaire* in 1673, while a third arrived too late to do so, and a new Archbishop of Paris left his body unburied for four days. Only the King's intervention allowed Molière to be interred in sacred ground, though the funeral occurred at night and, according to tradition, in a part of the cemetery of St Eustache reserved for stillbirths. But it wasn't the furtive affair the authorities ordained. A vast crowd of friends and admirers followed Molière to his grave: an indication that posterity would think rather differently of the author of *Tartuffe* than his foes.

PHÈDRE

Jean Racine's reworking of Euripides' *Hippolytus* is widely regarded as the finest of French tragedies, but it had a difficult birth. For reasons still disputed, but perhaps because he had ruffled feathers including those of the great Corneille, a highly influential patron of the arts plotted the play's failure. Hearing of the impending staging of *Phèdre et Hippolyte*, as it was originally called, the Duchess of Bouillon hired a minor dramatist, Nicolas Pradon, to compose a tragedy with the identical characters and title and (she hoped) lustre enough to distract the public from the already famous Racine. By some accounts she bought up seats in both the Bourgogne and the Théâtre de Guénégaud, where Pradon's spoiler was staged two days after Racine's play.

The ruse almost succeeded. Racine, reportedly 'in despair', failed in his efforts to get an injunction banning Pradon's play. Moreover, Paris initially found it hard to distinguish which portrayal of Phèdre's passion for her stepson was the better. And the rivalry intensified when a sonnet mocking Racine, written at the Duchess's instigation, was distributed. Racine's friends riposted with a still ruder sonnet alleging that the Duchess's brother, the Duke of Nevers, wasn't a courtier, soldier or Christian and implying he was in love with another of his sisters, the sexually promiscuous Duchess of Mazarin. The battle of the sonnets continued with Nevers emitting veiled threats in verse; and it took the intervention of Racine's friend, the powerful Prince de Condé, to save the dramatist from a beating or worse.

But Pradon's play soon disappeared and Racine's began to flourish, receiving 114 performances in Paris and eighteen at Court between 1680 and 1700. Before long Voltaire was to proclaim it a 'masterpiece of the human mind', and so it is. The language is simple, with Racine using only 800 different words in all. The verse is graceful, its eight-syllable 'alexandrines' coming in rhyming couplets. The action obeys the 'rules' of time and place that had given Corneille such trouble. Yet within that rigid structure, and perhaps partly because of it, the emotions seem as intense as they're complex.

Too intense for the period? Some thought the subject indecorous, even coarse, and others went further. Racine, orphaned while young, had grown up at the Convent of Port-Royal, the centre of Jansenism, which preached near-total or (sometimes) total renunciation of the world. And after he'd rejected such hard-line Catholicism, and seen his first two tragedies staged by Molière, one of his former teachers outraged him by publishing a pamphlet calling dramatists 'poisoners of the soul'. But bit by bit Racine was reconciled with Port-Royal, which may help to explain two things. After *Phèdre* he accepted the post of Louis XIV's Historiographer Royal, abandoning the theatre until his devout *Esther* was staged in 1689. And he published a preface to *Phèdre* itself, reassuring those 'celebrated for their piety' that he was upholding decorum and defending morality. He had, he wrote, never written a play in which virtue was more favourably presented and the slightest fault more severely punished.

This justifies, perhaps a bit disingenuously, the changes he made to Euripides. It's often said that the sophisticated French would never have credited so chaste a Hippolytus, even suspecting him of homosexuality, and that's why Racine introduced a young woman, Aricie, for him to love. But the dramatist argued that, since Aricie's family were the mortal foes of his father Theseus, this gave the noble youth the flaw that made his death less offensive. More importantly, he rendered his heroine 'a little less odious', making Phèdre's lowly confidante, Oenone, almost wholly responsible for the false accusations that cause Theseus fatally to curse Hippolytus – and emphasising Phèdre's own horror at emotions 'she makes every effort to overcome'.

Her desperate battle has continued to move audiences and excite players. The two greatest actresses of France's nineteenth century owed much of their fame to their triumphs as Phèdre. 'Nothing I have ever seen surpassed this picture of a soul torn by the conflicts of incestuous passion and struggling conscience,' wrote the critic G.H. Lewes of Rachel. For Arthur Symons, Sarah Bernhardt was dignified, beautiful yet 'a wild beast ravening upon prey': a blend of chant and escalating scream you can hear today on old recordings. And in our own time Barbara Jefford, Diana Rigg and Helen Mirren are among those who have used translations by Robert Lowell, Ted Hughes and others to demonstrate that *Phèdre* is not the cold, elegant and very French play the English have sometimes assumed – but one that can blaze with a fury that crosses national boundaries.

THE BEGGAR'S OPERA

Many thought that John Gay's ballad opera would never succeed, partly because its mix of jailhouse story and traditional tunes was so novel, partly because it fêted a highwayman disturbingly like the King's chief minister. London's leading actor, James Quin, turned down that particular role. The men running Drury Lane and the Queen's Theatre, Haymarket, rejected the opera. John Rich, manager of a less prestigious theatre, accepted it, but without enthusiasm and perhaps because Gay's great fan, the Duchess of Queensberry, had bribed him to stage it.

Not until the opera was about to open was it decided that its sixty-odd lyrics should have full musical accompaniment rather than simply be spoken or sung by the cast. And Gay's friends, Swift and Pope among them, were worried, Pope reporting that the dramatist Congreve thought *The Beggar's Opera* 'would either make a great hit or be damned confoundedly'. A comically baffled Duke of Queensberry was even more equivocal. 'This is a very odd thing, Gay,' he said. 'I am satisfied that it is either a very good thing or a very bad thing.'

Well, the first audience watched silently until Lavinia Fenton's touching Polly Peachum sang of her distress that her corrupt father seemed likely to end her secret marriage to the highwayman Macheath by getting him hanged. Then came the applause that was to make her an eighteenth-century celebrity and, thanks to a grand marriage, Duchess of Bolton. And the final ovation was so great that *The Daily Journal* declared that it hadn't been matched 'for these many years'. The very bad thing had become a very good thing and proceeded to run an unprecedented sixty-three performances. It was said that the opera made Gay rich and Rich gay, though that wasn't altogether true, for the improvident and rather unworldly Gay sold the opera's copyright for a mere £90.

He wasn't that unworldly, though. How could he be when he listened to Pope and Swift, who kept urging him to sharpen his satire of Sir Robert Walpole and his Whig administration? Actually, it was Swift who had given Gay the idea of a 'Newgate pastoral', meaning an ironic portrait of life in

and around London's main prison. And Gay had initially responded with *Newgate's Garland*, a ballad inspired by the hanging of Jonathan Wild, who, like Polly's father, simultaneously ran gangs of thieves and informed on those who displeased him. This attacked peers, courtiers, parliament men who had swindled their way to wealth, as did *The Beggar's Opera* itself.

Such accusations dogged Walpole in particular. He had attended the opera's opening and been observed smiling and clapping, ostentatiously unmoved by the mention of a highwayman called Bob Booty, which was one of his nicknames. Likewise with the song in which Macheath himself compared the charms of Polly and Lucy, daughter of Peachum's equally evil crony, the jailer Lockit: 'How happy could I be with either, were t'other dear charmer away.' That was reputedly a reference to Walpole who, though married, was living with his mistress. And *The Intelligencer*, a paper Swift and Sheridan had started in Dublin, compounded the attack by praising Gay for 'comparing the common robbers of the public and their several stratagems for betraying, undermining and hanging each other to the several arts of the politicians in times of corruption'.

Not everyone was thrilled. The sympathetic playing of Macheath by a glamorous young actor called Thomas Walker was said to be corrupting audiences, including a gallant who had grabbed a passer-by's gold watch as he left the theatre. Moreover, Macheath went unpunished, thus inciting street robbers to new crimes; or so claimed Thomas Herring, later Archbishop of Canterbury, in a sermon against Gay. Such attacks provoked Swift to defend 'this excellent moral performance' against stupid, injudicious, 'prostitute' divines and, later, Dr Johnson to point out that highwaymen seldom attended the theatre and were anyway unlikely to conclude they could rob with impunity.

But if Gay thought he could suggest with impunity that the difference between the great and the poor was that the great got away with their crimes, he was wrong. *Polly*, a sequel in which Macheath became a pirate in the West Indies, was banned without explanation by the then Lord Chamberlain, the Duke of Grafton, who was Walpole's friend. That opera wasn't performed until 1777, 45 years after the 'fat clown', as Walpole called Gay, had died.

The Beggar's Opera has often been revived and sometimes adapted, notably by Brecht, whose *Threepenny Opera* does, however, owe its fame mainly to Kurt Weill's wonderfully sleazy, cynical music. But in 1728 its success was largely due to the arrangements of Christoph Pepusch, who

drew on Handel and Purcell as well as old tunes like 'Greensleeves', to produce sounds hailed as a healthy corrective to the elaborate Italian scores then in fashion. And the effect was and remains ironic: to bring an odd innocence, a *faux-naïf* quality, to a story about innocence flouted and betrayed.

HAMLET

The most celebrated moment in the eighteenth-century theatre came when David Garrick's Hamlet confronted the ghost of his murdered father. He whirled around, saw what was clearly a pretty terrifying figure, and staggered back. His knees buckled and, thanks to a specially constructed 'fright wig' that let his hair stick up, his hat fell off. And he stood supported by his friends, his mouth almost as open as his eyes, his face somehow contriving to become paler and paler. And when he spoke it was at the end rather than the beginning of a breath, so that 'angels and ministers of grace defend us' became a hoarse gasp and he himself seemed even more agog and aghast.

'Would you not start as Garrick does if you saw a ghost?' James Boswell asked Dr Johnson. 'I hope not,' replied Johnson. 'If I did, I should frighten the ghost.'

Actually, Johnson's imaginary reaction was very like an actor's reaction when Garrick was playing Macbeth. 'There's blood upon thy face,' he hissed to the murderer who had just sidled into the usurping king's feast, and instead of answering "tis Banquo's then', the actor found the words so urgent and intense that he put his hand on his cheek and nervously replied 'is there, by God?'. But it was the 'start' of Garrick's Hamlet in the ghost scene that was to be remembered for years to come.

The novelist Fielding paid ironic tribute to its awful plausibility in *Tom Jones*. Taken to Drury Lane to see *Hamlet*, his Partridge trembled so much at that point that his knees knocked together. But that naïve countryman ended up far more impressed by a clearly very histrionic Claudius than by a 'little man' – Garrick was barely more than five foot four even when he was wearing his elevator shoes – who seemed not to be an actor at all. He himself, said Partridge with a contemptuous sneer, would have reacted in an identical way to a ghost. And he was even more withering about Hamlet's visit to Gertrude's bedroom: 'where you told me he acted so fine, why, Lord help me!, any man, that is any good man, that hath such a mother would have done exactly the same.'

Talk about unwitting compliments. For most theatregoers, Garrick remained refreshingly truthful whatever his Hamlet said or did. With Gertrude, he veered between rage and tenderness, a mixture of emotions that left audiences shocked yet moved. He harangued a very meek Ophelia with a roughness realistic enough to worry both the novelist Smollett, who thought it indelicate of him actually to shake his fist at her, and the actor Macklin, who thought he left her 'like a brute'. Yet he had his quieter, more reflective moments, his right hand supporting his chin and his left holding his right elbow as he earnestly decided whether to be or not to be.

But his performance's main emphasis seems to have been grief and indignation at the death of a father he greatly loved. In the first great soliloquy, 'oh that this too too solid flesh would melt', tears ran down his cheeks, so overpowering him that the words 'so excellent a king' became an almost inaudible twist of the lips. And contemporaries spoke of 'attitudes indicative of depression', 'feminine sorrow', 'indifference as to what may become of himself' and a 'righteous anger' combined with the 'irresolute temper' that helped to explain why so fiercely emotional a man delayed his revenge.

Garrick was to do philistine things to the play's fifth act, cutting the gravediggers, having Hamlet stab Claudius to death at the wrong moment, letting Laertes live to form a Danish coalition with Horatio, and dispatching Gertrude offstage for 'an hour of penitence ere madness end her'. But that famous 'start' remained, as did the passion and power. Garrick played Hamlet some ninety times in all, giving his final performances of the role in 1776, the year he retired to universal acclamation. He was fifty-nine and, it was said, still looked young, still seemed fresh. If that wasn't great acting, what was?

THE SCHOOL FOR SCANDAL

DRURY LANE, LONDON, MAY 8 1777

On the first night of what was to become Richard Brinsley Sheridan's most famous comedy, a twelve-year-old boy was passing Drury Lane Theatre when he heard a mighty rumble. Thinking that the building was collapsing, he put his hands over his head and ran for it, but later discovered what the noise was. The audience was loudly applauding the play's climax, at which a screen falls, revealing to the elderly Sir Peter Teazle that his supposed friend, the hypocritical Joseph Surface, has been hiding his (Teazle's) wife in his rooms. And *The School for Scandal* was about to become its century's most successful comedy.

Sheridan was only twenty-six and quite a meteor already. His gloriously funny *Rivals* and his comic opera, *The Duenna,* had been staged. He had bought Drury Lane Theatre from David Garrick, who proclaimed him a 'genius'. He was also alluringly notorious, having been the object of scandal in Bath, the fashionable city to which his father, himself an actor and theatre manager, had moved his family in 1770. Richard had accompanied a young singer, Elizabeth Linley, to France and gone through a dubiously legal form of marrying her there. Were they eloping? Was he genuinely helping her escape the unwanted attentions of one Thomas Mathews? Whatever the truth, Sheridan fought two duels with Mathews, who had libelled him in *The Bath Chronicle,* and the second of them left the doctors fearing for his life.

The Chronicle feasted on these events, as did Bath society. 'Let me see what they report of me today,' said Sheridan as he recovered from his wounds. 'I wish to know whether I am dead or alive.' Well, he remained alive enough to immortalise the gossips, notably in the character of Lady Sneerwell, whose conversation with her lackey Snake opens *The School for Scandal.* In one draft of the play that Sheridan first conceived as *The Slanderers - A Pump Room Scene,* she asks Spatter, as Snake was originally called, if he's successfully spread 'the innuendo of Miss Nicely's fondness

for her own footman' and is reassured that it has reached one Lady Clackit via a hairdresser and a milliner's girl whose mistress is first cousin to that lady's waiting woman, all within fourteen hours. Sadly, that exchange was cut, but Clackit's success in generating scandal that broke engagements and caused divorces made Sheridan's final version.

The finished play combined two plots he had been tackling separately. One involves Teazle's tricky marriage to a country girl much younger than himself, the other the fortunes of the Surface siblings: Charles, who is wild but goodhearted and generous, and Joseph, who is devious, self-serving and forever spouting moral sentiments. Sheridan's jealous father, or 'Old Surly Boots' as he was sometimes called, said that Richard had only to dip his pen into his own heart to find both brothers there, and maybe there was truth in that; but there were also suspicions that Sheridan, later to become a prominent parliamentarian, was surreptitiously playing politics. Did Joseph represent the pious-seeming banker Benjamin Hopkins and Charles the dissolute but engaging radical John Wilkes, men publicly battling for high office in the City of London? Well, that was perhaps why the play was refused a performing license at the last moment, a decision overturned after Sheridan brought his considerable charm to bear on the state censor, the Lord Chamberlain.

He also brought toughness to rehearsals he supervised himself, telling the famously formidable Mrs Abington that her Lady Teazle was 'shallow, shallow' when she should have been denouncing her husband 'like a volcano'. The result was an evening praised almost as much for its fine acting as for its sharp but good-natured humour, the main caveat being almost a compliment: that characters large and small were equally witty. The only dissenter seems to have been an envious tragedian, Richard Cumberland, who reportedly pinched his children to stop them laughing. Sheridan thought that ungrateful. 'I went the other night to see his tragedy and laughed at it from beginning to end,' he said – and later mocked Cumberland as Sir Fretful Plagiary in *The Critic*.

Anyway, the play's success left Sheridan so delighted that, as he later told Byron, he was arrested for getting drunk and 'making a row in the streets'. The critics were equally elated, *The Morning Chronicle* praising the satire on the 'prevailing vices' of detraction and hypocrisy, *The Morning Post* the 'wit and elegance of the dialogue'. *The Gazeteer* declared that Sheridan's genius had restored 'the English drama to those rays of glory of which it was long

shorn by a tedious set of contemptible scribblers'. Years later, Charles Lamb was to say that one compensation for growing old was to have seen the play 'in its glory' and William Hazlitt that he wished he'd seen the original production of 'perhaps the most finished and faultless comedy which we have', one with 'a genial spirit of frankness and generosity' and 'a faith in the natural goodness as well as the habitual depravity of human nature'. And its foreign fans included Catherine the Great, who commissioned its translation and performance, and George Washington, whose favourite play it supposedly was.

But who wrote it? Some whispered that the real author was a young lady, daughter of a merchant in Thames Street, who had given the manuscript to Sheridan, gone to Bristol and died. Now, there's a story that shows how pertinent the dramatist's attack on rumour, gossip and scandal was.

THE MARRIAGE OF FIGARO

Pierre-Augustin Beaumarchais's biographer, Maurice Lever, calls the first public performance of his *Marriage of Figaro* 'among the great moments of French history'. Certainly, few theatrical openings have been more eagerly awaited or more ecstatically received. But historic? Well, some were to claim that *Figaro* presaged the cataclysmic events that occurred five years later. Danton declared that the title-character had 'killed the aristocracy', Napoleon that the play was 'revolution in action'.

Nowadays that seems strange. Like the great opera Mozart based on it, the play hardly comes across as politically threatening. But what's merely mischievous now was subversive then; or so it seemed to Louis XVI, many of his courtiers, and perhaps even the author himself. Beaumarchais had expected trouble for his follow-up to his *Barber of Seville*, in which Figaro helps Count Almaviva to a wife. Remembering that *The Barber* had been 'censored four times, cancelled at the moment of performance three times, and even denounced in Parliament', he had, he said, kept *Figaro* in a drawer for five years before spending another four trying to get it publicly performed.

However, there were private readings at various salons during that hiatus, making the play so famous, or notorious, that Louis demanded one himself. As Queen Marie-Antoinette's principal lady-in-waiting delivered it, the King persistently interrupted a text that Beaumarchais had in fact already censored himself, toning down a rude reference to the Bastille and transposing the action from France to Spain. Suddenly Louis rose and said the play was detestable and would never be staged: 'the Bastille would have to be destroyed for its performance not to be of dangerous consequence. This man mocks everything that should be respected in a government.'

He was referring to the long monologue in which the valet Figaro, who has spent much of the play outwitting a count who plots to seduce his fiancée on their wedding day, attacks privilege and the misuse of authority:

'Because you are a great lord, you think your talents are infinite! Nobility, fortune, rank, influence, they all make a man so proud. What have you ever done to earn such wealth? You took the trouble to be born, and that's the sum of all your efforts. For the rest, a pretty ordinary man. Whereas me, my God!, lost in the obscurity of the herd, I needed more skill and know-how even to exist than it's taken to govern the Spanish Empire for the last one hundred years.'

That seemed to be that. But Beaumarchais was the wily diplomat, financier, spy and arms dealer who had secretly fed money to the American revolutionaries, and he had friends as well as enemies at court. The readings continued, spreading the play's fame across Europe to Russia, where Catherine the Great asked to hear it. A private performance was scheduled at the Château de Gennevilliers in June 1783, only to be stopped by royal decree two hours before it was to start, provoking thwarted aristocrats to use words like 'oppression' and 'tyranny'. Marie-Antoinette and the King's brother, later Charles X, interceded, and Louis finally gave way, allowing a court staging in their presence. And after the last of the six censors who had successively examined the play gave his approval, and a tribunal of academicians and other notables had endorsed his opinion, *Figaro* opened in a public theatre mobbed to suffocation with eager spectators, among them princes and aristocrats, some of whom had paid twenty times the regular price of a ticket.

They laughed and applauded so much the play lasted from 5.30 to 10.00 pm. 'There is one thing crazier than my play,' said Beaumarchais. 'Its success!' And the critic La Harpe declared himself 'stupefied' by the nonstop clapping of a play that seemed to demean the government. But though *Figaro* ran an astonishing sixty-eight performances, Beaumarchais's troubles weren't over. Furious when one of the play's original censors attacked it, comparing Figaro to a dirty dog, he replied that he'd vanquished 'lions and tigers' to get it produced. That remark enraged Louis, who dispatched him to Saint-Lazare, a house of correction for depraved youths where, it was rumoured, he was thrashed by monks.

That humiliated the playwright, angered much of Paris and further undermined the dwindling authority of a king who would end on the scaffold eight years later. And Beaumarchais? He was chased from his house by the mob, wrongly accused of appropriating weapons destined for the revolutionaries, imprisoned, forced into exile and virtually bankrupted. The era's paranoia threatened to destroy the dramatist who had (Beaumarchais

wrote) 'arranged my plot so as to include in it the criticism of many abuses from which society suffers', making a laughing-stock of 'a nobleman who is vicious enough to make his vassals contribute to his capricious wish to seduce every young maiden in his land'. Even the creator of Figaro was in danger of the guillotine.

But he survived, as did his comedy, the great opera it inspired and, with them, the libertarian valet who was to give the newspaper *Le Figaro* its name and motto. 'Without the freedom to criticise, praise has no value,' it reads: Figaro's wisdom and Beaumarchais's message.

MACBETH

'Well, sir, I smelt blood! I swear that I smelt blood!' So claimed the dramatist Sheridan Knowles after seeing Sarah Siddons in the scene that dramatises Lady Macbeth's mental collapse. 'The chill of the grave seemed about you while you looked on her,' he wrote. 'Your flesh crept and your breathing became uneasy.'

That's one of many contemporary accounts of the sleepwalking Siddons. Dressed in a white nightgown that looked like a shroud, she had become a demented ghost, her eyes open, fixed and glaring but the rest of her weirdly volatile. She poured imaginary water over her hands, scrubbed, smelt and even tasted the blood she believed was on them, then gave what was less a sigh than 'a convulsive shudder', 'very horrible' and with a 'tone of imbecility' in it. And when she spoke, it was in 'a hollow, broken-hearted voice'. One moment she was frighteningly still – she 'more resembled a majestic shade rising from the tomb than a living woman' – and the next she was alarmingly active, her eyes still staring ahead as she scurried off in frantic search of her husband, Macbeth.

Siddons herself made it clear in print what her aims were: 'Behold her wasted form, with wan and haggard countenance, her starry eyes glazed with the ever-burning fever of remorse, and on their lids the shadows of death. Her ever-restless spirit wanders in troubled dreams about her dismal apartment; and, whether waking or asleep, the smell of innocent blood incessantly haunts her imagination.'

Well, yes. So famous did her sleepwalking become that, not long before her farewell performance in 1812, the audience insisted that the play ended then and there; but by then Mrs Siddons was undisputed queen of the British stage. Hazlitt called her a goddess who had dropped from another sphere to 'awe the world', 'something above nature', 'tragedy personified', a woman who 'commanded every source of terror and pity'. So agonisingly convincing were her death scenes that one stage manager had to drop the curtain and reassure an aghast audience that she was alive and well.

In some ways she was the first modern actor, a woman who imaginatively immersed herself in the character she was playing. For Lady Macbeth she

reportedly observed actual sleepwalkers and, according to a playgoer called William Robson, had 'sought the cell of the maniac and the couch of the dying'. But she also attempted to discover, understand and express the inner person. Once she had put on her costume she seems to have been unable to stop identifying with her character, once alarming her dresser by repeating Lady Macbeth's 'here's the smell of blood still' and seeming to wipe it from her hands. 'I protest and vow, ma'am,' came the reply, 'it was not blood but rose-pink and water, for I saw the property-man mix it with my own eyes.'

She certainly brought remarkable power to *Macbeth*, beginning as 'a remorseless, terrible woman who knew no tenderness and was already unsexed by the enormity of her desires'. She terrorised Macbeth into murder, radiating contempt for his cowardice across the stage and eyeballing him as she emphasised her eagerness to commit infanticide. When he was murdering Duncan, she wore 'a ghastly horrid smile' and spoke in a sinister whisper. And it seems that she, too, saw the ghost of Banquo, but, unlike Macbeth, had the strength not to show it – and her fitful manner and frightful smiles, though presaging the breakdown to come, unsettled her guests almost more than her husband's ravings.

Ironically, her own writings show that she saw the lady as a subtler creation, a 'daring fiend but fair, feminine, perhaps even fragile'. Much later, those words influenced Ellen Terry's Lady Macbeth, who was more the selfless support of Henry Irving's Macbeth than his selfish provocateur. But Terry's interpretation, though sexist in another way, would have been unacceptable to a public which remembered and revered Mrs Pritchard's ferocious bullying of David Garrick's essentially decent Macbeth. In the eighteenth century all had to be 'revilings, contemptuous taunts and opprobrious aspersions of cowardice'. Sarah Siddons was, said Hazlitt, 'a being from a darker world, full of evil' – and it was to that dark, evil world she returned, destroyed by the murders she herself had incited.

ROMEO AND JULIET

The theatre was packed, as it invariably was for the man who called himself The Celebrated Philanthropic Amateur, but was better known as Romeo Coates or, because his scallop-shaped carriage boasted a heraldic cock and the motto 'while I live I'll crow', Cock-a-Doodle-Doo Coates. And Robert Coates's performance lived up to expectations. He ignored the usual shouting, hooting and crowing but couldn't ignore the bantam that was thrown from a box as his Romeo was fighting Tybalt or the ear-piercing yells and banging of sticks that came from his tormenters after Old Capulet had grabbed the strutting bird and taken it offstage.

Coates shook Romeo's sword at the box, an act that enraged its occupants, who demanded an apology from him. There ensued a mini-riot, with spectators throwing peel not only at the actors but at the hecklers in the box. Yet somehow the performance continued until a large orange hit the corpse of Paris on the nose. He got angrily up and stalked offstage, and, to cries of 'why don't you die?', Coates's Romeo did just that, no doubt in his usual way: laying a handkerchief on the floor, putting his diamond-studded hat carefully on it, and sedately expiring.

It's a tale that tells us plenty about Regency audiences but also much about the most notorious vanity actor to have trod a British stage. Coates had inherited a fortune that included hundreds of diamonds from his sugar-planter father in Antigua, where he indulged in amateur theatricals, notably as Romeo. And that was the role he first played in England, having come to Bath and impressed a fellow hotel guest who had influence at the local playhouse. Apparently he was apt to declaim extracts from *Romeo and Juliet* over breakfast and, told he wasn't always accurate, informed his new friend that he thought he had 'improved' on the original. The result was Coates's British debut, in February 1810, at Bath's Theatre Royal.

It wasn't an auspicious occasion. Coates's Romeo wore a spangled cloak of sky-blue silk, crimson pantaloons and a white hat that sprouted a feather cockade. Diamonds adorned his shoes and knee-buckles that partly covered legs said to be posed in the way 'most favourable to the display of

their symmetry'. There was laughter and heckling, which this exotic figure greeted by folding his arms and glaring at the offenders, but nothing worse until he entered Juliet's tomb incongruously carrying a crowbar, at which the uproar was so great that the manager lowered the curtain for good.

Coates wasn't deterred. He repeated the performance at Brighton, Richmond and Cheltenham, where a disbelieving audience saw Romeo crawling round the stage instead of making the exit demanded by the line 'O, let us hence, I stand on sudden haste'. He was searching for a diamond that had dropped off his shoe. No wonder that his London debut in a charity revival of Nicholas Rowe's *The Fair Penitent* was eagerly awaited. A thousand people were turned away from the Haymarket, leaving an audience including the Duke of Devonshire and the great Castlereagh to appreciate Coates's performance as a sly seducer called Lothario. But many had left by the time the Celebrated Amateur, this time dressed in silver silk and a pink mantle, arrived at a death scene that was received so ecstatically he repeated it three times.

Coates continued to perform until 1816, always for philanthropic causes, but never without incident. Sometimes the uproar was so intense that his fellow-actors, professionals hired for the occasion, added to the chaos by muffing their lines or worse. A line in *The Fair Penitent*, 'I wish I were a beggar and lived on scraps', became 'I wish I were a baker and lived on sprats'. One of his Juliets, a Miss Fitzhenry, became so terrified that, according to his biographers, 'she clung to the scenery and pillars in great agitation'.

Yet Coates remained resilient. His habit when annoyed past endurance was to confront the worst of the 'tipsy wretches', as he called them, and recite a retaliatory poem: 'Hilly ho ho, my bucks! Well, damn it, what's the fun? Though Shakespeare speaks, regardless of the play ye laugh and loll the sprightly hours away'. And, yes, he loved Shakespeare, for he went to Stratford, performed Romeo, told friends he wanted to rebuild a birthplace he thought unworthy of 'the divine bard', and recorded his appreciation on a tablet in Holy Trinity Church: 'his name in ambient air still floats and is adored by Robert Coates'. But perhaps Coates adored Coates just a bit more.

THE MERCHANT
OF VENICE

DRURY LANE, LONDON, JANUARY 26 1814

Nobody had high or even middling hopes of the provincial actor, only twenty-four and maybe five-four tall, who was brazenly bringing his Shylock to Britain's most prestigious theatre. It was a freezing, foggy night, the theatre was a quarter full, and an impoverished Edmund Kean had walked there through the slush, carrying his costume and leaving his wife with the words 'I wish I was going to be shot'. Moreover, there had been only one rehearsal with fellow-performers who patronised or snubbed him.

But that evening the impossible happened. Kean entered in the black gabardine and black wig that, together with his neat black beard, made him look far more the formidable merchant than his cringing, red-wigged predecessors. Then he turned his piercing black eyes on his enemy, Antonio, and he spoke. He spoke with such fierce yet humorous scorn – 'hath a *dog* money? Is it possible a *cur* can lend three thousand ducats?' – and went on to express such fury, grief, gloatingly murderous triumph and (finally) malignant defiance that those initially cynical actors hurried from their dressing rooms to watch from the wings. And the applause from an audience that had magically grown in numbers was overwhelming.

The theatre had found a genius whose brash realism made its presiding magnifico, John Philip Kemble, seem as ponderous 'as a man in armour'. So decided Hazlitt, then *The Morning Chronicle*'s theatre critic, who was in the audience that night. 'For voice, eye, action and expression, no actor has come out for many years at all equal to him,' he wrote, and was equally enthusiastic when he returned a week later to take another look at Kean's Shylock. 'His style of acting,' he declared, 'is more significant, more pregnant with meaning, more varied and alive in every part than any we have almost ever witnessed.'

When Kean played Richard III a fortnight afterwards, a virtuoso villain who veered from mood to mood before he died writhing and gnashing his

teeth, his reputation was made. Here was a performer in tune with a fresh era, an actor who would count the Romantic poets among his greatest admirers: Keats, who was especially impressed by death-scenes in which 'the very eyelid dies'; Byron, who admitted to shrinking in fear when Kean's 'frown of hatred darkly fell' and wanted to write a tragedy for him; Coleridge, who said that to see him was 'to read Shakespeare by flashes of lightning'.

Actually, that wasn't wholly a compliment. Kean sometimes coasted between brilliant 'hits' or 'points', sometimes engineered emotional transitions that were too obviously surprising. Yet he had the charisma to make them seem natural, for instance in Shylock's scene with a Tubal who, it was said, he would warn in advance not to be frightened by his ferocity. A theatre historian called John Doran wrote of his anguish at his daughter's flight, his wrath at the Christians who make sport of his anguish, his hatred of Christians in general and of Antonio in particular; and then his alternations of rage, grief and ecstasy as Tubal relates the losses incurred in the search of that treacherous Jessica, her extravagances and then the ill-luck that had fallen upon Antonio: in all this there was 'such originality, such terrible force, such assurance of a new and mighty master, that the house burst forth into a very whirlwind of approbation.'

This wasn't all instinct and intuition. Kean prepared hard and conscientiously, according to his ex-actress wife 'studying and slaving beyond any actor I knew'. That helped him overcome limitations which included not only lack of inches but a voice that came to sound 'somewhat between an apoplexy and a cold'. But the struggles with poverty, hunger and seeming failure that had preceded his London triumph – he once walked from Barnstaple to Dorchester with his son Charles on his back – combined with drunkenness and dissipation to spoil and shorten his career. Not long before his death in 1833 he had to change the closing line in the Tubal scene, asking his fellow-Jew to 'lead' him to the synagogue and using the actor as support as he dragged himself offstage.

Kean's self-destructive excesses brought him enemies. Sir Walter Scott called him 'a copper-laced tuppenny tearmouth, rendered mad by conceit and success'. But most seem to have been swept away by a man with such command of both pain and power that his Shylock was both a vulnerable Jew in a hostile city and, as one critic put it, 'a chapter of Genesis'. Was he the greatest actor of them all? I rather suspect so.

THE GOVERNMENT INSPECTOR

It's probably Russia's most loved comedy, but it seemed at first to be Russia's most loathed. The opening performance of Nikolai Gogol's *Government Inspector* was not only badly performed but left much of the audience outraged. How dared this Ukrainian upstart claim that provincial officialdom was so incompetent and corrupt? The balcony laughed but the stalls didn't, one dignitary calling the play 'an intolerable insult to the nobility, the civil service and the merchants' and a celebrated count later saying that Gogol was an enemy of Russia who should be sent to Siberia in chains.

That mortified Gogol, a monarchist who identified a strict imperial government with Providence itself. He fled the theatre and wandered the streets, ending at the house of a friend who showed him a copy of his play, which had been published that day. Gogol threw it on the floor and went into a kind of paranoid mourning. Everyone hated him. He hated the theatre. His own play repelled him. 'I am depressed, gloomy and bitter,' he wrote as the war between his conservative foes and liberal supporters continued – and he refused to go to Moscow for the rather better production of *The Government Inspector* that opened there a month later.

Why was Gogol so surprised? After all, he was to say he'd collected all that was evil in Russia, all injustices that were being done in places where justice was most needed, 'and laughed at the whole lot in one go'. Yet the play ends with a trusting salute to Tsarist authority. The minor functionary Khlestakov, on his uppers in the outback, is mistaken for an inspector general, terrifying local officials who have been threatening shopkeepers, taking bribes, neglecting the sick, and generally abusing their power. He's feted by the Mayor, 'lent' money by apparatchiks who include a hospital superintendent who claims his patients are 'recovering like flies', and disappears before he's unmasked – only for the real inspector, 'commanded

by His Majesty to proceed here', to arrive in town and doubtless bring retribution.

The original idea for *The Government Inspector* came from Pushkin. Told by Gogol he itched to write a comedy 'funnier than the devil', the poet recalled an occasion when he was suspected of being on a secret mission to report on administrative flaws in Orenburg. Gogol wrote the play quickly and easily, and read it successfully to his friends, though one of them sensed a worrying 'excess of glee' in the dramatist's mockery. Pushkin then persuaded a famously pretty woman to read the play to Tsar Nicholas, who duly ensured there were none of the expected problems with the censor.

There were, however, problems with the actors. They disdained an author who (one thought) looked like a stork in an unseemly green coat, disliked his play, and ignored him when he said that the less they worked for laughs, the funnier they would be. Nikolai Dyur, said a despairing Gogol, 'had no idea what Khlestakov was like'. He transformed a man who half-believes his increasingly exorbitant lies, and so is enjoying 'the most poetic moment of his life', into 'an anthology of vaudeville rogues'.

Still, Tsar Nicholas liked vaudeville. The critical reception would surely have been even worse if he hadn't attended the opening, been seen to laugh more than his aristocratic underlings, and forgivingly said: 'Now there's a play! Everyone has got a drubbing but I more than anyone'. As it was, the reviewers angrily complained that Gogol's comedy had no love interest and was grotesquely implausible: 'the landowners and retired civil servants have subhuman intelligence', 'all the characters are either swine or fools'. Although Vissarion Belinksy answered that the play was 'funny, true, but beneath, what bitterness!' and in Moscow the equally incisive Vladimir Stasov recorded his and young people's 'fanatical adoration' of Gogol, the dramatist remained aloof, hurt, fearful and indignant.

After all, Gogol believed that art had a moral purpose and he'd written a moral comedy. The theatre was a 'great school' that showed 'the absurdity of man's habits and vices'. And to emphasise this he wrote a dialogue, *After the Play*, set in the Alexandra's foyer. Assorted 'literary gentlemen' call what they've just seen 'rubbish', 'disgusting', 'sordid, sordid' and 'all caricature'. But a 'very modestly dressed man', presumably Gogol himself, declares that laughter is the best way of exposing hypocrisy. Let people see, he says, that a noble and unslumbering government 'watches equally over everyone and that sooner or later it will catch up with the violators of man's law, honour and sacred duty'.

The Tsar seems to have agreed, for he sent his Empress, heir and daughters to the play and ordered his ministers to see it. And posterity has endorsed that reactionary ruler's enthusiasm, though perhaps for different reasons. Who has mocked power more effectively than Gogol? Nobody.

MACBETH

Can you imagine a feud between, say, Simon Russell Beale and Kevin Spacey culminating in a massacre? Yet up to 30 people were shot dead and many more wounded when supporters of Edwin Forrest, who was playing Macbeth a few blocks away, besieged the playhouse where his British rival, William Macready, was also performing that notoriously ill-starred role. Thespian jealousy had become *casus belli*.

The two men, by then the undisputed leaders of their respective theatres, had initially been friends and mutual admirers. 'Might make himself a first-rate actor' was Macready's view of the young Forrest when he saw his Antony, though he tempered his admiration for his 'discernment' and 'good intellect' by questioning his 'rude force'. And though Forrest was meticulous when preparing a role – for Lear he visited asylums to study senility – it was power, intensity and his so-called 'biceps aesthetic' that made him special.

An English visitor to America compared his Macbeth to an angry sea or Niagara, 'a whirlpool, a tornado, a cataract of illimitable rage'. He was 'the ferocious chief of a barbarous tribe', an honest warrior struggling to recover himself after love for an ambitious wife had impelled him to do unconscionable things. Macready's Macbeth was subtler and surprisingly understated. Hazlitt thought him 'a mere modern, agitated by common sense and intelligible motives' and G.H. Lewes felt he stole towards Duncan's chamber 'like a man going to purloin a purse'. Yet Macbeth was Macready's favourite role, and he greatly impressed others with his portrayal of a man half-knowingly controlled by supernatural forces and reduced to mental chaos by their betrayal. He greeted the spectral dagger as if simultaneously mesmerised, fascinated and horrified, while Forrest, said one critic, was like a dyspeptic bear straining for meat from his cage.

Eventually there was conflict between two actors known for their fierce ambition and fiercer tempers. When Forrest found himself less successful on his second visit to London, in 1845, than he had been seven years earlier, he decided that Macready was plotting against him. Hadn't the

Englishman's friend, John Forster, persistently attacked him, saying that his Macbeth was 'very bad and very ignorant', even that it excited a 'great quantity of mirth'? And it was true that on his own second trip across the Atlantic, Macready had become unimpressed by the American's acting and suspicious when their two Macbeths coincided in Philadelphia. 'Much disgusted,' he confided to his diary, writing that Forrest didn't understand the character or Shakespeare: 'he is not an artist.'

It was in Edinburgh in 1846 that mistrust became war. When Macready's Hamlet signalled madness by performing a little dance there was hissing from a box, 'like the sound of a steam engine'. It was Forrest, as he acknowledged in a letter to *The Times*, describing his hiss as 'a wholesome corrective' to Macready's 'abuse of the stage'. For him, Macready was now a 'brute' with a 'narrow, envious mind' and a 'mechanical' actor. For Macready, Forrest was a 'low-minded ruffian', capable of murder. Sides were taken, as Macready discovered on his next visit to an America where there was a danger of real war with England, thanks to disagreements over territory and debt. Which was better, asked *The New York Herald*, 'the unsophisticated energy of the daring child of nature' or the Englishman's 'glossy polish', 'the tomahawk or the toga'?

In Philadelphia rotten eggs were thrown at the 'superannuated driveller' as Forrest now called him, and in Cincinatti half a sheep. But it was in New York that Macready was caught in what was also a class conflict between an Anglophile elite and a mixture of nationalists, Irish immigrants and local toughs. On May 9 1849 Forrest's supporters cheered when his Macbeth asked 'what rhubarb, senna or what purgative drug would scour these English hence?' The same night, Macready's Macbeth was defying eggs, potatoes, bottles, chairs and cries of 'down with the English hog'. Unsurprisingly, there were 325 police outside Astor Place on May 10 and arrests of the relatively few hostile spectators that hadn't already been excluded – but that wasn't enough.

Responding to posters asking 'SHALL AMERICANS OR ENGLISH RULE IN THIS CITY?', a mob of maybe 20,000 gathered, stoned the unarmed police and, shouting 'burn the damned den of the aristocracy', was about to break into the theatre when the military arrived. Those on horses were driven back, but the others had guns and used them, firing at first above the rioters' heads, then so inaccurately into the crowd that non-combatants were also killed. Inside, Macready insisted on continuing, remarking 'they would have cause for riot if all is not properly done' and

getting Anglophile cheers when his Macbeth declared he'd 'laugh a siege to scorn' and not fear 'death and bane till Birnam *Forest* come to Dunsinane'.

The actor avoided lynching by going disguised to a friend's house, then to Boston, then home. 'I flung my whole soul into every word I uttered,' he said of what was his final performance in America. Well, others flung away their lives.

THE BELLS

It was the night that made the name of the first actor to be knighted and the night that ended his marriage. 'Are you going on making a fool of yourself like this all your life?' his wife Florence asked Henry Irving as they drove through London after the triumphant opening of Leopold Lewis's *The Bells*. The thirty-three-year-old actor stopped the cab, got out, and never went home or even spoke to Florence again – but continued to perform the stricken burgomaster Mathias so successfully for so long that the near-endless applause which always greeted his first entrance seemed part of the play.

'It is I!' became a monosyllabic ''tsI!' as a gaunt, haggard Irving appeared out of a violent storm in a snow-covered overcoat, interrupting a conversation about a fifteen-year-old mystery. A Polish Jew had visited Mathias's inn, then disappeared into an equally devastating storm. What had happened, as became clear in a flashback, was that Mathias had seen his guest's gold-filled girdle, gone out, intercepted him, robbed him, killed him with an axe and thrown the body into a limekiln. And the murderer and the audience, but nobody else, once more heard the bells spookily jingling on the Jew's sledge – and then saw his ghostly face appear at the window with its big accusing eyes.

Melodramatic stuff but, as played by Irving, more than that. As Laurence Irving wrote in his biography of his grandfather, a play that might have been about a cunning rogue in fear of detection, and was exactly that in its original French version, became one about a human, even tender man destroyed by remorse. According to the great director Gordon Craig, who saw the performance thirty times and regarded it as 'the finest point the craft of acting could reach', someone's mention of the word 'conscience' was enough to freeze Irving's Mathias as he was buckling a shoe. His fingers stopped. The crown of his head seemed to glitter. And, added Craig, 'at the pace of the slowest and most terrified snail the two hands appeared to be coming up the sides of the leg' as his torso, also seemingly frozen, gradually straightened.

43

At the sound of those bells his whole body shivered, his jaws chattered, his hair seemed to writhe 'like a nest of little snakes', causing Mathias's friends and family to think him ill. But the illness was internal and shown in tiny details, as when he counted out gold set aside for the dowry of a daughter he clearly loved greatly. 'No, no,' he murmured as he picked out a coin stolen from the Jew, 'not for them, for me', and wiped his fingers on his coat, as if they were wet with blood. According to Craig, Irving's Mathias was a strong man who was suffering for one horribly uncharacteristic act, which he had performed 'as though impelled by an immense force, against which no resistance is possible'. According to *The Times* critic, John Oxenford, this had left him 'in two worlds between whom there is no link: an outer world which is forever smiling and an inner world which is purgatory'.

Bernard Shaw was to spend much of his time as a theatre critic mocking Irving, as he mocked almost every institution. The actor should, he wrote, be tied up in a sack with every copy of Shakespeare 'and dropped into the crater of the nearest volcano'. But his complaint was directed more at Irving's highhanded treatment of classic drama than at performances which, though they could be verbally affected, Shaw often grudgingly admired. And did that first-night audience mock when a third-act dream, in which Mathias went on trial and was sentenced to death, left an ashen Irving clawing at his throat, crying 'take the rope from my neck', rolling his eyes upwards, and falling dead in what his grandson was to describe as 'a violent egress of a soul from a body'? No.

What Laurence called 'a criminological study of fearful intensity' overpowered everyone. A lady fainted. The audience clapped and shouted unstoppably. And Irving went on to play Mathias 799 more times – and dominate the British stage.

A DOLL'S HOUSE

This was the play that made Henrik Ibsen an internationally famous dramatist. It was said that the sound of his protagonist, Nora Helmer, banging shut the front door as she left the dominating husband who had infantilised her, echoed around the world. And public acclaim and packed houses first in Denmark, then in the capitals of Sweden and Ibsen's native Norway, suggested that *A Doll's House* was and would be an unqualified success. But it took another decade for faithful productions of the play to reach England and America and, even then, its reception was decidedly mixed.

Ibsen's inspiration was an acquaintance called Laura Kieler, a Norwegian who married a Danish schoolmaster and, when he contracted tuberculosis, secretly borrowed enough money to take him to Italy, where he was cured. Unable to repay the debt, she forged a cheque, which duly bounced; and, when she confessed the truth to her husband Victor, he rejected her, precipitating her nervous breakdown, committal to an asylum and, after her release, a very cold and grudging reconciliation. That's close to Nora's story, with Torvald Helmer, like the ungrateful Victor, declaring that she's become unfit to look after their children. The big difference is that Nora realises she's been living in a 'doll's house', sees that Torvald isn't the man she thought nor herself the woman she should be, and makes that final exit, abandoning husband and children in her quest to become a grown-up person.

Ibsen made notes for 'a modern tragedy' when he was living in Rome in 1878, writing that were two kinds of moral conscience, with 'woman judged by masculine law, as though she wasn't a woman' and so unable to become 'her true self in modern society'. And he made impassioned speeches to Rome's Scandinavian Club, arguing that women should vote on all club matters because they had 'this instinctive genius which unconsciously hits the right answer' and, when the motion failed, describing those women who had voted against it as 'ill-bred, immoral, dregs, contemptible'. Yet he was to claim that *A Doll's House*, which he wrote soon afterwards, wasn't

about women's liberation – 'I don't know what the term means' – but about the liberation of the human spirit.

At the play's opening in Copenhagen the critic Erik Bogh hailed the artistic mastery with which Ibsen told an everyday story in so unshowy a way. It was a long time, he wrote, since a new play 'brought so much that is original to the stage'. That did not, however, convince the important German market, where a leading actress refused to perform the ending, saying she would never leave her children. Fearing that a less principled translator would do her bidding, Ibsen himself committed what he called a 'barbaric outrage' on the play, allowing Helmer to force Nora to the door of her children's bedroom, where she collapsed as the curtain fell.

There were greater outrages to follow. The first that America saw of *A Doll's House* was an 1882 version in Milwaukee called *The Child Wife*, which came with a still 'happier' ending. The first England saw was Henry Arthur Jones's 1884 adaptation, *Breaking a Butterfly*, which closed with a British Torvald taking the blame and his Nora declaring he was a thousand times too good for a poor, weak, foolish girl like herself. But then the first English translation of the play proper, by a Dane called T. Weber, wasn't encouraging. In it, Nora told her friend Rank 'don't utter such stupid shuffles' and, at the end, informed Torvald that one day 'that cohabitation between you and me might become a matrimony'.

By the time William Archer's complete, accurate and speakable translation was performed in London in 1889, it was clear that *A Doll's House* had so much power to disturb it was barely tolerable in its original form. Such was the lack of critical enthusiasm that Archer, who was to become Ibsen's leading British proponent, decided to list the harshest reviews: 'not an enlivening dramatic spectacle', 'a morbid and unwholesome spectacle', 'unnatural, immoral and, in its concluding scene, essentially undramatic'. Only Janet Achurch's Nora was well received, with *The Daily Telegraph's* Clement Scott, who disliked *A Doll's House* almost as much as he was to dislike Ibsen's *Ghosts,* declaring that the actress had considerably improved her reputation 'by this most intelligent embodiment of a most difficult character'.

'Difficult' is right, since any actress must find it tough to reconcile the babyish wife of the start with the articulate woman who makes that principled exit. And some of Ibsen's supporters found the ending implausible, Georg Brandes saying 'there must be a lover – no woman goes off to the country in search of self-improvement'. But neither that nor the

successes of feminism has prevented *A Doll's House* becoming one of the most frequently revived of all plays, with actresses from Eleanora Duse to Janet McTeer to Gillian Anderson bringing truth to the role of Nora. And it will remain so as long as people, and especially women, mutilate themselves for the sake of security or convention.

IOLANTHE

SAVOY THEATRE, LONDON, NOVEMBER 25 1882

It was the first opening at the Savoy since it had become the only theatre in the world with electric lighting. That ensured that the latest of Gilbert and Sullivan's already very successful operas drew an audience which glittered in more than one way. Even the Superintendent of the Metropolitan Fire Brigade sat among the famous and fashionable, an electric light playing on him as the Fairy Queen sang that his 'cold cascade' couldn't quench her love for a handsome mortal. And he and everyone surely chortled at the grandiose entry of actors dressed as peers by the Queen's robe-makers and preceded by the band of the Grenadier Guards – and, in some cases, designed to resemble well-known figures, among them Benjamin Disraeli, Lord Beaconsfield.

Not that the House of Lords was being celebrated. Rather, it was being mocked by a librettist whose satiric sharpness is still underrated. In the operas he created with Arthur Sullivan, as in his own plays, W.S. Gilbert couldn't present a member of the ruling classes without rendering him absurd or worse. He had already created a landlubber who had been made the Ruler of the Queen's Navy for his conformism as a corruptly elected MP and a judge who dumped a 'rich attorney's elderly, ugly daughter' as soon as he'd successfully defended enough wealthy thieves to make the marriage unnecessary. So it wasn't surprising that Gilbert's upper house consists of the comically idle, ignorant and stupid.

Not that he only lampooned social and political institutions. Hypocrisy and humbug were his great targets, and nowhere more so than when love or friendship was the subject. In his best play, *Engaged*, there are selfish and usually mercenary motives behind every profession of warm feeling. 'I like you *very much*, but not, perhaps, as much as you like me' goes a relatively mild example, this time from *Iolanthe* itself and spoken by one of two old friends, both eminent lords, both glad they are 'persons of no capacity whatever', both pursuing Phyllis, a ward of court who is also ogled by her guardian, the 'highly susceptible' Lord Chancellor himself.

Actually, pretty Phyllis is loved by every peer, but loves Strephon, an Arcadian shepherd who is half-mortal, being the son of the fairy Iolanthe

and (it emerges) the Lord Chancellor himself. However, this wasn't Gilbert's first plan. He had toyed with ideas that involved other flawed professions – solicitors, barristers, soldiers, doctors – before agreeing with Sullivan a plot in which Strephon becomes the leader of both parliamentary parties and, helped by the fairies, 'carries every Bill he chooses'.

Sullivan's music, ranging as it did from the tender to the mischievous, from Mendelssohnian parody to patriotic pomp, was at its best and most various in *Iolanthe*. Likewise with Gilbert's lyrics, which stretched to the patter-song in which the Lord Chancellor relives a horribly but hilariously restless night. But perhaps Gilbert would have expressed his cynicism about politics still more forthrightly if he hadn't felt so obliged to please the audiences that he, Sullivan and their producer, Richard D'Oyly Carte, were attracting.

Gilbert was more of a maverick Conservative than a radical. Nevertheless, his notes for *Iolanthe* show that at one point he imagined that his fairies were distressed to find legislators utterly neglecting 'the crying miseries' caused by 'filth, squalor and crime'. And the original opera contained a song in which Strephon confessed that with the wrong parents he too might have become a 'tipsy lout gathered from the gutter', though this was cut after the reviewers, who were otherwise enthusiastic, suggested that the second act dragged.

Still, the opera retained satiric bite as well as plenty of infectious fun. The Lord Chancellor clearly hasn't kept his youthful promise to avoid deceit, greed and jobbery. As for the House of Lords, it cheerily boasts of refusing to interfere with challenging issues and of having historically done nothing 'very well', which is why Strephon is promoting a Bill throwing the peerage open to competitive examination. 'But what's to become of the Commons if the Lords consists of people of superior intellect?', asks an appalled earl. What if MPs have to think for themselves rather than leaving their brains outside Parliament and voting 'just as their leaders tell 'em to'? Oh, and what if peers have to sit during the grouse and salmon season?

Some of those half-joky questions resonate still. Yes, Gilbert and Sullivan's operas were left looking pretty toothless by years of affectionately 'traditional' performances. Yes, the fresh productions that have followed the end of their copyright in 1961 have yet to destroy their reputation for blandness. But many are well worth reviving – and *Iolanthe* more than most.

LA DAME
AUX CAMÉLIAS

MALY THEATRE, ST PETERSBURG, MARCH 12 1891

Only in Paris did Eleonora Duse fail to triumph in Alexandre Dumas's play, and that was because Paris was the home of Sarah Bernhardt, and Marguerite Gautier was widely regarded as Bernhardt's greatest role. The rest of the world, Vienna to Rio, London to New York, was in awe of the Italian's playing of the doomed courtesan. And it had taken barely a night for her to conquer a Russia so ignorant of her international reputation that the Maly was half-empty when she opened there.

'An incomparable artist who lacks the glamour of Bernhardt but surpasses her as an actress by her extraordinary precision of tone and gesture,' concluded the editor and critic Alexei Suvorin, adding that every movement, every vocal inflection was so perfect that 'a complete harmony is established between the character's inner soul and outer appearance'. And Chekhov, who caught Duse's Cleopatra a bit later, reported that he'd never seen anyone like her. She left supposedly great Russian actresses looking wooden and, though he didn't know Italian, 'she played so beautifully I felt I understood every word'.

Duse, then thirty-two, left Petersburg triumphant, with the street from the theatre to her hotel covered with flowers, and had equal success in Moscow. 'She gives us a woman,' wrote the critic Vyacheslav Ivanov of her Marguerite, 'deeper and fuller than the one created by Bernhardt'. The young Stanislavsky saw her again and again, agog at the way her face and body subtly expressed her innermost emotions. Later, he declared that she was the inspiration for his Moscow Art Theatre. Who better exemplified his belief that actors should identify totally with their characters?

Duse certainly did that. The daughter of a nomadic actor-manager, she knew what it was to be socially marginal, poor, hungry, even destitute. She was always prey to illness and often to predatory men, one of whom abandoned her as a 'whore' and remained unmoved when their son died in infancy. And she brought what she once called her 'unspeakable anguish' to

the 'poor women' she played or, rather, didn't just 'play'. Her technique, she said, forced her 'much against my will to suffer with the beings I represent'.

That especially applied to Marguerite, who falls for Armand Duval, is persuaded by his father to sacrifice him, but confesses her love as she dies in his arms, the victim of tuberculosis. As always, Duse rejected wigs, costumes that impeded free and expressive movement, and even make-up, explaining that 'tint your flame, snuff your flame'. And truth marked everything that followed a notably casual, unpretentious first entrance: from the fierce, hungry kiss to the tiny, unconscious touches and caresses she gave Armand; from the blushes she could produce at will, to a pain made uglier by the red nose and eyes she unashamedly displayed, to a death in which her head dropped, her hands opened and she fell 'by the simple force of gravity' – a moment a New York critic found 'horribly real, terribly impressive'.

Yes, Paris was unimpressed, as Paris often is, and Duse seemed uncharacteristically nervous there, perhaps because her rival had not exactly been welcoming. Bernhardt had embraced the Italian in a way that reminded a witness of 'a collision' or 'mad wrestling match', had denied her the use of her dressing room, and, dressed to kill, had observed her performance from a prominent box. But elsewhere the undeclared war continued to go Duse's way. For the chronically sceptical Shaw, she made Bernhardt look like a stock of pretty effects. Her Marguerite was 'unspeakably touching'. Her acting restored Shaw's faith that 'a dramatic critic is really the servant of a high art'. Her every shade of thought and mood expressed itself 'delicately but vividly to the eye', and 'in an apparent million of changes and inflexions'. Bernhardt's Mona Lisa smile, consciously dropping eyelashes, carmined lips and brilliant teeth were effective in their way, but Duse 'with a tremor of the lip which you feel rather than see, and which lasts half an instant, touches you straight to the very heart; and there is not a line in the face that does not give poignancy to that tremor'.

In Lisbon, Duse's Marguerite won thirty-six curtain calls. In Washington, President Cleveland saw her every performance. In Vienna, Hofmannsthal felt he had been to the Great Dionysia in Athens, so powerful was her impact. In London, the actress Ellen Terry fell weeping into her arms and placed her portrait in her bedroom, writing beneath it 'there is none like her – none'. In Russia, her Marguerite moved Meyerhold to tears. In

her native Italy Pirandello was left unable to forget 'the romantic spell, the secret sweetness, the overwhelming passion' she brought to the part, and Verdi said he wished he'd seen her before composing *La Traviata*, his operatic version of *La Dame*: 'what a splendid finale I might have created if I'd heard that crescendo invoking Armand which Duse has achieved simply by allowing her soul to overflow.'

Has there been a finer, more complete actress? I doubt it.

GHOSTS

The idea that Ibsen's *Ghosts* was damned in England while being acclaimed in more enlightened countries couldn't be more wrong. Some of its author's ardent admirers attacked the play when it appeared in book form in 1881 Copenhagen, one reviewer railing against its 'diverse collection of indecent, gossipy and rascally people living in the midst of degenerating relationships and institutions'. Booksellers wouldn't stock it. Major theatres in all three Scandinavian countries rejected it, their directors variously calling it 'one of the filthiest things ever written in Scandinavia' and 'a repulsive pathological phenomenon which undermines the morality of our social order and threatens its foundations'. Not until mid-1882 did *Ghosts* get its premiere, and then from a group of Scandinavian amateurs for an audience of immigrants in Chicago.

Yet the play had gradually won acceptance in Europe by the time it belatedly reached London and its piranha critics. Since it stood no chance of being passed for public performance by Britain's censor, the Lord Chamberlain, *Ghosts* was staged as a 'private invitation performance' by J.T. Grein, an impresario who had just started the Independent Theatre Society. Shaw, who had already been transformed into an arch-Ibsenite by his friend William Archer's translations, described this as 'the most important theatrical enterprise of its time' – and gave Grein a copy of his first play, *Widowers' Houses*, which the Independent Theatre staged twenty-one months after the opening of *Ghosts*.

Ghosts itself was scheduled for what Shaw called 'the nearest thing to a barn left in the Tottenham Court Road', but, since the barn proved too small to accommodate Hardy, Meredith and crowds of other supporters, it was transferred to Soho's larger and more formal Royalty Theatre. Here, the play faced a critical lynch mob. 'A wretched, deplorable, loathsome history,' declared *The Telegraph*'s Clement Scott, adding that it was 'a mass of vulgarity, egotism, coarseness and absurdity', the 'deplorably dull' creation of 'a bungler'. For *The Chronicle*, it was 'revoltingly suggestive and blasphemous', for *The Gentlewoman* 'a wicked nightmare' written by a 'gloomy sort of ghoul' and a 'stupid old owl', and for *The Licensed*

Victuallers' Mirror so 'extremely dirty' that people were 'mad to enjoy it'. And that meant insane, not keen.

But how else was a play that treated venereal disease, prostitution and incest likely to be received in Victorian England? Worse, the 'Scandinavian humbug', as the magazine *Truth* called Ibsen, seemed to be blaming social convention, middle-class respectability and church bigotry for a failed marriage, a father's adulteries, a dreadful hereditary illness and the slow destruction of a son's brain. Imagine the horror in the stalls when those critics heard the young man's mother wonder if it might be a good idea if he married his half-sister, or saw that poor syphilitic boy collapse babbling 'give me the sun' into that mother's arms. Little wonder that an editorial in *The Telegraph*, also written by Scott, called for the rejection of a 'positively abominable play', a 'disgusting representation', an 'open drain', a 'loathsome unbandaged sore', a 'lazar house with all its doors and windows open', a 'dirty act done publicly', a 'dunghill', 'literary carrion' and, as a final blow, 'crapulous stuff'.

It took a combative yet calming defence by Archer in *The Pall Mall Gazette*, an article much admired by Shaw and Henry James, to challenge and begin to change such attitudes. Eventually the world was able to see *Ghosts* for what it is: a domestic tragedy about the terrible and sometimes irresistible hold that the past exercises over the present. And now the play is so firmly established in Britain that it has had some 20 major revivals in the last 30 years alone. Actors ranging from John Gielgud to Simon Russell Beale have played Ibsen's doomed Oswald. Actresses as fine as Peggy Ashcroft and Judi Dench have played his mother, Mrs Alving. The crapulous dunghill has become a theatrical mountain.

THE IMPORTANCE OF BEING EARNEST

ST JAMES'S THEATRE, LONDON, FEBRUARY 14 1895

It was the most glamorous of first nights. It was also the most ominous. Oscar Wilde, author of *The Importance of Being Earnest*, had just opened *An Ideal Husband* and was riding high in popularity and esteem. However, his attachment to Lord Alfred Douglas had brought him the enmity of Douglas's father, the Marquess of Queensberry, who planned to invade a theatre packed with the fashionable and famous and shame the author by handing him a bouquet of rotting vegetables. 'The most infamous brute in London', as Wilde called him, was successfully stopped from entering the foyer and stage door – but his campaign of destruction had only just begun.

Wilde had started writing his 'trivial comedy for serious people' the previous August in a hideaway in Worthing, naming his principal character after that town. Indeed, the plot turns on the pretence of the country magistrate John Worthing that he has a rakish younger brother called Ernest whose regular scrapes force him to visit London, where he becomes the pleasure-loving Ernest himself. Similarly, his friend Algy Moncrieff has invented a valetudinarian called Bunbury, whose illnesses allow him to flee alone to the country. Worthing loves Gwendolen, but his hopes of marriage are stymied by her mother, the formidable Lady Bracknell, who isn't pleased to discover that John is an orphan, left as a baby in a handbag in a railway station. Posing as Ernest, Algy falls for Cecily, who is Worthing's ward. Obstacles appear and disappear, letting love triumph.

The writing of the play came easily to Wilde, but he found the production a strain. George Alexander, the actor-manager playing Worthing, persuaded him to cut the least relevant of what had been four acts. No longer was Algy saved from Holloway Prison after running up huge debts at the Savoy. Again, Wilde left a run-through of *The Importance* declaring that he'd written a play very like it but 'even more brilliant than this', and, since he was prone to interrupt the actors, was briefly banned

from rehearsals. However, he exuded confidence, telling a journalist who asked if the play would be a success that it already was one – 'the only question is whether the first-night audience will be one too.'

Well, the audience *was* a success. William Archer reported that Wilde had sent 'wave after wave of laughter curling and foaming round the theatre'. Cheer after cheer greeted the author at the end. H.G. Wells described the play in *The Pall Mall Gazette* as 'delightful'. The only significantly undelighted critic was Shaw, who declared that the laughter its farcical situations provoked in him was 'miserable, mechanical'. The famous scene between Gwendolen and Cecily he dismissed as being almost inhuman enough to have been conceived by W.S. Gilbert, and perhaps he was right, since one hears the older dramatist's voice behind an encounter in which two women profess undying affection and then, thinking they love the same man, exchange stilted insults. However, the play would clearly have run for aeons if Queensberry hadn't struck again.

The story is too familiar to need repeating in detail. Enough to recall that Queensberry left a card in the dramatist's club on which he'd scrawled 'to Oscar Wilde, posing as a Somdomite'. Wilde sued him for criminal libel, lost, was arrested himself, convicted of gross indecency, and sentenced to two years imprisonment. As he disappeared, initially into the prison with which Algy had been threatened, later into Pentonville, Wandsworth and Reading, his name was removed from the bills and posters for both *The Importance* and *An Ideal Husband*, and both plays closed, as did a promising production of *The Importance* on Broadway.

Some have seen a subtext in the play, claiming that 'Ernest' was code for homosexual, though this has also been authoritatively denied. However, Wilde said after his release from prison that rereading the text had left him feeling that it was extraordinary 'how I used to toy with that tiger life', and W.H. Auden, quoting this in an essay on Wilde, wrote that when Algy talks of going Bunburying he, Auden, immediately visualised the male brothel at the scandal's core. There's little doubt that, behind the fun, the play involves the secrecy engendered by Victorian morality, the deceit that was to destroy Wilde.

But it *is* fun, as revivals and performers galore continue to prove. If Edith Evans, for instance, is remembered for anything, it is for the haughty horror her Lady Bracknell brought to two words, 'a handbag!'. And examples of the play's mischievous wit – 'to lose one parent may be regarded as a misfortune, to lose both looks like carelessness', 'I hear her hair has

turned quite gold from grief', and so on – remain in every dictionary of quotations. If Wilde had survived his humiliation better and longer than he did, what plays he might have left us!

THE SEAGULL

The actors, most of whom had taken valerian drops to soothe their nerves, couldn't believe it. Chekhov's *Seagull* had flopped horribly at its premiere in St Petersburg, and it was hugely risky for the newly formed Moscow Art Theatre to make the play its opening offering. And the first-act curtain fell to what Stanislavsky, who was playing the writer Trigorin as well as directing, called 'the silence of the tomb'. The performers huddled together, one starting to sob and Olga Knipper, who was playing the actress Arkadina and would marry Chekhov, barely avoiding hysteria.

'At that moment the audience gave a kind of moan,' wrote Stanislavsky, 'and burst into applause.' The play's success was so colossal, he added, that it was like a second Easter onstage. At the end everyone kissed everyone else and many people, among them Stanislavsky himself, 'danced a wild dance for joy and excitement'. The audience chanted 'author, author!' and then, hearing that Chekhov was in virtual hiding 800 miles away, 'send a telegram'. And one was duly dispatched to Yalta, telling the dramatist of a triumph he never expected.

After all, the play had been so extravagantly hissed, booed and mocked two years earlier that Chekhov had left Petersburg's Alexandrinsky Theatre with his overcoat collar hiding his face and exacerbated his worsening TB by walking the cold streets alone until the early hours. Mark you, he had expected disaster. He himself had said *The Seagull* 'flagrantly disregards the basic tenets of the stage', adding that it had 'much conversation and five tons of love'. His friends and family had been unimpressed when he'd read the play to them. The theatre committee thought it lacked structure. The cast seemed oblivious to the subtlety with which Chekhov had charted Arkadina's affair with Trigorin, Trigorin's seduction of the aspiring actress Nina, and the suicidal despair of Nina's would-be lover and Arkadina's son, Konstantin.

After leaving a rehearsal he wrote 'it's boring, dull and has nothing to say to anyone. The actors aren't interested, which means the audience won't be either.' He thought of withdrawing the play, especially as he couldn't prevent the cast delivering half-learned lines bombastically or convince them that

his characters were 'simple ordinary people'. Nevertheless, he allowed the performance to go ahead, and at the very worst time. *The Seagull* was, in effect, the curtain-raiser in a benefit evening for a famous farce actress, and her supporters were in no mood for a delicate tragi-comedy. 'It's an insult, putting on a play like that,' said one as Chekhov fled the place.

'Everyone kept assuring me that my characters were all idiots and my play was dramatically unsound, ill-advised, incomprehensible, even nonsensical,' he wrote to a friend who had admired the piece. And he declared he'd never again write for the stage, 'even if I live for 700 years'. Yet *The Seagull* was played with success in Kharkov and Odessa; Chekhov had already written *Uncle Vanya* and it was also thriving in the provinces; and, though he at first resisted the Art Theatre's blandishments, he eventually gave his blessing to the Moscow revival.

It was this production that forged a permanent relationship with Stanislavsky, who was to give premieres to *The Three Sisters* and *The Cherry Orchard* as well as stage *The Seagull* and *Uncle Vanya*. Yet all wasn't straightforward. Chekhov always thought Stanislavsky opted for realistic atmosphere at the expense of comedy and, in the case of *The Seagull*, wasn't pleased by sound effects that included birds and frogs or by the idea of introducing a crying baby. Moreover, he found Stanislavsky's downbeat Trigorin in need of 'a sprinkling of thyroid extract': 'He walked and talked like a paralytic. He interpreted his part as that of a man without a will of his own and in a way that absolutely nauseated me.'

Ungrateful? Though I'd rather see it as an example of Chekhov's honesty, perhaps a bit. After all, Stanislavsky established him as a great dramatist, though it took some years after Chekhov's death in 1904 for this to be acknowledged in the English-speaking world. A Russian-language production of *The Seagull*, presented in the New York of 1905 by an impresario who declared that his mission was 'to make suffering fashionable', was well enough received, but not until 1916 did the city see an English-language production. The play gave Chekhov his British debut when a translation was performed in Glasgow in 1909 and, again, was warmly received, *The Evening Times* praising the 'sure hand' with which Chekhov portrayed contrasting characters, *The Herald* admiring the play's humanity, warmth and vivid picture of rural dullness.

But that wasn't the reaction when Chekhov made his London debut with *The Cherry Orchard* in 1911. *The Times* thought that play 'queer, outlandish, even silly' and *The Morning Post* 'no good whatever' for a general

public. *The Seagull*, which followed the next year, left *The Daily Telegraph* feeling that, for all its subtlety, it 'left no decisive mark'. It wasn't until the 1920s that Chekhov's influential admirers – Desmond McCarthy in London, Edmund Wilson in New York – found themselves in the majority. 'Sheer light, a work of unalloyed genius,' wrote the *New York Times*'s Brooks Atkinson of *The Seagull* in 1929. Nowadays almost everyone would agree.

HAMLET

I t's one of the theatre's myths that Sarah Bernhardt was an old woman with a wooden leg when she took her Hamlet to Britain in 1899. Actually, it was sixteen years later that a damaged left knee convinced her and her surgeons that amputation was unavoidable. Nevertheless, she was 54 and in pain when she first appeared as Hamlet in London: no great stretch, perhaps, for an actress who would be a sixty-five-year-old grandmother when she played the nineteen-year-old Joan of Arc but still a performance that impressed almost all the British critics.

Bernhardt had regularly performed in London, most memorably as the title-character in Sardou's version of the Cleopatra story, a performance that gave rise to a famous theatrical anecdote. As she feverishly pulled her Egyptian palace apart and collapsed shrieking in its ruins an old lady in the stalls was heard to remark 'how different, how very different from the home life of our own dear queen'. But Bernhardt had also often played males, usually males much younger than herself, notably Pelléas in Maeterlinck's *Pelléas and Mélisande*.

Her Hamlet was unusually boyish, surprisingly so given her age. For Bernhardt, the prince was a twenty-year-old student and far from the hesitant introvert whom middle-aged actors had played 'without making allowance for the impetuosity of youth'. Indeed, she wrote to a spectator who thought her prince too manly, saying he was strong, resolute and 'not a sad German professor'. Again: 'how entirely I have striven to identify myself with his passion of hate, his thirst for vengeance and his strong, suppressed love for Ophelia'.

A photo of Bernhardt's Hamlet shows a slim, blonde, credibly masculine figure staring boldly ahead from above folded arms. And boldness clearly characterised her performance. She displayed no dread of her dead father, moving bravely towards him, arms stretched out imploringly and trembling only with grief. She treated Rosencrantz and Guildenstern with 'scorn and rage', Polonius with 'passionate disgust', kicking the old man's shins and on the words 'buzz, buzz' grabbing an imaginary bee from his nose. And when she realised Ophelia was being spied on by her father, her tenderness – 'get

thee to a nunnery' coming with a sob and quivering lips – turned instantly to scorn, bitterness and a 'fierce anger'.

Unusually aggressive Hamlets – Nicol Williamson would be another example – raise an obvious question. Why do they delay their revenge? Bernhardt's answer, not wholly plausible given that the ghost reappears to chide his son for indecision, was based on Hamlet's refusal to kill his usurping uncle while he's praying. The prince, she said, wanted to do so at a moment of mortal sin and so send him to Hell. Certainly her Hamlet's loathing of Claudius was intense. She gave a great cry of joy when she mistakenly thought she'd killed him, not the hidden Polonius. Reacting to Claudius's fearful call for lights in the play scene, she burst into peals of laughter, grabbed a torch and thrust it into his face, forcing him to flee. And her suggestion that he seeks the dead Polonius in 'the other place', meaning Hell itself, had a 'terrible force'.

In Paris her Hamlet triumphed, critics admiring its truth and intelligence. A poet called Catulle Mendès actually fought a duel with a journalist who had dared say her wig was the wrong colour. In London Maurice Baring, soon to be a famous belle-lettrist, thought Sarah 'a marvel, a tiger, natural, easy, lifelike and princely'. *The Times* praised her as 'less the melancholy Dane than a full-blooded Latin', Clement Scott of *The Telegraph* found her 'imaginative, electrical and poetical', and *Punch* decided that this 'precocious child badly brought up by his injudicious mother' was as near to the ideal Hamlet as its critic had seen.

But not everyone succumbed to her fierce magic. Max Beerbohm, who had succeeded Shaw as *The Saturday Review*'s drama critic, summed her up as 'très grande dame': fine, dignified, but so hilariously awkward in a black doublet that British customs should have confiscated it. What would he have said if he'd seen her in Edinburgh, when her Elizabethan costume went missing, forcing her to wear a kilt? Très Morningside perhaps.

PETER PAN

❛Oh for an hour of Herod,❜ cried the novelist Anthony Hope after the premiere of James Barrie's celebration of eternal boyhood. It's a plea that must have been repeated by a million adults over the play's irrepressibly long life, but clearly not by the zillion children who have cheered what Beerbohm saw as the waking dream of a man who could never grow up. ❛Here, at last, we see [Mr Barrie's] talent in its full maturity; for here he has stripped off from himself the last flimsy remnants of a pretence to maturity,❜ he wrote, adding that the playwright was ❛the child in a state of nature, unabashed - the child, as it were, in its bath, splashing, and crowing as it splashes.❜

Other reviewers were kinder, *The Telegraph* calling *Peter Pan* ❛so true, so natural, so touching that it brought the audience to the writer's feet and held them captive there❜. And the first Captain Hook, Gerald du Maurier, did much to counteract the sentimentality of Barrie's tale of winsome boys cheerily living in a Neverland populated by friendly Indians, ethereal mermaids and a spot of fairy light called Tinkerbell. ❛He was a tragic and rather ghastly creation whose soul was in torment,❜ wrote his daughter Daphne, ❛a bogey of fear who lives in the grey recesses of every small boy's mind, the phantom who came by night and stole his way into their dreams, a lonely spirit that was terror and inspiration in one.❜

The upper-crust pirate, who loathes children, menaces them with his steel hand and dies shouting ❛Floreat Etona❜, certainly had his effect on me when I was six or seven. I'm told I leapt out of my seat in London's Scala Theatre, where *Peter Pan* was revived every Christmas, and cried ❛you wicked, wicked man❜ at him, though I don't know whether this was when he plotted to poison the Lost Boys with an over-rich cake or when he was trying to make them walk the plank. I think Alastair Sim was playing the part, and hope he took my moral outrage as a tribute to an emotional power Hooks don't always generate in our queasy era.

Anyway, we know now that other ghosts, phantom and spirits were haunting Barrie, primarily the elder brother whose death had left him marooned in the past, forever trying and failing to replace thirteen-year-

old David in his distraught mother's affections, initially by dressing in the boy's clothes, later by idealising females in their asexual aspects. The Lost Boys' appeal to the girl the eternally pre-pubescent Peter Pan has lured from her London home, 'Wendy lady, be our mother', and Peter's own 'I want always to be a little boy and have fun' surely come from Barrie's damaged heart.

The fact that he called his fictional family the Darlings adds to the feeling that *Peter Pan* demands the attention of the psychiatrist as much as the critic. Its beginnings were odd, with the unhappily married and possibly impotent Barrie befriending the beautiful Sylvia Llewelyn Davies, fascinating her small sons with stories that included that of Peter Pan, making himself a near-permanent guest in their Kensington home, and getting so possessive of them that he virtually supplanted a father who became deeply uneasy at so intense a bond. And you can understand that father's feelings when you read the stage-direction that describes the woman based on his wife as 'the loveliest lady in Bloomsbury, with a sweet, mocking mouth'. Likewise when you ponder the male casting that has been traditional from the start, with the actor playing Hook doubling as Mr Darling, the father whose folly and neglect means he ends up literally in the doghouse, atoning for the loss of Wendy and her brothers by living in a kennel.

Not that Barrie's troubled pathology has spoiled the play for those with a taste for whimsy – 'when every new baby is born its first laugh is a fairy' is a characteristic line – or for the gleeful malevolence that an Ian McKellen or a Simon Callow has brought to Hook. The trouble, though, is that few actors are of that calibre. Celebrities are invading Neverland. The metal-handed captain is getting softer and *Peter Pan* itself becoming just another pantomime. Why, I've seen the pirate Smee transformed into a Buttons who cracked silly jokes, did Bruce Forsyth imitations and invited kids onstage for singalongs. The play may be a childish fantasy, as Beerbohm thought, but it has more originality, more integrity than that.

THE PLAYBOY OF THE WESTERN WORLD

Seldom has any theatre in the British Isles seen anything like it. A nationalist paper, *The Freeman's Journal*, had just denounced John Millington Synge's play as an 'unmitigated libel upon Irish peasant men and, worse still, upon Irish peasant girlhood', adding that 'the blood boils with indignation as one recalls the incidents, expressions, ideas of this squalid, offensive production, incongruously titled a comedy'. And that late January night the audience's blood boiled over.

There was such stamping, booing, striking of seats with sticks, cries of 'God save Ireland' and what *The Freeman's Journal* called 'vociferations in Gaelic' that the performance halted. W.G. Fay, co-manager of the Abbey, came onstage to offer those who disliked the play their money back, only to be interrupted by roars of 'Sinn Fein for ever' and loud threats against Synge. The curtain fell, the police arrived, the performance resumed amid booing, and the police left to triumphant yells and the singing of 'The West's Awake'. The performance stopped, restarted, and then came to a final stop because nobody could hear a word, given the hissing, tramping of feet and cries of 'kill the author'.

Why? Well, Fay had called Synge's play 'wrath disguised in a grin'. It was genuinely provocative, as the dramatist knew, having reacted to the failure of his *The Well of the Saints* by promising that 'the next one I write I will make sure I will annoy them'. Hence his tale of Christy Mahon, the simple boy who comes to a tacky 'shebeen' or pub in a remote west of Ireland village claiming to have killed his father because he was 'a dirty man, God forgive me, and he getting old and crusty, the way I couldn't put up with him at all'.

And Christy's reward? To be mythologised as a hero by the village women, and especially by Pegeen Mike, the innkeeper's daughter and a 'wild-looking but fine' girl not looking forward to marrying a young man whose preoccupation is pleasing the local priest. The play is subtle, funny,

but also harsh, since it suggests that the peasantry spouts Christian words – 'by the grace of God herself will be safe this night with a man killed his father holding danger from the door', say the drinkers as they leave Pegeen in charge of the shebeen – but that it harbours pagan instincts.

For the next two nights the riots continued, one of the character's references to 'shifts' or undergarments reducing the audience to what Fay called 'a veritable mob of howling devils'. Students came from the Protestant Trinity College to stop the interruptions. There were fights in the foyer, arrests, singing of 'A Nation Once Again', counter-singing of 'God Save the King'. There was a little light relief when a man in a smart overcoat challenged anyone and everyone to a bout of fisticuffs, announced 'I am a little bit drunk and don't know what I'm saying', and tried to play a waltz on the piano in front of the stage. He was ejected, only to reappear and repeat his challenges at the very moment that W. B. Yeats, one of the theatre's founders, came onstage to ask the audience to give a hearing to 'a most distinguished fellow-countryman'.

But the objectors wouldn't be silenced, least of all the overcoated gentleman, who stood up and shouted 'woa, woa, you chap there'. Despite the arrival of yet more policemen, the hubbub continued. So, sort of, did the play. As one paper reported, 'from start to finish not half a dozen consecutive sentences had been heard by the audience'.

It has been argued that the riots were understandable, even healthy. At least the protesters cared. At least they felt the theatre had social, political and religious significance. Certainly, it's clear that the original production was unusually realistic, with Pegeen very sensual, Christy unpleasant-looking and the attack she makes on him after she's discovered he's a fraud akin to a murder attempt. However, a softer, more sentimental revival after Synge's death in 1909 caused no trouble. The play the nationalists had damned as 'a hideous caricature that would be slanderous of a Kaffir kraal' was on the way to becoming an acknowledged masterpiece – one that a later Abbey company could present as a leather-bound gift to the Pope himself.

JUSTICE

How many British plays have had a direct effect on public policy and the law? I can only think of one, and that's John Galsworthy's *Justice*. Winston Churchill, who had just become Home Secretary, came, saw and was moved. Moved enough to push through several prison reforms, including one that would eventually end the practice of putting convicts into solitary confinement at the start of their sentences.

The plot involves William Falder, a twenty-three-year-old lawyer's clerk of previously good character who changes a cheque from £9 to £90 and pockets the difference. He hopes to start a new life in South America with a young woman who is being abused by her husband, but, no, he's arrested, convicted of forgery and sent to jail for three years. And halfway through *Justice* comes the wordless scene that must largely have explained why a cheering first-night audience refused to go home until Granville Barker, its producer, came onstage to tell them Galsworthy wasn't in the theatre.

Falder sits, shrivels, paces, gasps for breath in his tiny cell as a noise 'like some great tumbril', presumably of prisoners beating on metal, rolls towards him and enters his half-crazed brain. And 'panting violently, he flings himself at the door and beats on it' as the curtain falls. Like the trial that has preceded it, the scene seems to have a documentary authenticity. Indeed, the play's forensic strength is what admiring critics called its objectivity, its impartiality and a 'scrupulous fairness' that banished any sense of special pleading.

Falder is callow, neurotic and vulnerable, but also weak and unprepossessing. The judge, though unimpressed by young men who plan to abscond with married women, does no more than his duty. The prison governor is relatively humane. His former employers and, especially, his immediate superior try to be helpful after his release. If anything causes the hapless, helpless Falder's suicide it's what the judge calls 'a majestic edifice sheltering us all,' and his defence lawyer sees as 'that great cage': that seemingly inflexible thing, British 'justice'.

Galsworthy resisted Barker when he tried to persuade him to let Falder live, declaring that he wanted audiences to feel 'thank God he's dead' and

see the social criticism inherent in this. Indeed, he called *Justice* 'a tragedy' and must have felt justified in that claim by the response to the suffering he had evoked. *The Times* pronounced Galsworthy England's 'sole tragic writer'. H.G. Wells, who had found his previous work 'austere' and 'cold', praised *Justice*'s 'quite tremendous force'. An influential MP privately told him it had turned the Home Office 'upside down'. Churchill wrote saying that 'your admirable play' had done much to create the 'atmosphere of sympathy and interest' that made change possible. And in 1916 *Justice* was restaged on Broadway, with John Barrymore as Falder. There, too, the play was enthusiastically received and contributed to a debate about prison reform, this time at New York's Sing Sing.

For Galsworthy this was more than a public achievement. Yes, he had long taken an active interest in law and order. He had visited Dartmoor, Pentonville and other prisons. He had interviewed sixty convicts at Lewes and Chelmsford. He had written an open letter to Churchill's predecessor as Home Secretary objecting to the psychological and physical effects of solitary confinement. 'Revenge, which may be a justifiable individual emotion, is not a justifiable official or State emotion,' he informed Churchill himself before meeting him and, it's said, helping him in drafting measures he found 'splendid all round'.

But the play also reflected a private agony. Galsworthy told his friend and fellow-reformer Beatrice Webb that solitary confinement was his 'nightmare' and, later, gave what he called a psychoanalytical explanation for this. He had, he said, been put in a state of 'acute terror' at the age of five by a nurse who had forced him onto his back and held him down. Ever since he had had an 'abiding aversion to being shut up or in any way controlled'. Falder's agony was his vicarious pain – and he had the skill and power to communicate it.

PYGMALION

Who would have believed that a six-letter word could reduce a sophisticated first-night audience to laughter that lasted a full minute? But that's what happened when Mrs Patrick Campbell's Eliza Doolittle, using her newly acquired elegance of accent, said 'not bloody likely' to the suggestion she should walk rather than take a cab to the house of Professor Higgins, the elocution maestro who was transforming the Cockney girl into a plausible lady. There was such 'abandonment and disorder,' wrote Bernard Shaw of the comic climax of his *Pygmalion*, 'that it was really doubtful they could recover themselves and let the play go on.'

All very different from *My Fair Lady*, the hugely successful musical adaptation of *Pygmalion*, whose producers thought 'bloody' too weak and instead made Eliza yell 'move your blooming arse' at a horse at Royal Ascot. Forty-two years earlier, bishops denounced the use of That Word. *The Daily Express* took a girl who shared Eliza's trade as a flower-seller to Her Majesty's, and she duly pronounced the Word 'horrible', saying flower girls would never use it. Still, the reviews were excellent, which was surprising, considering the troubles preceding that first night.

Shaw had initially wanted the actor-manager George Alexander to present the play and perform Higgins, and Alexander had been keen on what he saw as 'a dead cert' until he heard the dramatist wanted Mrs Pat as Eliza, saying he'd 'rather die' than hire her. She had recently appeared with and for him in a play called *Bella Donna* and he'd become so infuriated by her wayward behaviour, which included flicking chocolates at the backcloth during an emotionally intense scene, that he had forgotten they were not on speaking terms. 'Your wife wouldn't like me to speak with you when you are angry,' Mrs Pat told the raging impresario. 'She says it upsets your indigestion.'

In the event everyone upset everyone else when another great actor-manager, Beerbohm Tree, took Alexander's place. Shaw, desperate to maintain the play's integrity, had maddened both Mrs Pat and Tree by badgering them with verbal or written notes during rehearsals. 'I won't go so far as to say that all people who write insulting letters of over eight pages are mad,' mused Tree,

'but it's a curious fact that all madmen write letters of more than eight pages.' 'I can always find a good use for a little piece of paper,' bluntly remarked Mrs Pat.

And though Shaw had recently become so infatuated with the actress that his wife Charlotte had left for a long holiday in America, he often clashed with her, as he did with Tree, once bringing rehearsals to a halt by asking him if he had to be so 'treacly'. He made it clear that the forty-nine-year-old Mrs Pat was too old for the 'pretty slut', as she called Eliza, calling out from the stalls 'good God, you are forty years too old; sit still and it's not so noticeable'. Several times she refused to continue rehearsing if he remained in the theatre, once remarking that one day the vegetarian dramatist would eat a pork chop 'and then God help all women'. And several times Shaw flounced out, leaving Tree to complain that leaving him to Mrs Pat's tender mercies was 'unbrotherly'.

Tree too had his moments, so botching his lines that paper reminders had to be pinned behind the stage furniture. He also maddened Shaw by begging him to change 'bloody' to 'ruddy', introduce a grand ball scene, and let him use a Scots accent. Then again, he burst into tears during a rehearsal, having taken Eliza's blow with a slipper, which is in the text, as proof of Mrs Pat's personal hatred. But it was the actress who caused such turbulence that a stagehand remarked to Philip Merivale, playing Higgins's friend Pickering, that her late husband was a lucky man. 'Yes, she's still a handsome woman,' replied Merivale. 'No, he got 'isself killed in the Boer War.'

At times she communicated with Tree only through intermediaries, at times sent him screaming from the stage, and at times enraged him by turning her back on him, answering his furious objection with 'but it's a very nice back, isn't it?' Shaw actually fell to his knees to beg Mrs Pat to speak his lines accurately, getting the response 'that's where I like to see my authors, at my feet'. Then, five days before opening night, she disappeared without warning, and got married to an old flame, returning for the dress rehearsal to tell an appalled Tree that she'd been on her honeymoon.

Anyway, the tantrums and quarrels ended happily for everyone but Shaw, who thought Tree was playing Higgins as 'a bereaved Romeo'. What, he wondered, had happened to the play's message that differences of class were at base only differences of speech and demeanour? And when he came to the play's 100th performance he was appalled to find Tree ending the evening by romantically throwing Mrs Pat flowers – and refused to see the production ever again.

LA RONDE

Arthur Schnitzler never wanted his play about serial sexual encounters to be staged, and probably wished it never had been, given the furious reactions it provoked. In his native Vienna there were riots in the theatre, near fist fights in Parliament and reviews in right-wing papers assailing his ethnic origins, one calling *Reigen* or *La Ronde* or *The Round Dance* 'a Jewish pig's mess'.

The son of a distinguished physician, Schnitzler became a doctor whose interest in psychology so infused his writing that Freud called him his *doppelgänger*. He also rose to literary fame at a time when their city was in intellectual and artistic ferment and known for its laid-back ways. His bitter-sweet work reflected the *fin-de-siècle* mood, as did his personal life. Young Schnitzler was sexually unstoppable, his diary recording his many affairs and his letters voicing his agony when his mistresses resisted or betrayed him.

He wrote *Reigen*, reportedly in a particularly melancholy mood, in 1896, when he was thirty-four. In 1900 he paid for a private edition of 200 copies, provoking his fellow-dramatist Hugo von Hofmannsthal to write him an appreciative letter starting 'Dear Pornographer'. That was a joke, because *Reigen* coolly, wryly and never salaciously observes the mating game as it's practiced by mendacious, needy men and women who tend to be artful even when they seem artless. What makes the play still more original is that it's a ten-scene circular chain, starting with a brusque encounter between a prostitute and a soldier, continuing with the soldier's seduction of a chambermaid, then bringing onstage a young gentleman, a married woman, her husband, a working-class 'sweet girl', a poet, an actress, and a count who ends the play in the original prostitute's bed.

By 1903 *Reigen* had been so widely circulated that Schnitzler thought further suppression pointless, only to find most papers ignoring the published play and some reviewing it in abusive, anti-Semitic terms. Before long a public reading in Vienna had been forbidden, the University of Munich had responded to pressure from the Bavarian Ministry of Education and Religion by closing down a student society that had staged

a few scenes, and the play had been banned in Germany. A first staging occurred against Schnitzler's wishes in 1912 Budapest but was stopped by the police after two days.

Expecting more unauthorised performances, Schnitzler sanctioned an official premiere in Berlin in 1920. Though the authorities had got an injunction banning the production a few hours before its scheduled opening, its directors defiantly went ahead and were admired by most reviewers for a staging that Schnitzler had implored them to make discreet. 'It will,' wrote one critic, 'probably become a classic of German erotic literature, an area in which we are badly off.' But days later the scene in which the married woman succumbs to the young gentleman was greeted with a yell of 'schweinerei', stinkbombs were let off, and several dozen people were arrested. The performers were then put on trial for immorality but acquitted by judges impressed by an array of expert witnesses – and by the court's earlier declaration, when overturning that injunction, that the performance was 'a moral deed'.

So to Vienna, where critics applauded the production's artistry but denounced the play, one calling it 'a vile frenzy of indecency' and another 'brothel scenes from the Jew Schnitzler' and 'the filthiest thing that's ever been seen on a stage'. One night twenty young nationalists noisily interrupted the count as he embraced the actress, and two weeks later things greatly worsened. During the bedroom scene between the unfaithful married woman and her philandering husband a 600-strong mob invaded the auditorium, letting off a bomb filled with hydrogen sulphide, swinging canes, throwing balls of tar and even seats from the boxes, causing panic in a packed auditorium and provoking the stagehands to turn hydrants on the rioters, flooding the theatre. In the ensuing storm Vienna's burgomaster, who had refused the federal government's orders to ban the play, survived its attempt to impeach him but couldn't stop *Reigen* closing. Yet a revival a year later occurred without incident, presumably because only one entrance was open, every ticket-holder was scrutinised and policemen were profusely scattered throughout the theatre.

The play was then banned in Rotterdam and Budapest, shouted down in Munich, heavily censored in Copenhagen, and halted by the police in Rome. In a deeply confused Manhattan a magistrate declared that it didn't contain a single indecent line as he dismissed a complaint against one bookseller, but New York's Supreme Court upheld another's conviction for

selling an 'obscene and indecent' book. At least Schnitzler, who died in 1931, didn't see his works, *Reigen* among them, burned by the Nazis.

Thirty years after the play's belated British premiere in Manchester in 1982, the fuss seems extraordinary. After all, *Reigen* has been frequently filmed and televised, turned into a musical, and adapted and updated onstage, recently by David Hare as *The Blue Room*, a two-hander starring Nicole Kidman in all the women's roles and sometimes out of their robes. Cynical? Perhaps. But an incisive portrait of lovelessness and hypocrisy? Surely so.

THE PLOUGH AND THE STARS

It was *The Playboy of the Western World* once more, or so W. B. Yeats clearly felt as he strode onto the same Dublin stage to tell an unruly audience 'you have disgraced yourselves again – is this to be an ever-recurring celebration of the arrival of Irish genius?' Unluckily, he couldn't be heard above a hubbub that mainly came from members of Cumann na mBan, the Society of Women, who first invaded the stage, then accosted the author in the foyer. Seán O'Casey, they felt, had ridiculed sacred Ireland and, especially, Irish womanhood. 'I'd like you to know there isn't a prostitute in Ireland from one end to th'other,' declared an appalled lady patriot.

Their specific objection was to a pub scene in which a prostitute complains about business, and men from the Dublin slums bicker, while a 'figure at the window' praises patriotic bloodshed as 'a cleansing and sanctifying thing'. Provocatively, this man was using the same rhetoric as Pádraig Pearse, the inspirational martyr who had been executed after taking part in the uprising against British rule at Easter 1916, the time the play was set. To seek to demythologise so heroic an event, using a title that evoked the flag of the rebellious Irish Citizen Army, was an offence against all that nationalists held holy.

O'Casey was rounded up when the Easter Rising began and, as an unskilled worker and socialist activist who then believed that the key struggle was with international capitalism, anyway didn't fully support it. But as his autobiography was to recall, he observed the Dublin poor exploiting the chaos, among them a looter wailing 'Jasus, not a drop left' as a bullet shattered the whisky jar he had stolen. It's a cry that could have come from Fluther Good or the other tenement dwellers we see drinking, quarrelling, boasting, and playing cards beside a coffin that contains the bodies of a consumptive girl and the heroine's still-born child.

That unheroic heroine is Nora Clitheroe, who utters the play's key line as her husband Jack is fighting offstage: 'no woman gives a son or husband to be killed, and, if they say so, they're lying against God, nature and themselves.' That, too, upset nationalists who said that Volumnia, the bellicose matriarch in Shakespeare's *Coriolanus*, was the right model for an Irish mother. And Nora increased their outrage when she inveighed against the fear, and the fear of showing fear, she saw in the rebels' eyes – and then lost her husband, baby and sanity.

O'Casey, who dedicated the play to the 'gay laugh of my mother at the gate of the grave', always thought it was the women who ultimately paid for male folly and excess. And he made this clear in a debate and then a public exchange of letters with Hanna Sheehy-Skeffington, the widow of a noted pacifist who had been killed by a crazed British officer after he'd rescued one of the man's wounded comrades. She had been part of the 'mass of moving, roaring people' who had invaded the stage, only for the actors to push them down, sit on them or force them back into the stalls before the police ejected them 'like peas from the pod of the theatre'. Now Sheehy-Skeffington denounced O'Casey as no more than a theatrical photographer who 'likes to see the meanness, the littleness, the squalor, the slum squabbles, the women barging each other and the little vanities and jealousies of the Irish Citizen Army'. The dramatist replied that her blindness to ordinary people's concerns 'makes me sick'.

But the first critics supported her romanticism rather than his realism, *The Irish Independent* concluding that O'Casey's plays were 'naught but a series of Tableaux Vivants', examples of music-hall humour written without music-hall skill by a man who is 'a combination of the cinema and the dictaphone'. Soon afterwards the dramatist left for England, where the influential James Agate invoked Dickens, Balzac and Shakespeare in his enthusiasm for *The Plough*. And in 1928, when the Abbey rejected his war-play, *The Silver Tassie*, O'Casey settled permanently there.

It's a truism that severance from his roots caused a decline in his work. But *The Plough*, like his earlier *Juno and the Paycock*, shows a breadth of sympathy, a truth to life in all its contradictory aspects, and a range of tone that combines the painful and the hilarious and does, indeed, remind one of Shakespeare. It's as if counterparts of Falstaff, Bardolph, Pistol and Doll Tearsheet are surviving in an Irish Eastcheap, observed by the unforgettably complex character of Bessie Burgess.

She's a drunken, quarrelsome Protestant and loyalist, who taunts her Catholic neighbours with promises of retribution, herself starts the looting, yet dares every danger to help Nora in her desolation and madness, only to scream 'you bitch you' when a bullet hits her. And then on come her shruggingly apologetic English killers to drink a cup of tea and bring to an end what, in my view, is the finest play written in English in the twentieth century.

THE WHITE GUARD

Bizarrely, Mikhail Bulgakov had Stalin to thank for much of the success of a play that provoked more controversy and suffered more virulent attacks than any in Russian history. The old monster saw it fifteen times and overrode the hit-men who thought its dramatisation of 'white' Tsarist sympathisers in the Kiev of 1918-19 ideologically unsound. The play did well to show a strong and intelligent enemy, he declared, because its defeat suggested that 'nothing can be done against the all-powerful might of Bolshevism'.

Well, Bulgakov knew all about a topic he first treated in a novel, then adapted into a play at the request of the Moscow Art Theatre (MAT). As a young doctor, he'd been wounded in the First World War and, as a member of a well-to-do Kiev family, he claimed to have witnessed ten changes of power in the Ukraine. Hence his wry, funny yet poignant and moving portrait of the Turbin clan: people who talk politics, recite poetry, bicker, drink, sing, emote and, with one big exception, survive as Whites, Reds, peasant rebels and German occupiers converge on a confused, confusing city.

MAT's Stanislavsky was 'rather unsure' about the play's quality but changed his mind after he was left throwing down his pince-nez and wiping away tears during a run-through of a staging by his company's younger actors. The powerful Lunacharsky, People's Commissar of Enlightenment, wavered too, initially describing the piece as 'extremely poor' but later becoming its defender. The title had been changed from *The White Guard* to the less provocative *Days of the Turbins*; much had been changed, much cut, including a scene in which peasant soldiers brutalise a Jewish cobbler; the ending had become more 'positive', with the Internationale being loudly heard as the Reds triumph and the Turbins' feistiest, most patriotic friend announces he'll join them; the first night seemed a major success; and yet the most influential critics assailed the play.

It was old-fashioned, sub-Chekhovian, bourgeois, reactionary, harmful. Why did the Turbins have no servants to express proletarian attitudes? Bulgakov was compared with 'rich kulaks'. MAT 'was falling into a puddle

along with that roué Bulgakov'. The new Russia had no more need of Bulgakov's work 'than a dog needs a brassiere'. Though the play drew packed houses, though Lunacharsky publicly argued that the public no longer needed protecting from 'strong meat', the attacks continued. And in 1929 the long-running *Turbins* was removed from MAT's repertoire, an impending production of Bulgakov's *Flight* was forbidden, and two of his other plays closed.

The dramatist declared himself 'ruined, persecuted and completely isolated'. But it might have been worse. Mayakovsky had shot himself, largely because of hostility to his satiric *The Bathhouse* and *The Bedbug*. The seemingly unassailable Gorky, a strong defender of Bulgakov, was soon to die under suspicious circumstances. Other gifted dramatists – Erdman, Babel, Shvarts, Olesha – disappeared into the Gulag, fell silent or both. The right sort of play was Pogodin's *Aristocrats,* a portrait of the building of the White Sea Canal, actually a murderous and virtually useless enterprise, which ends with 'sabotaging' engineers and other prisoners transformed into good Bolsheviks – and hurrahing, weeping with pride, and happily tossing their Chekist commander in a blanket after he has shaken their hands and praised Stalin.

Bulgakov asked permission to leave Russia or take a menial job at MAT. Then came a surprising phone call from Stalin, who ensured that he became an assistant producer at the theatre and, in 1932, that *Turbins* was restored to its repertoire. Despite a quarrel with Stanislavsky, who withdrew Bulgakov's *Molière* after it was attacked in *Pravda*, the play remained there until 1941, a year after the dramatist's death, running up some 900 performances in all. And revivals by the RSC and the National have shown that Pavel Markov, MAT's literary director, was right to declare at a heated public debate that Bulgakov's achievement was 'the revelation of the moral destiny of a man and, through that, of an era and its events'.

Even though no translator can give us the uncensored play Bulgakov would have wished, it remains an exciting piece, for instance when Alexei Turbin sends away his cadet officers while peasant soldiers advance on the school where they're ensconced and is himself shot before he can escape. It's disturbing, for instance when those soldiers murder a deserter with rotting saying he's not worth a hospital bed. It's hilarious, notably when the man puppet leader, the Hetman, is disguised as an invalid, swathed in bandages and, looking like a mummy but still issuing orders, carried from place. It's quirky, for instance in its portrayal of the Hetman's aide,

an opportunist who becomes Alexei's sister's lover, looks set for a career as an opera singer, and has wise advice for those caught in a civil war: 'wear a neutral overcoat.' It's sharp, allowing the heroic, disillusioned Alexei to look forward to a world that's 'a gaping, gasping, endless stream of envy and hatred'.

And it's generous yet measured in its depiction of the Turbins, clustered together with their vodka and verse, their grief, dread and wary acceptance of a dangerous future. This is, you feel, what living through political cataclysm must be like.

JOURNEY'S END

There's a romantic story behind the British theatre's best-known treatment of a most unromantic subject: the conflict that J.B. Priestley once said 'sliced my generation into sausage meat held above a swill bucket'. The play which an unassuming insurance agent called R.C. Sherriff based on his front-line service in the First World War, and which followed a series of pieces he'd written just to raise money for the Kingston-on-Thames Rowing Club, became an unlooked-for triumph in both London and Broadway and was revived again and again. A production mounted in 2004 played for over a year in three successive West End theatres, went on tour, and returned for a decent run at a fourth.

What's *Journey's End*'s pull? Its authenticity for a start. Joining the East Surrey Regiment as a nineteen-year-old in 1915, Sherriff rose to the rank of captain, won the Military Cross, and was twice wounded, the second time so seriously by debris that, as he wrote, 'the doctor took fifty-two pieces of concrete out of me'. And if you compare *Journey's End* with O'Casey's *Silver Tassie*, which treats the same war in a grand, liturgical way, you quickly see which dramatist saw action and which didn't. It was Sherriff who knew about the rats, the Verey lights, the dreadful dullness, the spasms of terrifying violence, and the curious habit of men about to face extreme danger: they yawn.

Moreover, the officers who gather in their damp, grotty dug-out just before a major battle are pretty unheroic heroes or, rather, heroes who are the more heroic for not considering themselves heroes. As Sherriff himself wrote, his characters were 'simple, unquestioning men [who] fought the war because it seemed the right and proper thing to do. Somebody had got to fight it, and they accepted the misery and the suffering without complaint'. And when he composed the piece, he felt he was simply remembering men 'I had lived with and knew so well that every line they spoke came from them and not from me'.

But that's to suggest that *Journey's End* is merely a slice-of-life docudrama, as Shaw concluded when he was asked his opinion of the play by the Stage Society, which was to give it its first production. For him it was

reportage, 'useful as a corrective to the romantic conception of war'. And as Sherriff himself conceded, there's little plot. Insofar as there's a main one, it involves the arrival in the trenches of a new lieutenant, Raleigh, who hero-worshipped his commander, Stanhope, at school; Stanhope's unjustified fear that the boy will send home accounts of his drinking that will alienate Raleigh's sister, whom he hopes to marry; and Raleigh's death, followed by the near-certain deaths of Stanhope and the surviving officers in the German offensive that ends the play.

Yet the characterisation is strong and the unostentatious behaviour of men who were, Sherriff said, 'caught in a trap with no hope of escape' touches the heart. The first actor to play Stanhope – a very young, able, conscientious leader who appals himself by finding solace for his shattered nerves in the whisky bottle – was the then obscure Laurence Olivier, who much later designated it his favourite-ever role. But a film took him away from the original cast, whose performance for the Stage Society picked up reviews so ecstatic that a major production, with Colin Clive replacing Olivier, was the eventual result.

However, all along the play had faced difficulties. It involved a subject many people wanted to forget and hadn't a woman in the cast. 'How can I put on a play with no leading lady?' asked one of the many managers who rejected it. Yet it was that unpretentious originality which won over the critics – 'I have never been so deeply moved, so enthralled, so exalted,' wrote Agate – as did the lack of sermonising against war. Though Stanhope has his cynical moments, and Raleigh remarks that 'it all seems rather silly' when he hears how furious hostilities resumed after a German helped the British recover a wounded soldier, Sherriff could say that 'no word of condemnation was uttered by any of the characters'.

And that, of course, is a key strength. Here are unremarkable men tolerating the intolerable and enduring the unendurable because, as Stanhope tells an officer faking illness, 'it's the only thing a decent man can do'. Now there's a lesson for a luckier but often thankless generation – and a lesson that, given the play's lasting popularity, hasn't gone unnoticed.

PRIVATE LIVES

Could Noël Coward's best-known comedy have happened without Gertrude Lawrence, the actress he met when they were both child performers and, he said, 'loved from then onwards'? In his autobiography he recalled that he was in Tokyo on a far-eastern trip in late 1929, went early to bed on the night before he was to meet his travelling companion, but couldn't sleep: 'The moment I switched out the lights, Gertie appeared in a white Molyneux dress on a terrace in the South of France and refused to go away until four a.m., by which time *Private Lives,* title and all, had constructed itself.'

In Shanghai Coward developed flu, allowing him to prop himself up with a pencil and a writing block and, in just four days, complete a play that came easily and enjoyably, 'with the exception of a few of the usual "blood and tears" moments'. He then cabled Lawrence in New York asking her to keep autumn 1930 free and received back a telegram which read 'your play is delightful and there is nothing that can't be fixed', to which an indignant Coward cabled back 'the only thing to be fixed will be your performance'.

But Gertie was talking about her contractual obligations and, after much to-ing and fro-ing during which Coward huffily pretended he was offering the lead role to another actress, she fixed them. And the following September she and he were on the London stage, as Amanda and Elyot in a production that won the thirty-year-old dramatist and actor mixed reviews. 'The critics described *Private Lives* variously as 'tenuous, thin, brittle, gossamer, iridescent and delightfully daring', Coward was to recall, 'all of which connoted in the public mind cocktails, repartee and irreverent allusions to copulation, thereby causing a gratifying number of respectable people to queue up at the box office.'

What those people saw was a divorced couple who find themselves on adjoining balconies in a French hotel, where each is honeymooning for the second time. It speedily but subtly becomes apparent that the bond between Elyot and Amanda is far stronger than that between their new spouses. Off they sneak to a flat in Paris, where mutual exasperation eventually turns to a mutual violence that horrifies the far duller Sybil and Victor when they track

the fugitives down. And so to an ending which leaves Elyot and Amanda reunited and quietly exiting a stage on which the other two are now raging at each other.

There are plenty of characters like Elyot and Amanda in Coward's comedies: hedonistic, selfish, unreliable, difficult, even maddening, but also witty, vital, fun. They're attractive egoists with strong sexual drives, disturbing anarchic impulses and little respect for conventional morality. And, more than most, Amanda and Elyot find it hard to live with but harder to live without each other, meaning that behind the sophisticated chatter there's a certain poignancy: a melancholy about the unavoidable contradictions of love, a defiance in the face of 'all the futile moralists who try to make life unbearable', a rueful awareness of what it meant to be different (as the gay Coward was different) in an England still shedding its Victorian fetters.

Unsurprisingly, Coward had run into trouble with the Lord Chamberlain, who thought the play 'too risqué for the public standards of morality' and wanted it drastically rewritten. However, Coward went to St James's Palace, personally read all the roles to the censor, and convinced him that he wasn't inciting audiences to adultery. The rebellious spirit of his era emerged triumphant. Indeed, Coward had just one regret about *Private Lives,* which was that he had underwritten the roles of spouses who were originally played by Adrianne Allen and the young Olivier. They were, he wrote, 'little better than ninepins, lightly wooden and only there to be repeatedly knocked down and stood up again'.

Maybe, but that didn't prevent the play moving to New York, where the reviews were enthusiastic, and becoming Britain's most frequently revived twentieth-century comedy. Indeed, it was a London production of *Private Lives* in 1963, followed by his own revival of his *Hay Fever* for the National Theatre, that brought what Coward called 'Dad's renaissance', the rehabilitation of a man who had fallen into critical disfavour with the advent of the 'kitchen sink' school of socially aware dramatists.

Private Lives has attracted performers from Richard Burton to Robert Stephens, Tallulah Bankhead to Maggie Smith, but few can have been as enchanting as Gertrude Lawrence. She was, wrote Coward, exactly what he had imagined in Tokyo, down to that white dress: witty, romantic, tender, alluring, volatile, the epitome of grace and charm and imperishable glamour. 'Sometimes in *Private Lives*,' he said, 'I would look across the stage at Gertie and she would simply take my breath away.'

BLOOD WEDDING

I s there anything harder for English speakers to translate, direct or perform than this, the most violent yet poetic of García Lorca's major plays? They must fling themselves into a world where the arid, stony earth is as unforgiving as an Andalusian peasantry which believes blood must be repaid with blood. They must cope with moments when blunt, realistic prose abruptly gives way to verse packed with florid imagery. They must find ways of staging a scene in which woodcutters rhapsodically introduce the Moon, who then discusses with a spectral beggar how to lure lovers to disaster. And they must leave us believing that human passion, like an uncontrolled fire, devastates whatever it touches.

We have the testimony of Lorca's brother, Francisco, that though the dramatist wrote the play in a week, he'd been talking about it since reading accounts of a murder that had occurred near the Andalusian town of Nijar. A few hours before one Francisca Morales was to marry a labourer, Casimiro Pino, she absconded with her cousin, Curro Canadas, only to run into the groom's own cousin, who shot Canadas dead. That gave Lorca the story of *Blood Wedding*, though he made changes that intensified the drama. The Bride – most identities are deliberately made general, even universal – leaves the decent but dull Bridegroom immediately *after* their wedding. And it's the Bridegroom who kills and is killed in a climactic fight with his rival, the glamorous Leonardo, whose family (another change) is already hated by the Bridegroom's powerful mother for killing his brother.

Lorca's influences included Greek tragedy, for there's a sense that implacably hostile forces are determined to destroy these men, and Synge's *Riders to the Sea*, which also leaves a bereft but fatalistic mother mourning the death of her last son. Salvador Dalí and Manuel de Falla, friends who shared his love of folk tales and music, had an impact too. Lorca's anguished but defiant homosexuality, a subject he had treated in his little known *El Publico*, must also have informed his treatment of an illicit but irresistible desire that is fatally punished. And he himself said he couldn't have written *Blood Wedding* if he hadn't loved the countryside so intensely as to have 'at the heart of my life what psychoanalysts would call an agrarian complex'.

That *Blood Wedding* was a triumph must have surprised Lorca. After all, it was stylistically as unconventional as his first play, *The Butterfly's Evil Spell*, whose tale of warring and loving insects had been heckled by the conservative Madrid audiences of 1920. Directing it himself, he had sometimes lost his temper with actors who lacked the precision necessary for a mix of prose, poetry, movement and music he compared to 'the performance of a symphony'. Moreover, he was a poet with known leftish sympathies, had recently been touring Golden Age plays to deprived areas, and had become a target of right-wing papers. Yet the audience was wildly enthusiastic, forcing him twice to take a bow during the performance, and most critics followed, *Heraldo de Madrid* calling the play 'a great work' and *El Sol* lauding the 'human spirit' that infused it, the 'common breath that comes from deep within'.

The first-night audience in Buenos Aires the following October was even warmer, giving Lorca long standing ovations before and after the performance. However, the play's English-speaking premiere, in New York in 1935, was a flop. Brooks Atkinson found *Bitter Oleander*, as it had been retitled, dreadfully stylized and the influential John Mason Brown mocked a 'torrid melodrama' whose characters used horticultural images 'as if they had eaten whole libraries of seed catalogues'. But the play fared better when the then unknown Peter Hall gave *Blood Wedding* a belated British premiere in 1954. Hall later wrote that he 'loved Lorca's ability to mix surrealistic poetic theatre with the concrete depiction of peasant life', himself rewrote an 'appalling' American translation, and was well rewarded, for instance by a *Spectator* critic who called the production one of the most exciting he'd ever seen.

Myself, I've seen the play four times and only once felt transplanted to a hot Spanish outback where blood-feuds have seethed for generations. At times I've thought I was not watching outraged villagers running dangerously amok, only some genteel unrest at a vicarage fete. The exception was Rufus Norris's revival at London's Almeida Theatre in 2005. That avoided the perils of Englishness by casting the Mexican actor Gael García Bernal as Leonardo and surrounding him with a multinational company. The result caught both the play's passion and its strange magic – and left me impotently mourning Lorca himself.

He was murdered by rightists at the start of Spain's civil war in 1936. He was just thirty-eight, author of the marvellous *The House of Bernarda Alba* as well as *Yerma*, a play that, with *Blood Wedding*, he saw as part of a 'rural trilogy'. Its third component was never written: a terrible loss, like Lorca himself, to the world's drama.

WAITING FOR LEFTY

CIVIC REPERTORY THEATRE, NEW YORK, JANUARY 6 1935

Clifford Odets's forty-minute *Waiting for Lefty* was 'the birth cry of the Thirties'; or so said the author's close friend, the director and critic Harold Clurman. Certainly, no play did more to move and exhilarate Americans troubled, injured or ruined by the Great Depression. How many other dramatists have left a first-night audience storming the stage and chorusing 'Strike! Strike! Strike' in support of an oppressed workforce?

Though Odets disingenuously denied it when he appeared before the House Committee on Un-American Activities (HUAC) seventeen years later, the play was inspired by the strikes that started when a young New York cab-driver was fired for failing to earn enough money on a long night shift. With 40,000 men and 19,000 cabs off the road for forty days at one time, a dispute over conditions and wages grew violent, with police placing machine guns on the roofs above a mass meeting and the drivers' union's leader, one Samuel Orner, drugged, beaten and left for dead.

At the end of Odets's play Lefty, the aptly nicknamed leader of the cabdrivers' union, actually is dead, found 'with a bullet in his head'. That leaves one of his members, Agate Keller, declaring that 'we're stormbirds of the working class', and swearing to 'die for what is right'. Keller then invites the audience, who have been made to feel they're part of the meeting, to give that famous answer: strike, strike, strike.

Agitprop theatre, which *Lefty* undeniably is, has a bad name. It tends to deal in romantic stereotypes and angry caricatures. It's usually crude, two-dimensional, politically simplistic. But Odets, then a rather mediocre actor with New York's pioneering Group Theatre and a convert to communism, combined passion with a surprising degree of realism when he created the scenes that led to those ringing words, that fiery denouement.

A double-dealing union potentate, Fatt, admittedly veers towards cartoon when, flanked by a gum-chewing gunman, he warns a workers' committee that they're being used by 'reds' who will 'have your sisters and wives in the whorehouses, like they done in Russia'. But then Odets introduces a series of men who become cabbies and support a strike,

including a Jewish doctor driven by anti-Semitism from his hospital job, a young scientist fired for refusing to help develop poison gas, and a driver too poor to marry on his wages. And though the situations are politically manipulative, the characters come vividly to life and much of the dialogue fizzes and crackles, rising at times to a sort of urban poetry.

That first audience was more than gripped by a rough-theatre production that cost all of $8 to mount. As Odets remembered it, people stood up after each scene to cheer and weep and 'the audience became the actors on the stage and the actors became the audience: the proscenium arch disappeared'. At the end there were twenty-eight curtain calls, hats and coats were thrown in the air, and, according to Odets's fellow actor Elia Kazan, 'the balcony, like a Niagara, seemed to roar down on the audience below'. Clurman persuaded a stunned Odets, who had been sitting with Kazan in the audience, to mount the stage, which he did, though he also went to the men's room to sob and vomit.

As a result *Lefty* was either staged or banned throughout America and then the world, from Moscow to Tokyo. It even appeared along with Odets's anti-Nazi melodrama, *Till the Day I Die,* in a Broadway double bill that left critics calling the dramatist 'a boy wonder', the 'poet laureate of the Group Theatre' and, from John Mason Brown, a writer with 'a sweeping, vigorous power as welcome as it is thundersome'. The enthusiasm was even greater than it would be for his *Awake and Sing!*, a larger, subtler play which was about to give Odets his Broadway debut when *Lefty* appeared.

Things went badly wrong for Odets when he appeared before HUAC and, like Kazan, disavowed his earlier political credo and 'named names', though the Communists and 'fellow-travellers' he did name had all been named before. He expressed 'revulsion' at his own action, wrote little but Hollywood screenplays afterwards and was reportedly a tormented man when he died of cancer, aged fifty-seven, in 1963. But in *Lefty,* as in some of the plays that followed it, he had written eloquently not just about economic oppression in America but about what Clurman called 'every impediment to that full life for which youth hungers'. That's an achievement in itself.

MURDER IN THE CATHEDRAL

CANTERBURY CATHEDRAL, JUNE 15 1935

Back in 1934 T.S. Eliot was asked by the Bishop of Chichester, George Bell, to write a play for the arts festival in Canterbury he had started when he was dean of the city's cathedral. The poet agreed at once, decided that his subject would be the martyrdom of Thomas Becket that had occurred in 1170 in that very place, but thought that such a piece would have limited appeal. 'The play was to be produced for an audience of those serious people who go to festivals and expect to have to put up with poetry,' he said. 'People who go to a religious play expect to be patiently bored and to satisfy themselves with the feeling that they have done something meritorious.'

Well, Eliot was wrong. The first audiences were small, but not because of any lack of enthusiasm. Instead, it was because the play was staged in the cathedral's chapter house rather than in a nave that, in the words of its director, E. Martin Browne, was 'acoustically impossible'. This still meant that Becket's theatrical murder occurred only 50 yards from the site of the actual one. And it didn't deter the London critics coming, applauding, and ensuring that the play would have a distinguished afterlife.

Its staging also re-galvanised a personal and professional campaign. In 1929 Eliot had published an essay in which he argued that realistic prose plays tend to deal with the ephemeral rather than the 'permanent and universal' and that 'the human soul, in intense emotion, strives to express itself in verse'. He looked for a drama to rival that of the Elizabethans and had already made a start with his part-prose, part-verse *Rock*, which involved the building of a church and, indeed, of the Church itself.

It's about spiritual discovery and self-discovery, as were all Eliot's later plays, most obviously *Murder in the Cathedral* itself. Archbishop Thomas must prepare himself for a selfless martyrdom, and does so, facing out tempters that Eliot's notes reveal were variously based on Bertrand Russell, H.G. Wells, D.H. Lawrence and 'Huxley'. These represented courtly

hedonism, power, an alliance with the barons against Henry II, the king Becket has alienated, and, most insidiously, the pride which he admits to reflecting his own desires: 'make yourself the lowest on earth to be highest in Heaven.' Whether or not he triumphs over the last of these – and Eliot told Browne that 'none of us can achieve victory while we live' – his death means spiritual renewal for an initially null, finally uplifted chorus that consists of 'the scrubbers and sweepers of Canterbury' but is meant to represent the laity everywhere.

The chorus, in particular, has some magnificent verse and striking moments, as when it reacts to Becket's assassination with 'clean the air, clean the sky, wash the wind – wash the brain, wash the soul, wash them, wash them!' But what made those first spectators gasp aloud was the immediate aftermath. The four knights responsible turned to them and justified their atrocity in prose that wasn't only very modern but as topical as Eliot hoped when he said he wanted to 'shock the audience out of its complacency'. When one knight demands approval for helping to achieve 'a just subordination of the pretensions of the Church to the welfare of the State', the spectators' thoughts perhaps turned to Hitler's growing power. Likewise with another murderer's request that they disperse quietly, without loitering in groups or provoking 'any public outbreak'.

Did the play and its protagonist reflect Eliot's combination of grief at his failed first marriage and increasingly austere Christian beliefs? Many thought so, from Virginia Woolf, who decided the American-born author had created a 'pale New England morality murder', to his director. Browne saw Eliot change the title from *Fear in the Way* to the present, more exciting one and invited him to stay for a working weekend in which the poet was taciturn, withdrawn and, at one point, sound asleep while Mrs Browne crept through her own drawing room. There were frequent meetings afterwards, but not at rehearsals, only the last of which Eliot attended. He did, however, obscurely tell the chorus that there should be 'a colon, not a semi-colon' in one line.

Though most characters were originally performed by amateurs, the main exception being Robert Speaight's formidable Becket, professionals took over the other leading roles when the play moved to London's little Mercury Theatre. *Murder in the Cathedral* was then described by *The Times* as 'the one great play by a contemporary dramatist now to be seen in England', toured Britain, had a brief but critically acclaimed run on Broadway, appeared in the West End, was performed in bomb shelters

during the war, and got a famous revival at the Old Vic in 1953. And now it has entered the repertoire as (*The Family Reunion* possibly excepted) the only wholly successful play the pioneer of a new poetic drama managed to create.

OKLAHOMA!

❛No gags, no gals, no chance' was the producer Mike Todd's dismissal of *Oklahoma!* after he left its out-of-town premiere at the interval, explaining he had to bail a friend out of jail. But then few people thought Rodgers and Hammerstein's first collaboration could succeed in New York. Would that sophisticated city really appreciate a corn-belt show that replaced the usual opening chorus with a homely woman called Aunt Eller churning butter as a melodious cowboy called Curly hailed a 'beautiful mornin"? Yet the show received rave reviews and ran for a then record 2,212 performances, changing the musical stage forever.

It began when the producer Theresa Helburn lured Richard Rodgers to a revival of Lynn Riggs's *Green Grow the Lilacs*, a play about love in the early twentieth-century outback that had flopped on Broadway in 1931. Surprisingly, the urbane composer was delighted to hear hokey Okies spouting lines like 'I ain't wantin' to do no hoe-down till mornin" and decided on a musical adaptation. The problem was that his long-time collaborator, Lorenz Hart, was succumbing to alcoholism. Enter a new librettist: Oscar Hammerstein II, whose successes included *Show Boat* but whose recent musicals had abjectly failed.

Hammerstein was widely regarded as a has-been, the choreographer Agnes De Mille as too upmarket for Broadway, the show itself as 'Helburn's Folly'. Moreover, the plot seemed absurdly thin, since its prime concern was whether wholesome Curly or Jud, the hired hand with a taste for dirty postcards, would take pretty Laurey to a 'box social'. Unsurprisingly, Rodgers and Hammerstein found few backers when they travelled the 'penthouse circuit', playing their songs to rich New Yorkers. And Mary Martin, potentially the star of an otherwise unstarry musical, rejected the role of Laurey for one in a show called *Dancing in the Streets*, which folded in Boston at the same time as *Oklahoma!* surprised everybody by succeeding there.

That promising moment – it left Rodgers joking that he wouldn't again open a can of tomatoes without taking it to Boston – had been preceded by anxieties galore. Joan Roberts, the chosen Laurey, was

dreadfully late for a rehearsal because she'd been to Mass praying for the show. 'Let her pray,' Rodgers told the outraged director, Rouben Mamoulian, who then had a screaming row with De Mille that ended with the choreographer's head held under a cold tap. But De Mille won her argument with Hammerstein, who wanted Laurey's dream, which closed Act One, to become a circus spoof, with the girl on a trapeze and her Aunt Eller in a 'surrey' with diamond wheels. She argued that sex was the issue and that young women had 'dirty dreams' – and the result was a daringly original ballet revealing Laurey's fascination with the dangerously violent Jud.

Some ingredients disappeared during a New Haven tryout De Mille described as 'being in a cement mixer': the living cow which mooed so much that 'Oh, What a Beautiful Morning' couldn't be heard, the pigeons that flew into the flies, imperilling the cast's heads. But the title was changed from the original *Away We Go!* to *Oklahoma!* after Helburn remarked that there should be a song 'about the earth', inspiring the salute to Oklahoma that's maybe the most glorious of many terrific numbers: 'The Surrey with the Fringe on Top', 'I Cain't Say No', and Curly and Laurey's shy, wary 'People Will Say We're In Love'.

Some tickets were left unsold and others had been given away when *Oklahoma!* opened on Broadway, but the audience's scepticism speedily evaporated. That opening number, recalled De Mille, 'produced a sigh from the entire house I don't think I ever heard in the theatre'. The composer Arthur Schwartz remembered the excited 'storm' that ended the first act and a final ovation 'that must have lasted fifteen minutes'. The critics were ecstatic, with even *The New Yorker*'s formidable Wolcott Gibbs hailing 'a completely enchanting performance – gay, stylish, imaginative, and equipped with some of the best music and dancing in a long time'. And those backers who had shut their eyes and taken the plunge were to make a profit of 2,200 per cent on their investments.

What was the appeal, apart from hummable tunes and deft, simple lyrics? First, a seamlessness that meant the songs and dances were never isolated numbers but unfailingly expressed character and advanced narrative. For Rodgers, even 'the orchestrations sounded the way the costumes looked'. Second, a sense of togetherness, renewal and optimism that meant much in 1943, a year after Pearl Harbour. As another number suggests, Oklahoma Territory's 'cowmen' and farmers are renouncing traditional rivalries and

becoming joint founders of a new state that sheds evil in the form of Jud and embraces the warmth of Laurey and Curly.

Inadequate revivals can leave one feeling sorry for Jud, not least when Curly sings a song inviting him to kill himself, but sensitive ones, like Trevor Nunn's at the National in 1998, still leave one feeling exhilarated. When Rodgers was wondering what he should do after *Oklahoma!*, Sam Spiegel had a simple reply: 'shoot yourself.' It really seemed that the most artistically influential show of our era couldn't be bettered. It sometimes still does.

THE GLASS MENAGERIE

CIVIC THEATRE, CHICAGO, DECEMBER 26 1944

Tennessee Williams had no great regard for the play that made him famous at the age of thirty-three, either when it triumphed in Chicago and New York or afterwards, when it was it was clearly becoming what his friend and fellow-dramatist William Inge pronounced it: 'an American classic'. He scrawled 'a rather dull little play' on its typescript, called it 'a potboiler' and thought it sentimental: 'I put all the nice things I had to say about people into *The Glass Menagerie*. What I write hereafter will be harsher.'

Actually, he had already had two harsher plays staged without success outside New York: *Not About Nightingales*, a portrait of a corrupt and murderous prison regime that had to wait for recognition until a fine National Theatre revival in 1998; and *Battle of Angels*, an early version of what was to become the strange and violent *Orpheus Descending*. So Williams was surprised but wary when Laurette Taylor, who had been driven by her alcoholism into semi-retirement, declared it was the opportunity she had been waiting for and agreed to play Amanda Wingfield, the character the dramatist had based on his mother, Edwina.

No wonder Edwina, like Amanda a one-time Southern belle trying to maintain gentility in tacky St Louis, jumped 'like a horse eating briars' when she joined her son at the play's first night. The parallels with the troubled Williams family were evident. *The Glass Menagerie* is a memory-play, narrated by an aspiring writer called Tom, which was Tennessee's real name, and, as was also the case with Williams, is fretting away his life in a shoe factory. The shy, repressed, ailing sister who is cloistered with her glass animals is called Laura but is clearly based on the young woman who was to obsess Tennessee all his life and haunt his plays: his sister Rose, who was permanently hospitalised after undergoing the prefrontal lobotomy he attributed to his mother's dislike of her sometimes loose tongue.

But it was Edwina who was most recognisable. Right at the beginning Amanda is nagging her alienated son in precisely the way Tennessee's brother Dakin remembered: 'Chew, chew! Animals have sections in their stomachs which enable them to digest food without mastication, but human beings are supposed to chew their food before they swallow it down.' Likewise with Edwina's 'suffering-Jesus facial expressions [that] were the most lethal and unendurable bits of her repertoire'. The play's events were, Dakin said, so 'literal a rendering of our family life' that his mother could have sued Tennessee. Even the young man who gave the play its first title, a 'gentleman caller' who Amanda foolishly hopes might marry Laura, was based on a real visitor.

Laurette Taylor rubbed in the point, asking Edwina how she liked seeing herself portrayed on stage and adding something tactless about having to wear bangs in order to hide her own higher, more intellectual forehead. Yet it was clear that she gave a wonderfully touching, true performance, even though the signs seemed ominous. Taylor mumbled through rehearsals, muddling her line and misjudging her Southern accent. The opening had to be postponed after she was found drunk and unconscious in the theatre basement. And she persistently quarreled with Eddie Dowling, who was directing as well as playing Tom: a feud which apparently gave unusual intensity to Amanda's arguments with her son.

Nevertheless, the Chicago critics were so delighted ('a lovely thing and an original thing,' wrote Ashton Stevens, adding that he hadn't been so moved since Duse gave her last performance) that they republished their recommendations until a worryingly slow box office became rampant and a New York transfer occurred. On opening night on Broadway Taylor was so sick, probably less because of alcohol than the cancer that would soon kill her, that a bucket was placed into the wings, allowing her to vomit between scenes; and yet she again gave a magical performance, strong but sympathetic.

The play ran for 563 performances, even getting grudging praise from the eminent critic Williams was to regard as his foe and 'nemesis', George Jean Nathan. It was, Nathan wrote, a freakish, humourless experiment that also provided 'far and away the theatre's loveliest evening'. As for Williams, he was already writing the harsher, stronger *A Streetcar Named Desire* and trying to forget the autobiographical *The Glass Menagerie*. 'It is the saddest play I have ever written,' he was to say. 'It is full of pain. It's painful for me to see it.'

MOTHER COURAGE

DEUTSCHES THEATRE, BERLIN, JANUARY 11 1949

In the penultimate scene of Bertolt Brecht's finest play the title-character's daughter, Kattrin, hears that the city of Halle is about to be attacked by night and its population slaughtered. So she climbs onto the roof of a peasant's house and bangs a warning drum, awakening the sleepers below before she's shot dead. And in the final scene her mother gives the peasant money for Kattrin's burial before dragging off her wheeled shop-cum-canteen in search of military custom – and, as Helene Weigel played the role, grabbing back a coin to put in the old leather purse she'd spent the evening snapping shut in her curt, mercenary way.

It was a telling moment in an episode that had long worried Brecht and was still doing so at a time in East Berlin when, as he wrote, audiences were coming in acrid-smelling old clothes 'from ruins and going back to ruins'. The first-nighters, who had suffered far more from war than an author who had spent it in American exile, first sat in a mesmerised silence, broken by sobs, then stood, wept and clapped unstoppably. The irony was that they were moved in what Brecht thought the wrong way. That they were stirred by the altruism of Kattrin, who had been left dumb and disfigured by violent soldiers, was fine by him. But to see Mother Courage as a gallant survivor? That flouted his intentions – which was why Weigel, who was Brecht's wife, had inserted business specifically but not quite successfully designed to desentimentalise her.

When Hitler invaded Poland, Brecht was in Sweden, a nation still exporting iron ore to the Nazis, and promptly wrote *Mother Courage* as a warning that, he said, you need a long spoon to sup with the devil. But no Scandinavian theatre dared touch a play that was also intended to show the contagion and waste of war. Seeking to profit from the endless clash of armies, Courage drags her wagon across a seventeenth-century Europe whose devastation, Brecht feared, would soon be matched in the twentieth century. And in the process all three of her children are killed, leaving Courage old, poor and alone to (George Steiner's words) 'march on like a vulture hobbling after carrion', having learned nothing from her suffering.

The play's premiere occurred in neutral Switzerland in 1941, when Brecht was in California, and, though hugely successful with an audience

of German refugees, left him feeling misrepresented. How could critics call it a 'Niobe tragedy' – a reference to the mythological heroine who lost her fourteen children – which celebrated Courage's 'great mother's heart'? It wasn't about the 'moving endurance of the human animal' or the resilience of the 'little people'. For the Marxist Brecht, it was rather a cool, cutting attempt to show that war, which anyway was 'business continued by other means', contaminated and corrupted all it touched.

That's why his Berlin production was to be a demonstration of his famous 'alienation effect'. Thanks to austere staging, unchanging white light, unstagey acting, visible musicians accompanying some very didactic songs and visible captions introducing scenes, the audience would be encouraged detachedly to consider Brecht's arguments rather than lose themselves in his story. Still less should they identify with a character that, as played by Weigel, was 'hard and angry': a woman who, in a scene rewritten by Brecht, now tried to deny soldiers needing bandages the costly shirts she had herself ripped up in the first version.

It didn't quite work. The rough-theatre staging left East Berlin's Soviet commander so touched by the show he offered Brecht money. The leading communist critic, Max Schroeder, actually called Courage 'a humanist saint from the tribe of Niobe'. And why not? It's now a truism that Brechtian practice contradicts Brechtian theory, and nowhere more so than with a character who has been played in our era by Glenda Jackson, Diana Rigg, Judi Dench, Fiona Shaw and Meryl Streep. At best, actresses have caught the contradictions of a woman who combines self-destructive avarice with strong maternal instincts.

Even Weigel couldn't eradicate the spectators' unreconstructed sympathies. Indeed, it was said that she and the cast became noticeably more emotional when Brecht was absent. And who couldn't be moved by the moment when her Courage, having bargained too long over the bribe that would have freed him, heard the shots killing her younger son? She gave a silent scream, her gaping mouth like the horse in Picasso's Guernica, her posture mimicking a half-remembered photo of an Indian woman crouched over the body of her son.

Or by the death of Kattrin, protecting the children she could never have? 'Possibly the most powerful scene, emotionally, in twentieth-century drama,' wrote the critic Eric Bentley, who had come to Germany to see what became the birth of the Berliner Ensemble. And so, despite Brecht, perhaps it was.

THE DEEP BLUE SEA

Here's a *mea culpa*. Back in 1970 I wrote a review of Terence Rattigan's play about Nelson's self-destructive passion for Emma Hamilton, *A Bequest to the Nation*, declaring that America's avant-garde Open Theater was more arresting, relevant, provocative and even profound than 'the entire oeuvre of Terence Rattigan'. And the fact that it appeared in *The New Statesman* only compounded the stupidity, because the playwright, who always considered himself a man of the liberal-left, had frequently written for the magazine. It was there that he attacked 'the theatre of ideas', though by this he simply meant drama that rated 'things' over people and plot, and there that he introduced the world to Aunt Edna, the supposedly archetypal theatregoer whose middlebrow tastes he felt obliged to remember when writing a play.

How could I have forgotten *Separate Tables*, *The Browning Version* and (above all) *The Deep Blue Sea*, which revivals have shown to be more arresting, provocative, profound and lastingly relevant than America's once avant-garde Open Theater? And how could Kenneth Tynan have led the attacks that all but destroyed Rattigan's reputation after John Osborne's *Look Back in Anger* opened the British drama's doors to a more socially aware drama? After all, the critic had called *The Deep Blue Sea* 'a searing study of the destructive zeal of love', adding words like 'masterly' to what, aside from a misconceived cavil about the denouement, was a pretty powerful encomium.

Tynan described the play's subject as 'the failure of two people to agree on a definition of love'. And, yes, Freddie Page, the airhead airman for whom Hester Collyer has left her judge husband, can't understand why she's so obsessed with him that she attempts to gas herself when he forgets her birthday, only surviving because there isn't enough money in the meter. But Tynan's summary is too abstract, too dispassionate for a play written, not in some imaginative limbo, but derived from a painfully personal event.

In 1949 Kenneth Morgan, a young actor, left the over-possessive Rattigan for another man and, when that relationship failed, gassed himself all too successfully. Rattigan seems to have started work on *The Deep*

Blue Sea while he was still recovering from the shock, and some believe that his first draft involved an affair between Page and a Hector Collyer. But homosexuality was a taboo subject in the 1950s British theatre, and Hector, if he existed, became Hester. Still, the subject remained the same: 'the phenomenon of love is inexplicable in terms of logic,' as Rattigan told Laurence Olivier, who he hoped would play the kindly but unexciting judge.

Olivier refused, but Peggy Ashcroft, who at first dismissed her as a 'silly woman', agreed to play Hester and later called it one of her favourite roles. Certainly, she impressed the critics, as did the then unknown Kenneth More, who impressed nobody at his first audition for the part of Freddie, but, plied with drink by Rattigan, impressed everybody at his second. 'A finely written and superbly acted piece of emotional drama,' wrote Philip Hope-Wallace in *The Manchester Guardian* after a first night in which the play was heard with 'an unmistakable hush', then greeted with cheers.

The Broadway production wasn't such a success, perhaps because of the limitations of Margaret Sullavan's Hester and her intense dislike of the actor who played Freddie, James Hanley. At any rate, even the admirable Brooks Atkinson found the result too understated and talked of an excess of 'craftsmanship'. He and other American reviewers didn't see that Rattigan's overriding theme, which was to surface again in plays from *Bequest to the Nation* to *Cause Célèbre*, was that of *Phèdre*: the power of love to waylay and betray us, its visceral battles with convention, self-interest and reason.

But then nor did we in Britain. That's why my own files contain several courteous but rambling letters, clearly penned late at night at the Jamaican hideaway where loneliness, bitterness, self-hatred and terminal leukemia were combining to drive Rattigan both to drink and to episodes in which he believed T.E. Lawrence was sending him messages of support in Morse code through the waterpipes. In one, he laments his status as 'an old has-been, reactionary, slavering, ex-fashionable, thirties-forties playwright'. In another he confesses to having been terminally damaged by his invention of Aunt Edna: 'I've never been allowed to bury the old bitch, or explain her seriously', though all he had meant was that she was 'something like Shakespeare's groundlings who had to be satisfied as well as Francis Bacon and Walter Raleigh, or his plays would have been for the library'.

Rattigan died in 1977, when his rehabilitation was under way but not yet complete. Perhaps only now do we fully recognize the extraordinary empathy with the obsessed, humiliated, weak, vulnerable and lost of an

emotional outsider who believed that 'the word normal applied to any human being is utterly meaningless', even 'an insult to our maker'. Nothing else matters, he said in 1961, 'nothing at all but to write a play that will be remembered in fifty years time'. Half a century later we're remembering plenty of them – and none more than *The Deep Blue Sea*.

THE CRUCIBLE

Back in 1953 it was hard to believe that *The Crucible* would become Arthur Miller's most frequently revived play. It was received nervously by audiences who saw the parallels between its subject, witch-hunts in 1692 Massachusetts, and the McCarthyite persecutions then scarring America. And since the original production was clearly also a bloodless affair, it's unsurprising it ran for just 197 performances on Broadway, far less long than *Death of a Salesman*, the play that had made Miller a dramatist of whom great things were expected.

Miller had considered writing about the Salem witch-hunts, which had ended in the hanging of nineteen people and two dogs, as a student of American history at university, but thought it too absurd a subject. Fifteen years later his mind was changed by the frantic anti-communism that had given Senator Joe McCarthy and the House Committee on UnAmerican Activities (HUAC) sudden prominence and dangerous power. He himself expected to become another of the many liberals and radicals who were being subpoenaed, quizzed about their past associations with the Red Devil, ordered to name those they'd seen at leftist meetings – and, if they resisted, held in contempt, professionally ruined, even imprisoned.

Anyway, Miller drove to Salem to inspect its archives, stopping en route to see his friend and former director Elia Kazan, who appalled him by saying he planned to 'name names' to HUAC, and then discovering which seventeenth-century citizens had similarly betrayed their fellow-townspeople. *The Crucible* came into being, only to fall victim to Jed Harris, a notoriously bullying director (George Kaufman said that he hoped he'd be cremated and his ashes thrown in Harris's face) who demanded little but rigidity of his cast. 'After ten days of rehearsal with a powerful company, something leaden and dead lay on the stage,' wrote Miller in his autobiography, *Timebends*. 'The whole thing was becoming an absurd exercise not in passion but in discipline.'

By the time it opened on Broadway, Miller felt that a hot play had become so cold it wouldn't move anyone. And though there was plenty of applause he sensed a hostility in the first-night audience, 'an invisible

sheet of ice' as the theme became apparent. Afterwards he was snubbed by several acquaintances as he stood in the foyer and then had to face mixed notices, Walter Kerr seeing the play as gifted but polemical, a 'mechanical parable' much of which was nevertheless 'an accurate reading of our own turbulent age'.

Miller himself redirected, restoring a cut scene in which Abigail Williams, whose vindictive hysteria has set the madness in motion, confronts John Proctor, the farmer whose wife she plots to supplant. And an off-Broadway revival several months later ran for nearly two years. By then McCarthyism was in retreat, though that didn't stop HUAC subpoenaing Miller in 1957, perhaps in hopes of restoring its fortunes with the publicity generated by ('Pinko Playwright Lands Love Goddess' ran one headline) Miller's forthcoming marriage to Marilyn Monroe. He was held in contempt and, until the sentence was overturned on appeal, fully expected to go to jail after declaring that he took responsibility for himself but 'could not use the name of another person and bring trouble on him'.

Those words echo those of Proctor, who goes to the gibbet rather than deceive and destroy, giving *The Crucible* a moral centre it retains today. Yes, the play spoke to an American era when, as Miller later remarked, new sins were invented, conscience became a state concern and betrayal was a civic duty. 'Manifestly ridiculous men paralysed thought itself', he wrote, and attitudes that had merely been unwelcome to orthodox society became 'unholy, morally repulsive, and, if not actually treasonous, then implicitly so'. But, as he also pointed out, *The Crucible* was an 'attack on any kind of fanaticism'. It was even 'a protest against what has happened and is happening in Russia and elsewhere where the communists have thrown their opponents on the witchfires'.

Much later Miller told me, not quite joking, that the staging of *The Crucible* in a nation was a pretty infallible sign of impending upheaval there. He was particularly moved when a writer whose daughter had been murdered by Red Guards, and who had herself spent six years in solitary confinement, saw a Shanghai production in 1980 and told him she couldn't believe a non-Chinese wrote the play. A tragedy about panic in an oppressively conformist village three centuries ago, and an ordinary man's struggle to sustain his integrity in the teeth of institutionalised terror, seems as timeless as any in the modern era.

WAITING FOR GODOT

You'd never have guessed from the English-speaking premiere of Beckett's *Godot* that a National Theatre poll would one day pronounce it the twentieth century's most important play. Peter Bull, a gloriously pompous Pozzo, wrote that there were waves of hostility in the stalls, followed by a mass exodus 'which started quite soon after the curtain had risen'. There was ironic laughter at the line 'I've been better entertained' and audible groaning at 'it's not over'. Very few people came round to congratulate Bull and his fellow-actors afterwards, 'and most of those were in a high state of intoxication and made even less sense than the play'.

Peter Hall, who directed, remembered 'yawns, mock snores and some barracking' from an audience which threatened to erupt in rage but 'settled instead into still, glum boredom' and then an unhappy encounter with his new agent. This usually smooth gentleman was 'puce with rage' and spluttered 'you've done it now', adding that just when he, Hall, was on the brink of international fame 'you go and do an awful thing like this'.

The play Beckett had written 'to get away from all the awful prose I was writing at the time' had started uncertainly in the Paris of 1953, but had become a *succès de scandale* and a *succès d'estime*, generating performances all over mainland Europe. However, progress had been slow and omens poor in a Britain then theatrically far behind the times. There had been arguments with the Lord Chamberlain, who demanded cuts that Beckett found 'preposterous', though the censor relented when the dramatist refused to cut the anti-climactic climax in which the tramp Estragon's trousers fall down, insisting only that his penis was 'well covered'.

The roles of Estragon and Vladimir, who wait endlessly for an all-powerful Godot but only encounter the bullying grandee Pozzo and his slave Lucky, had been rejected by leading actors, including an initially keen Alec Guinness and Ralph Richardson, who was greatly disappointed by Beckett's answer to his main query: if Godot was God, the dramatist told him, he'd have said so. The actors who finally played those characters – Paul Daneman and Peter Woodthorpe – worked hard but reportedly wondered if it wasn't all a con job. And although Hall remained passionate about a

play that rehearsals revealed to contain 'much comedy and a harsh seam of terror', he recognised it was 'a huge gamble' for the tiny theatre he hoped to turn into the pacemaker in the West End's ailing heart.

And he succeeded, despite next-day notices he recalled as 'dreadful', the headline in the *Daily Mail* announcing 'The Left Bank Can Keep It' and the *Evening Standard* opining that *Godot* was 'another of those plays that tries to lift superficiality to significance through obscurity'. Yet *The Times* called the play original, witty, brilliantly performed, and saw that 'the significance is that nothing finally is significant'. And the following Sunday Kenneth Tynan and Harold Hobson came to the rescue, the former pronouncing himself a 'godotista' and the latter praising the 'tremendous' if philosophically questionable way in which Beckett identified his tramps with a humanity that 'dawdles and drivels its life away, postponing action, eschewing enjoyment, waiting only for some far-off divine event, the millennium, the Day of Judgement'.

There was an even tougher birth for *Godot* in America. There, the play was performed in Miami to audiences whose expectations had been formed by publicity calling it 'the laugh hit of two continents' and the casting of the comedian Bert Lahr as Estragon. It was said that taxis always waited en masse when the interval came at the Coconut Grove Playhouse, as most spectators were sure to leave. Yet the Broadway production that followed, still with Lahr as Estragon, was a surprising and substantial success.

Likewise when the London production, now seen as interestingly controversial, transferred to the West End. Despite the famous moment when Bull defused a raging heckler by saying 'I think it's Godot', the play flourished and has continued to do so. Myself, I've seen it a dozen times, with Vladimirs varying from Peter O'Toole to Patrick Stewart to Steve Martin and Estragons from Robin Williams to Ken Campbell to Ian McKellen, who has played the role more times than any other in his long career.

I've seen the casting of African or Middle Eastern actors give Beckett's text political resonance. I've seen John Kani and Winston Ntshona confront an Afrikaaner Pozzo, suggesting that a play which still evoked Everyman's hopeless hopes was also about apartheid South Africa, and I've seen Roger Rees and McKellen in post-apartheid Cape Town, performing to a township audience that seemed to identify with the impoverished protagonists. The play Beckett wrote as a 'relaxation' is clearly an enduring stimulus.

LOOK BACK
IN ANGER

ROYAL COURT, LONDON, MAY 8 1956

The first reviews of the play that was to change a moribund British theatre for the better, or at least for the more passionately concerned with real people in the real world, were by no means as bad as legend claims. Yes, the *Evening Standard* called it a 'self-pitying snivel' and *The Times* weirdly decided that 'its total gesture is altogether inadequate'. Yet some of the most patronising critics of Tony Richardson's production of *Look Back in Anger* still spotted the frustrations of post-war youth in the scorching rhetoric of John Osborne's Jimmy Porter, a protagonist who was doing no more with his university education than run a sweet stall in a Midlands town and rail against a British establishment represented by a wife from a more privileged background than himself.

They also saw serious promise in a twenty-six-year-old writer who disclaimed precise identity with Porter, calling the character's voice that of 'ordinary despair', yet clearly had much in common with him. After all, Osborne was nearing the end of the first of his five marriages, was living in poverty on a houseboat on the Thames, was taking the odd job as an actor, and had seen two of his plays staged without much success in the regions, one at Huddersfield, one at Harrogate. He was not a very happy man.

Anyway, *The Guardian* thought Porter a 'spoiled and neurotic bore', but felt there was 'tension, feeling and originality of theme and speech' in the play. *The Daily Telegraph* found it 'intense, angry, feverish, undisciplined and even crazy', but 'young, young, young'. The *Daily Mail* thought that the Royal Court had discovered 'a dramatist of outstanding promise, a man who can write with a searing passion', adding somewhat condescendingly that 'we can see what a brilliant play this young man will write when he lets a little sunshine into his soul'. Even the *Standard* acknowledged that 'underneath the rasping negative whine' Osborne displayed 'a dazzling aptitude for provoking and stimulating dialogue' and could 'draw character with firm convincing strokes'.

Still, it took Kenneth Tynan's formidably positive, wonderfully lucid review in *The Observer* the following Sunday to transform the fortunes of a piece that had been speedily rejected by every agent and producer ('like being grasped on the upper arm by a testy policeman and told to move on,' wrote Osborne) before it was accepted by the newly formed English Stage Company. Not that the company expected success. George Devine, its moving force, decided that *Anger* 'is the play we must do, even if it sinks the enterprise'. Richardson, weary of reading 'endless blank verse shit' from aspiring dramatists, told Osborne that it was the best play written since the war but also that a theatrical dame had said it should be thrown in the Thames and washed out to sea. Indeed, that maverick director seemed positively to welcome the prospect of the original Angry Young Man, as the ESC's press officer dubbed Osborne, alienating audiences, critics and elderly actresses by throwing kitchen sinks and verbal vitriol in their bourgeois faces.

Well, the sun never entered Osborne's grouchy soul. He remained alienated from each and every aspect of the status quo right up to *Déjàvu* in 1992, a play in which an aging Jimmy Porter rails blimpishly against everyone from trendy vicars to anti-smokers. But though Osborne himself called *Anger* 'a formal, rather old-fashioned play' – after all, Jimmy alienates his wife and then jumps into bed with her best friend, creating a plot involving the hoary subjects of misalliance and the eternal triangle – it is regularly revived, with actors of the calibre of Kenneth Branagh, David Tennant and Michael Sheen in the lead role.

'I doubt if I could love anyone who did not wish to see *Look Back in Anger*,' wrote Tynan, welcoming a character who was cruel yet tender, gloriously articulate yet incapable of action, and deeply dismayed by an England dominated by the likes of his brother-in-law, the bowler-hatted 'platitude from outer space'. The play was, Tynan conceded, likely to remain a minority taste; but the size of the minority, he added, was roughly 6,733,000, the number of citizens between twenty and thirty. Surely they and refugees from other age-groups would wish to see a play that at long last 'presented post-war youth as it really is'.

Well, Tom Stoppard, then nineteen years old and a would-be novelist, has said that it was the excitement generated by *Look Back in Anger* that made him think of writing plays. John Arden, an aspiring dramatist of twenty-five, felt it supplied 'passion and contemporary relevance at a time when their absence was barely noticed'. Let's not overstate the case, as

some did at the time. Was Jimmy Porter, as Tynan claimed, the 'completest young pup in our literature since Hamlet prince of Denmark'? No, but his fierce contradictions spoke to 1956 – and speak to us still.

THE QUARE FELLOW

THEATRE ROYAL STRATFORD EAST, LONDON, MAY 24 1956

Brendan Behan claimed to have chatted with a murderer on the day before his hanging in Dublin's Montjoy Prison, where the IRA member and dramatist-to-be was serving time for trying to shoot two policemen. It was 1943 and Bernard Kirwan, a pork butcher who had killed, filleted and (joked Behan) fed his younger brother to Jesuits, impressed everyone with his calmness before he was led to his death through the red metal door at the bottom of D Wing. 'Tomorrow, at ten past eight, I'll be praying for you in Heaven,' he told Behan, then a twenty-year-old who had already served time in an English borstal after being caught with bombing equipment in Liverpool.

The result of that experience was a play in which the 'quare fellow', as the Irish inmates call a man also condemned for dismembering his brother, is never seen. Instead, life in the prison gets more tense, and chatter about the impending hanging more frantic, up to the point when the fateful walk to the gallows is breezily described by a prisoner parodying a commentary on a horse-race. Though he filled his play with humorous observation, though only a compassionate warder who has seen too much of 'neck-breaking and throttling' openly expresses his feelings, you never doubt Behan's dismay at the capital punishment then prevalent in both Britain and Ireland. *The Quare Fellow* is a 'comedy-drama' which eschews the didacticism or twisting of evidence that would have allowed supporters of the death penalty to accuse Behan of special pleading.

Coming from a man brought up in working-class Dublin to be a housepainter and republican activist, it's a remarkably sophisticated piece, and Behan was acclaimed as potentially 'another and, I think, greater O'Casey' by one of several admiring reviewers when *The Quare Fellow* was staged by Dublin's little Pike Theatre in 1954. The author himself had behaved in what was to become a familiar way, bringing drinking chums into rehearsals, chortling at his own gags, shouting encouragement at the actors and going onstage to sing to the first-night audience. However, his only seriously bad behaviour came when he went behind the backs of the

theatre's supportive directors to wangle the production of *The Quare Fellow* that won him international renown.

Joan Littlewood, whose Theatre Workshop was becoming famous for the lively, unconventional work it was staging in east London, received what she called 'a tattered bundle' of mistyped pages, covered with beer stains, that she quickly recognised as a play by 'a great entertainer'. Twice she sent Behan the money to come to Stratford East. Twice he drank it. But the third time he appeared in the theatre bar, a 'good-looking Irishman, with a coxcomb of black wavy hair, a Roman nose, a few teeth missing, and a pronounced stutter'. According to Littlewood, he readily agreed to cuts and trimming and, accompanied by republican friends who (she later wrote) amounted to 'three hundred years of prison sentences', was there on the first night, noisily applauding a cast that included Richard Harris and the dramatist Henry Livings.

The reviewers were mostly ecstatic, Kenneth Tynan calling the play 'tremendous – a tragedy concealed beneath layer after layer of rough comedy'. Transfer to the West End duly occurred, but not before a spectacularly drunken television interview with Malcolm Muggeridge had made Behan famous. He demolished a bottle of whisky in the hospitality room, sent a flock of debutantes about to talk about finishing schools running away in terror by shouting 'I'd like to fuck the lot of you', told two generals discussing bomb disposal that 'I've planted more bombs than you've had hot dinners, you pox bottles', and was so incoherent on air that Muggeridge had to answer his own questions.

Behan's legendary drinking bouts – he was once brought back to Stratford by policemen who had found him hazily trying to steer the Woolwich Ferry – led to his death in 1964, after his *Hostage* had given him a second substantial success but before he had revised his hilarious *Richard's Cork Leg*. However, *The Quare Fellow* best shows his infectious humanity. A man is hanged and anonymously buried under a headstone with the wrong number on it. These events distress and disturb everyone, yet still the warders talk about promotion, the young convicts about women, the old lags about food and drink. Still two ancient alcoholics play practical jokes and outwit the guards by, for instance, surreptitiously swigging the spirits meant for a faked bad leg. Life goes on – and Behan was always ready to celebrate it.

LONG DAY'S JOURNEY INTO NIGHT

HELEN HAYES THEATRE, NEW YORK, NOVEMBER 7 1956

Eugene O'Neill called that day in August 1912 'long' and didn't exaggerate. Over breakfast the Tyrone family is in a relatively cheerful mood despite a worrying appointment the younger son, Edmund, has made with his doctor. By midnight his 'summer cold' has been diagnosed as TB, his mother Mary is in a morphine-induced trance, his elder brother Jamie is half-crazed with bitterness and whisky, and his father, a retired actor called James, is looking as if his Connecticut summer house has fallen onto his head. The day seems to have lasted a lifetime.

And so, for O'Neill, it more or less had. After all, Edmund was himself and the others were the immediate family he'd renamed in ironic tribute to those O'Neills who had been the warrior kings of County Tyrone. And within those sixteen hours Eugene crammed all that had been most traumatic in his life and seminal in an oeuvre that had dealt obsessively with similarly troubled relationships. Dedicating *Long Day's Journey* to his wife Carlotta, he wrote that he was at last facing his dead with 'this play of old sorrow, written in blood and tears'.

The idea for an autobiographical play, which had struck him in the 1920s, hardened in 1939. He would talk about it all night to Carlotta, saying he must get it out of his system, must understand the 'hell' that had engulfed his parents and brother, must forgive them. But he didn't start it until 1940, a time when his usual depression was combining with events in Europe which convinced him that only pessimists were not 'morons' and only 'blithering idiots' could desire to live very long. Feeling that it was 'hard to take the theatre seriously' as the war worsened, he stopped writing for two months after finishing the first act, then wearily resumed a task that caused him another kind of pain. According to Carlotta, he would emerge from his study gaunt, red-eyed and looking ten years older than when he entered it.

But what to do with the play? After all, it showed his father to be a miser, his brother a self-hating idler, cynic, drunk and whoremonger, and his mother a monstrous martyr who relentlessly offloaded her guilt for her addiction onto everyone else, meaning her husband, the eldest son who supposedly murdered her second son by fatally infecting him with measles, and the youngest son and dramatist-to-be whose painful birth hooked her on drugs. O'Neill declared that it must never be performed and shouldn't be published until twenty-five years after his death, which occurred in 1953. However, Carlotta, who was his literary executor, argued that he had meant otherwise and sanctioned a production in Stockholm in early 1956 that left the audience applauding for almost thirty minutes.

Next came a Broadway opening that won O'Neill a posthumous Tony Award and Pulitzer Prize as well as almost universal praise, Brooks Atkinson declaring that the play had given the American theatre 'size and stature', Walter Kerr calling it a 'stunning theatrical experience', others using hurrah words like 'harrowing', 'shattering', 'heart-breaking' and 'emotional dynamite'. It fared less well in Britain in 1958, with most reviewers finding its four hours a slog, but better when Laurence Olivier played old Tyrone in a 1971 revival, though visiting American critics thought his performance too external.

Two Broadway revivals in particular have shown the power of a play in which the always restless O'Neill renounced his customary theatrical experimentation for an unsparing realism as he sought to comprehend the terrifying hold of the past over the present. In 1988 Jason Robards – who had played Jamie in the original production and the same dark, doomed but more sympathetically conceived character in the semi-biographical sequel that O'Neill called *A Moon for the Misbegotten* – gave a stirring performance as Tyrone. And in 2003 Vanessa Redgrave was as good as I've seen her as Mary.

'The Mad Scene, enter Ophelia,' sneered Philip Seymour Hoffman's Jamie as Redgrave drifted onstage, trailing her old wedding gown and launching into the long reverie that ends both the play and the scene O'Neill thought the best he'd ever written; and, yes, this was an aged, ashen, ghostly Ophelia haunting her own past. That episode had a weird serenity and others proved still more disturbing. Redgrave variously twitched, gaped emptily, yelled, twisted, flinched, impotently pummeled her disappointing husband, obsessively jabbered, gave phony laughs, wailed, glazed over, and stared in stark, silent horror into her private abyss. She acted with mind,

heart, voice, body, face and, forlornly practicing on an invisible piano with hands half-turned to claws by rheumatism, her very fingers. Doing so, she caught Mary's terrible self-absorption and rancorous regret but also her thwarted tenderness and baffled love.

A great performance in America's greatest dramatist's greatest play? I felt so.

THE BIRTHDAY PARTY

The author himself later described it as 'the most universally detested play London had known for a very long time' and admitted that, but for a favourable notice that came too late to save its first London production, he might have abandoned the theatre. 'You poor chap,' said an usherette when he came to its only Thursday matinee, directing him to a dress circle the management had closed. From there he looked down on an audience that numbered six and had paid a total of just over £2. The play closed two days later, having run one week.

That author was Harold Pinter, who would become a Nobel Prize winner but was then a twenty-eight-year-old actor with a wife and baby to support and virtually nothing in the bank. And that play, his first apart from the one-act *The Room*, was *The Birthday Party*. It had been well received on its short regional tour. Its producer, Michael Codron, had high expectations of it in London and, as he later said, couldn't understand the critics' complaint. Was it really off-puttingly 'obscure'?

The germ for the play had come in 1954 when, looking for digs in Eastbourne, Pinter had been taken by a man he'd met in a pub next to his lodgings. As he wrote to a friend at the time, 'I have filthy insane digs, a great bulging scrag of a woman with breasts rolling at her belly, an obscene household, cats, dogs, tea-strainers, mess, talk chat rubbish shit scratch dung poison, infantility, deficient order in the upper fretwork'. The 'scrag' was the landlady, a woman who kept lubriciously fondling Pinter's new acquaintance, a jobbing pianist who struck him as lonely and odd – and she was the model for Meg in *The Birthday Party*, as the pianist was for that odd loner, Stanley Webber.

Stanley is idling away his days in Meg's seaside lodgings when two strangers, the originals of the many demanding intruders who haunt Pinter's plays, arrive from nowhere. Together, Goldberg and McCann accuse Stanley of scores of improbable sins, reduce him to a speechless wreck, then spruce him up in bowler hat and striped trousers and drive him to an unnamed destination. As they go, Meg's passive, put-upon husband,

Petey, delivers a line Pinter said was one of the most important he'd written: 'Stan, don't let them tell you what to do.'

That was a clue to Pinter's drift. As he also said, he was thinking of the Gestapo and the false security of its prey when he wrote the play. And in a letter he told its original director, Peter Wood, that 'the hierarchy, the Establishment, the arbiters, the socio-religious monsters arrive to effect alteration and censure upon a member of the club who has discarded responsibility', so that their victim 'collapses under the weight of their accusation'. Stanley is a dissenter and a rebel, as Pinter himself was to become a prominent rebel and famous dissenter, but he isn't strong enough to resist the Jew and the Irishman who are themselves the uneasy representatives and victims of an organisation that seems to combine their and others' political, religious and cultural traditions.

Not that the daily reviewers saw this. *The Times* admitted to having abandoned Pinter's puzzles 'in despair'. *The Guardian* thought that the characters spoke in 'non sequiturs, half-gibberish and lunatics ravings', *The Telegraph* that Petey could have been a still more unhappy man: 'he might have been a dramatic critic, condemned to sit through plays like this.' But the morning after *The Birthday Party* closed came a truly remarkable notice.

While *The Observer's* Tynan dismissed the play as a frivolous treatment of the stale idea that 'society enslaves the individual', *The Sunday Times's* Hobson declared that its author 'possesses the most original, disturbing and arresting talent in theatrical London'. The subject was the subtlest but most terrifying of threats, one 'that cannot be seen but enters the room every time the door is opened. There is something in your past – it does not matter what – which will catch up with you'. Hide as you may, two men will be looking for you, you can't get away – 'and someone will be looking for them too.'

Hobson's emphasis was personal rather than political, but still gets close to the heart not only of a play open to several interpretations but of Pinter himself. *The Birthday Party* communicates an insecurity the more unsettling for being unclear. One slip, one push, and who knows what horrors may not overwhelm you? So be vigilant, be wary: of people, organisations, systems, governments that never quite say what they mean or mean what they say – and rebuff their attempts to invade your territory, your mind, your very spirit.

A RAISIN IN THE SUN

ETHEL BARRYMORE THEATRE, NEW YORK, MARCH 11 1959

Nobody had much hope for Lorraine Hansberry's *A Raisin in the Sun* when it opened on Broadway. It had been difficult raising enough money to stage a first play by a twenty-eight-year-old African-American woman, especially as its subjects were the dreams and tribulations of a humble black family. A pre-Broadway tour had gone well enough, but there was an ominous racism in some reviews. Hansberry herself was reduced to a mixture of laughter and tears by a Connecticut critic who was pleased that 'our dusky brethren' could 'come up with a song and hum their troubles away' – this, though nothing of the sort occurs in the play – and wasn't delighted by the Boston reviewer who appreciated characters 'endowed with that lighthearted humour which seems to be inherent to their race'.

But New York brought triumph. It wasn't just that respected critics appreciated a play which has its humorous moments but is far from lighthearted, Brooks Atkinson praising a dramatist who 'has told the inner as well as the outer truth of a Negro family in the Southside of Chicago' and Harold Clurman calling *Raisin* 'an honestly felt response to a situation that has been lived through, clearly understood and simply and impressively stated'. Hansberry won the critics' best-play award, the youngest American dramatist and only African-American then to have done so. And *Raisin* ran for 530 performances, became a film in which Sidney Poitier repeated the leading role he took onstage, and brought new audiences to what was all too accurately called the Great White Way.

'Never had I seen so many black people in the theatre,' James Baldwin wrote in a eulogy of 'sweet Lorraine' after her death from cancer in 1965. 'Never had so much of the truth of black people's lives been seen on the stage.' It was, he declared, 'an historical achievement'.

Hansberry did indeed understand the predicament of the Youngers, whose matriarch gets $10,000 insurance money and, defying the representative of the New Neighbours Orientation Committee who tries to expel them, relocates her family in an all-white Chicago suburb. Her

own father, a real-estate broker, had made just that move. She remembered going as a child to 'a horribly hostile white neighbourhood in which literally howling mobs surrounded our house'. Her mother kept a pistol loaded, and Lorraine herself was spat at, cursed and pummeled on her way to the public school to which her parents, who had strong political convictions, had insisting on sending her. The Hansberrys eventually left the enclave, though not without continuing a legal struggle that ended in the US Supreme Court.

Lorraine shared her parents' convictions. She worked for Paul Robeson's journal *Freedom*, married a radical Jewish artist, and became politically active during the battle for desegregation. She wrote *Raisin* after seeing an unnamed play: 'I suddenly became disgusted with a whole body of material about Negroes. Cardboard characters. Cute dialect bits. Or hip-swinging musicals from exotic sources.' After *Raisin*'s success, the FBI investigated her as a security risk, but concluded that her play was 'not propagandist', as indeed it isn't.

True, Mama ends up braving white hostility, but she's a God-fearing, non-political soul who slaps her daughter when she professes atheism and dedicates herself wholly to what she sees as her family's good. True, that daughter is a precursor of the Black Pride movement and falls for an equally principled and intelligent African – Alex Haley said he 'helped dispel the myth of the cannibal with a bone in his nose' – but her brother is as flawed as any character in August Wilson's great series of black-history plays. His mother entrusts most of the money to him, expecting him to open the liquor store he wants and pay for his sister's training as a doctor, but he loses the lot to a dodgy 'friend'.

In 1959 the debate was whether *Raisin* was a topical play for a mainly black constituency or whether it was 'universal'. Asked by an interviewer if it could be 'about anybody, a play about people', Hansberry wryly replied that she hadn't noticed the contradiction: 'I'd always been under the impression that Negroes *are* people.' The title, which is taken from the Harlem poet Langston Hughes, reinforces her point: 'What happens to a dream deferred? Does it dry up like a raisin in the sun? Or fester like a sore and then run?' The play is about the lure of wishfulness and the dangers of frustration, as is Arthur Miller's *Death of a Salesman*, which Hansberry acknowledged as an influence.

But it also had and retains social punch. In 2009 Bruce Norris set his *Clybourne Park* in the same house the Youngers bought, using the same

names for his characters and raising the same questions about tribal prejudices. A man raised in a similar area, 'only more virulent in its racism', Norris was consciously celebrating the half-centenary of the play that, he said, had introduced him to American drama. 'I always loved it,' he added. So do the many thousands who now study it or see it revived in the theatre.

BEYOND THE FRINGE

It was the start of the Satire Boom: meaning the magazine *Private Eye*, David Frost and *That Was The Week That Was* on television, a maverick nightclub that was mischievously called the Establishment and would soon bring Lenny Bruce to London, and an England 'sinking into the sea under the weight of its own giggling'. That's a quote from Peter Cook, who was involved with most of those enterprises, but first and crucially was one of the four writers and performers in a show originally staged by an Edinburgh Festival keen to match an Edinburgh Fringe which was regularly importing comic work from Cambridge's Footlights Revue.

It wasn't a wholly promising enterprise. When the prospective revue's four graduates – two from Oxford, two from Cambridge – met in a tacky London restaurant they 'instantly disliked each other', or so Jonathan Miller was to recall. And since he was a junior doctor, Alan Bennett a medieval historian, Dudley Moore a professional jazz pianist, and only Cook an aspiring comedian, they were clearly very different beings. And as a pointed number in the revue was to show, the confident Cook and Miller came from privileged, public-school backgrounds and were to work ('a most worthwhile, enjoyable and stimulating experience') with the shy Bennett, whose father was a Leeds butcher, and the socially awkward Moore, son of a Dagenham electrician. But they had all shone in Oxbridge 'smokers' and all were keen to earn a few shillings in a revue so sparely staged it cost just £100.

After a slow start, with the Lyceum Theatre one-third filled, Edinburgh proved a success, but the tour that unexpectedly followed was less so. At Brighton audiences flounced out, angered by sketches whose targets included The Few and other war legends: 'I want you to lay down your life, Perkins,' declared squadron leader Cook. 'We need a futile gesture at this stage. It will raise the whole tone of the war. Get up in a crate, over to Bremen, take a shufti, don't come back. Goodbye, Perkins. God, I wish I was going too.' 'Goodbye, sir,' replied pilot Miller, 'or perhaps it's *au revoir*?' 'No, Perkins.'

Then again, a London impresario wanted to sack 'the one in the spectacles', meaning Bennett. However, his sly mockery of a dim vicar ('Life, it's rather like opening a tin of sardines, we're all looking for the key') was one of the numbers that, along with parodies of Shakespeare ('Get thee to Gloucester, Essex, thee to Wessex, Exeter') and the trendier sort of Anglican cleric ('it's my aim to get violence off the streets and back into the churches where it belongs') brought the increasingly famous four a long West End run – and, with the addition of a sketch in which a one-legged actor auditions for the role of Tarzan, triumph on Broadway.

By today's standards the satire seems tame. These were less Angry Young Men than Sophisticated Young Sceptics. However, the revue's mockery of civil defence and its blimpish proponents ('the first golden rule of hydrogen warfare is to be out of the area where the attack is about to occur') had an anti-establishment bite. And Cook's parody of Harold Macmillan had enough clout for the then Prime Minister to order MI5 to investigate the comedian, discovering he had a drinking problem but not much else. Though he had left the Fortune Theatre proclaiming himself amused, Macmillan was deeply angered not only by the suggestion that he was a bumbling old buffer but by Cook's insulting improvisations on the night: 'When I've a spare evening there's nothing I like better than to wander over to a theatre and listen to a group of urgent, vibrant young satirists with a stupid great grin spread all over my silly old face.'

Still, Macmillan felt he had to see the show, which wasn't the case with Benjamin Britten, who was outraged to hear that Moore's parodies included 'Little Miss Muffet' set to music by himself. The Queen went too, as did the then American president and Mrs Kennedy. 'The funniest revue since the Allies dropped the bomb on Hiroshima' was Kenneth Tynan's oddly worded encomium. Myself, I'd call it the funniest ever.

KING LEAR

ROYAL SHAKESPEARE THEATRE, STRATFORD,
NOVEMBER 6 1962

Unfashionably, I regard Paul Scofield as the greatest actor of my lifetime, insufficiently acknowledged because he was a modest, reclusive man who refused both a knighthood and a Hollywood career. Darryl Zanuck, no less, expostulated 'that actor! The best since John Barrymore'; but that didn't stop Scofield explaining to disbelieving producers that he couldn't star in a major film because 'I've got to housetrain the dog'.

Beside him John Gielgud lacked physical energy and a sense of danger, Laurence Olivier was wanting in soul and Ralph Richardson hadn't the versatility of a performer who could succeed as a deeply wounded Hamlet and an Andrew Aguecheek that one critic called 'a knight made of pink blancmange', an embittered, brooding Salieri in Peter Shaffer's *Amadeus*, a gay barber in Charles Dyer's *Staircase*, a wry, wise Thomas More in *A Man for All Seasons* – and the title-character in Peter Brook's production of *King Lear* for the Royal Shakespeare Company.

Brook first met Scofield in 1945 and later recalled looking 'into a face that unaccountably in a young man was streaked and mottled like an old rock' and of being instantly aware that 'something very deep lay hidden beneath his ageless appearance'. And, yes, to see that fissured, craggy face, and hear that gravelly voice echoing up as if from a dark crypt, was always to know he was different and special. But with those physical qualities went a rare determination to think, feel and battle to a character's core, and never more than when, aged thirty-nine, he tackled Shakespeare's most harrowing tragedy for the RSC.

According to Charles Marowitz, Brook's assistant director on *Lear*, Scofield initially growled his way through the play's verbal and emotional thickets, testing and retesting scansion and stress, 'like a hound chasing an elusive hare through densely wooded terrain'. But by the dress rehearsal he was so powerfully in character that, angered by a camera whose clicks were accompanying his blood-curdling denunciation of Goneril, he threw his hunting cloak at the photographer and snarled 'please get that thing away

from here' in Lear's voice, leaving one stunned spectator to remark 'it was so exciting, I felt like saying, keep it in'.

Brook's view was that Lear was 'not feeble but a strong old man, obstinate, powerful and often wrong'. That explains why many critics found Scofield's interpretation revolutionary, with the king observed not with conventional sympathy but from a stance of moral neutrality. As an enthralled Tynan wrote, gone was 'the booming, righteously indignant Titan' of theatrical tradition. Gone was 'the majestic ancient, wronged and maddened by his vicious daughters'. Here was 'an edgy, capricious old man, intensely difficult to live with' who deserved much of what he suffered.

Scofield's grizzled, savage, utterly unsentimental Lear raged and bullied, turning 'I shall go mad' into a threat and 'blow winds!' into an aria of vindictive fury, only to end up discovering the humanity he'd always despised. His reconciliation scene with Diana Rigg's Cordelia, the child he'd callously rejected, was apologetic, halting, painfully poignant. And this was the more moving because Brook's primaeval England was rather like the world of Beckett's *Endgame*: cruel, deathly, seemingly absurd and meaningless.

Not everyone admired Scofield's performance. Laurence Olivier called him 'Mr Lear', saying he had robbed the King of his glamour and made him 'down to earth'. But jealousy may have played its part in that judgement, for Olivier hadn't only tried and failed to persuade Scofield to join his National Theatre rather than the RSC: he himself had had only modest success in the role fifteen years earlier.

Moreover, Olivier was quarrelling with the production and performance's raison d'être. Irene Worth, who played Goneril, remembered how Scofield's 'eyes always spoke more than his words and how our fury and hurt against each other was fierce'. Yet when she observed the very human pain he brought to the closing scenes, especially to his encounter with Alan Webb's blinded Gloucester, she had to go off into a corner because she was weeping so much. 'And when Cordelia died Paul's howl was so truly a howl I marvel how he could create it time after time,' she said. 'But a man with great talent makes these miracles.'

OTHELLO

OLD VIC, LONDON, APRIL 21 1964

That great Irish thespian Ray McAnally once told me that Laurence Olivier wasn't an actor, just 'a performer'. And I remember watching a television programme that tried to debunk Olivier's posthumous reputation, at one particularly annoying point showing sixth-formers chortling in disbelief as they watched the film of the most famous of his later roles, Othello. What a ham! – or so they clearly thought.

In each case the sceptics missed the point. True, Olivier didn't accept McAnally's credo, which was that an actor must enter a character's inner self as truly and deeply as possible. True, his Othello did seem artificial as he roared into action in a film that, in my view, was simply an unsatisfactory *aide mémoire* for a major piece of stage acting or theatre performance. For who could command a live audience as powerfully and at times mesmerically as Olivier?

Were the reviewers of his Othello intimidated by his pre-eminence? After all, Olivier was the recently formed National Theatre's first artistic director and the leader of the British theatre as a whole. No, the critics recorded what they saw and said what they felt. 'Sensational,' wrote Harold Hobson of a performance whose power, passion, verisimilitude and pathos 'will be spoken of with wonder for a long time to come'. *The Daily Express's* Herbert Kretzmer thought Olivier's Othello was 'full of grace, terror and insolence', adding that he would 'dream of its mysteries for years to come'. And for *The Guardian's* Philip Hope-Wallace this was 'great acting', 'an experience *in the theatre* (my emphasis) altogether unforgettable by anyone who saw it'.

It was a role Olivier had long avoided, thinking it 'a monstrous, monstrous burden' that was 'pretty well unplayable', especially now he was fifty-seven and busy running the new National. But ambition and determination changed his mind. He worked hard at the gym and, believing Othello needed what he called 'a dark, black, violent, velvet bass voice', toiled to lower his natural baritone by an octave. He also decided that the Moor was not an Arab but very much an African, 'a soft black

leopard', and each night he spent over two hours staining and greasing his entire body from the feet upwards.

Logically enough, he saw Othello as a black man who had triumphed in a white world, adopted the white religion, married into the white elite and, as a result, become over-confident, even conceited. At any rate, he sauntered onstage, loose-limbed and lazily swaying, fondling the cross round his neck, laughing and smelling a rose with which he brushed the cheek of Frank Finlay's redneck Iago. There was narcissism here, a complacency that was punctured to particularly telling effect. For one thing, this Othello was fiercely in love with Maggie Smith's Desdemona. For another, Olivier was not the man to duck climaxes that, he felt, 'begged you to scream to the utmost'.

Emotionally poisoned, his Othello went physically to pieces, ripping the cross from his neck, wailing out his atavistic rage and despair, thrusting his forehead to the ground and making his 'sacred vow' to what were presumably the tribal gods he had rejected. There was animal feeling here but also a new dignity and a strange tenderness when the time for murder came. And the effect was such that John Dexter's production became its era's biggest box office draw, with touts reduced to charging £5 for replacing would-be spectators in the long queues.

Each performance left Olivier feeling the next day 'as if I'd been run over by a bus'. Likewise with the spectators, some of whom did think, with *The Sunday Telegraph*'s Alan Brien, that the performance was perversely over-the-top, 'a kind of bad acting of which only a great actor is capable'. And it remains special for another reason. Though Othello was played in the 1980s and 1990s by Michael Gambon, the half-Asian Ben Kingsley, and Patrick Stewart in a Washington production in which he was white and everyone else black, it's now generally accepted that it's a role for black actors only.

Perhaps that's a pity and not wholly logical, since Shakespeare calls Othello a 'Moor' and major white actors, from Burbage to Kean to Forrest, have clearly regarded the role as a natural challenge. Yet 'blackface' makes most nowadays feel uneasy and some revolted. And there are fine black actors who are still too often denied roles that would stretch their talents. James Earl Jones in America and Chiwetel Ejiofor in Britain have proved more than equal to the role Olivier called 'enormously big'. More will surely follow.

THE HOMECOMING

First there was a clatter of seats as members of the audience flounced out. Then there was an aghast twittering in the bar as people ordered and ingested what were probably stronger interval drinks than usual. Then I retired to a nearby hotel lounge to dash off a review for my then employers at *The Guardian*. And all around me were people who had also been in Cardiff's New Theatre and were interrupting my own confused thoughts with yelps of 'Bloody disgusting', 'What did it mean?' and 'Why couldn't they have put on *Hamlet* instead?'.

The company was the RSC, the director Peter Hall, and the occasion the world premiere of the play that established Harold Pinter as a major dramatist and he himself came to think his best: *The Homecoming*. And, yes, the Welsh capital was a peculiar place to choose for the pre-London opening of so disturbingly original a piece. It was also a daunting play for a young critic to assess in some forty minutes, especially when notices had to be phoned to notoriously erratic copytakers in Manchester and hastily shoved into the next morning's pages by not always sober sub-editors.

They had once managed to rename Shylock 'Skylark'. More happily, President Eisenhower had become President Eisenhowever. But until *The Homecoming* my own worst experience was to discover that the title of the adaptation of Lloyd C. Douglas's biblical epic *The Robe* I had reviewed in Oldham was actually *The Lobe,* someone presumably thinking of the moment Peter cuts off a priestly servant's ear. So perhaps I shouldn't have been surprised and upset when the first words of my notice of *The Homecoming*, which were 'Harold Pinter's constant message is that greed and violence lurk in everyday places', had become 'How old Pinter's constant message is...'. But I was, very.

I still think that I was right in my enthusiasm but also that Pinter's audience was possibly right to blink, shudder, expostulate and even exit. I don't know how many Welsh chapelgoers were at the premiere, but if they needed confirmation that Cockneys were godless savages, the *enfant terrible* Pinter, child of the East End, had certainly provided it. There was something primal about his tale of the once-powerful London butcher,

his enfeebled brother and his sons, one a would-be boxer, the other a pimp, all of them more at ease with their violent and presumably criminal environment than with each other.

After all, what happens? They offhandedly welcome home the son and brother who has fled to an American university with an English wife who was once 'a model for the body'. They mock him. They commandeer a woman who was being played with maximum slinkiness by Pinter's first wife, Vivien Merchant. They decide to put her on the game. She drives a hard bargain, but clearly finds it viscerally congenial to ditch her wintry husband and become a part-time prostitute and a surrogate mother for these sleazy but vital men in what's been an all-male lair since the death of the butcher's wife.

It's as if human stags are fighting for dominance over a doe, only to find that she's dominating them. No wonder the play got what are euphemistically called mixed reviews when, after stimulating yet more walkouts in Brighton, it arrived at the Aldwych. 'An intensely unattractive play,' wrote *The Express*. 'Long stretches of the second act seem to be no more than the actions of a tired man keeping the ball in the air,' said Bernard Levin in *The Mail*, finding it 'not a very happy homecoming' for the Pinter who had succeeded with *The Caretaker* five years before. 'Leaves us feeling cheated,' opined *The Guardian*.

But there were also those who agreed with Hall, who felt that Pinter's characters were 'stalking round a jungle, trying to kill each other but trying to disguise from each other that they are bent on murder'. In a brilliant review in *The New Statesman* Ronald Bryden suggested that the lady who stalked into the foyer fuming 'they're exactly like animals' had unwittingly got the point. The purpose, structure, joke and strength of the play was its disclosure that these characters were best described 'in the language of a zoologist reporting the mating customs of fighting seals on the beaches of Sakhalin'.

The reviewers in New York were warmer, despite the doomed attempt of the American producer, Alexander Cohen, to get a steely Pinter to 'fix' a play that had provoked walkouts in Boston. *The Homecoming* won four Tony awards, including the one for best play. The view of *The Nation's* Harold Clurman, that it's a tough, unsentimental look at a plausible if unlovely world, prevailed then – and, as revivals all over the world have proved, has prevailed since.

TWANG!!

What's the most memorably awful musical I've reviewed? That's a tricky one because the competition is intense. *The Man in the Iron Mask?* Or *Time*, a sci-fi musical about the search for galactic peace that featured a hologram of Laurence Olivier as Akash the Ultimate Word of Truth, a piece of casting somewhat spoiled by the technology department's failure to match the mouth with the face, giving the titanic timelord a weird, shark-like look? Or *Heathcliff*, which bizarrely tried to pass off the ineluctably amiable Cliff Richard as the grim and ferocious lover who put the wuther into *Wuthering Heights*?

Or *Marilyn*, a Broadway flop notable for the chorus of purple-clad plumbers who feted Monroe as she wallowed in a bubble bath? Back in 1983, the programme claimed that *Marilyn* had 16 producers and ten songwriters, a number which emphasises something everyone involved with the genre should heed. Sensing failure, you're tempted to spend and spend as you mend and mend. But the theatrical algebra is grimly paradoxical. The more you spend and mend, the less likely success becomes. There's nothing more financially voracious and artistically intractable than a misconceived musical.

Actually, few were more misconceived than *Fields of Ambrosia*, an American show that had its premiere in London in 1996. It opened with a chorus of Southern belles celebrating the death of the young man strapped into an electric chair behind them, and went on in its cheery, folksy way to follow the fortunes of the travelling executioner responsible. Did I really hear a sadistic prison warder sing 'your ass is too good to fry' as he prepared to assault a German murderess called Gretchen, or prisoners chant 'I'm hungry for you' as Gretchen prowled her cage on Death Row, or she herself warble 'Do it, boy, fry me while I'm hot'? Did I really see the lovable executioner's wimpish assistant emerge from the forest in which he's been gang-raped by escaping inmates to sing 'if it ain't one thing it's another', irrelevantly adding 'I was just ten when I lost my mother'? Yes, I did.

But *Twang!!* was the bad musical extraordinary, though it had one big plus, which was the heroism of that lovely comic actress, Barbara Windsor.

There she was, all alone on the Palace's vast stage for the premiere of Lionel Bart's long-awaited Robin Hood musical, and almost inevitably, she had to say 'I don't know what's going on here'. And she got the equally predictable answer from the audience: 'nor do we'. Her reaction, a grin that was both complicit and in character, was that of the plucky trouper *in excelsis*.

Anyway, *Twang!!* went on to ruin both Bart's bank balance, because he'd sold the rights to his *Oliver!* and put his own money into the show, and his reputation. But then the original idea was always better on paper than in practice. How could a collaboration between so hot a composer and that exciting director, Joan Littlewood, possibly fail? Well, Manchester brimmed with tales of how both were feuding, how he was dropping LSD, how she was spending rehearsals organising Vietcong improvisations by way of getting the cast into a Sherwood Forest mood, how the rewriting had become so frantic that Ronnie Corbett, returning from a pee to find some of his lines as Will Scarlett gone, wailed: 'don't let me go for a shit or you'll cut my entire part.'

Littlewood resigned the day before the show's Manchester opening. In came the script doctor Burt Shevelove and made changes so instant that the story, which vaguely involved Robin's storming of Nottingham Castle to rescue Windsor's sexy Delphina from one Roger the Ugly, became yet more inscrutable. Before the show's transfer to London, where it lasted three weeks, words came and went with such frequency that new ones were scrawled on the scenery and even on the floor. A number in which medieval beauties begged for a locksmith to undo their chastity belts disappeared before anyone learned it.

Myself, the only song I recall was a brassy chorus that claimed an atom bomb goes bang, an armoured suit goes clang and an arrow's bow goes tew-wang!! And Babs? 'Whenever I'm in a show that's not doing well,' she said, 'I remind myself of *Twang!!*, because if one can survive that one can survive anything.'

SAVED

As we've seen, a sadly familiar sign of the arrival in Britain of an original dramatist is a critical mauling. It happened to Ibsen, Beckett, even Chekhov. It happened to Sarah Kane, though the importance of her debut play, *Blasted*, is still debated. It certainly happened to the dramatist who became one of Kane's chief admirers: Edward Bond. Almost every reviewer winced away in horror from his *Saved*, a play in which a band of thugs smeared a baby with its own excrement, then stoned it to death in the pram that its mother had left in a London park.

The Times, calling this 'the ugliest scene I have ever seen on any stage', rejected Bond's claim that he was 'illuminating violence'. *The Telegraph* recorded its 'cold disgust at being asked to sit through such a scene'. *The Express*, clearly dismayed by characters who were 'almost without exception foul-mouthed, dirty-minded, illiterate and barely to be judged on any human level at all', also thought *Saved* 'without aim, purpose or meaning'. *The Sunday Times* went farther, saying that the play debased life and art and asking if 'there ever was a psychopathic exercise so lovingly dwelt on as this, spun out with such apparent relish and refinement of detail'.

But there's usually one critic who resists the flow, and with *Saved* it was *The Observer's* Penelope Gilliatt. In a brilliantly argued review she reassured Bond, who had been stunned by the hostile reception of a play he called 'almost irresponsibly optimistic', that it wasn't brutish but 'a play about brutishness'. It was, she added, about people at the very bottom end of human possibility. They were 'thick, vengeful, incoherent and terrified'. And the result was a 'study of reduction of personality that makes no excuses and offers no kicks, executed with a hard-headed humanity and a brazen technique'.

Revival after revival has left critics agreeing with her. *Saved* remains a play that successfully evokes the terrible frustrations of underclass London – the 'brick desert', as Bond described the part of Holloway where he himself had grown up – exposing its indigenous life in all its pettiness, spite, numb inarticulacy and motiveless violence. A couple haven't spoken to each other for years, but can't remember why. Their daughter neglects her crying baby,

since she's interested only in its feckless father, and that neglected baby is duly murdered for fun by a gang that includes that father. The baby is never named, invariably called 'it', and only once, in a monosyllable that's easily missed, revealed to be male.

It's disturbing and meant to be. The play's problem, if any, is the integrity of its realism. Bond trusted audiences to make the connection between people's environment and their behaviour. All the characters in *Saved*, from the baby to his mother to his killers, were ultimately to be seen as the victims of an unjust, uncaring society. The violence, he said, was the consequence of institutionalised violence, 'not done by thugs but by people who like plays condemning thugs'. He didn't make the same mistake again: which is why some of his later plays became preachy. Nevertheless, the more vivid of these – *Bingo, The Sea, The Fool* – have deservedly continued to be revived. The ideologue hasn't quite ousted the artist.

Oh, and how could Bond describe as optimistic a play with so hideously defining an atrocity at its core? Because one young character, Len, remains concerned, kindly, resilient and helpful despite being subjected to the pressures that lead others to infanticide: 'I cannot imagine an optimism more tenacious, disciplined or honest than this.' A sentimental touch in one of the last century's least sentimental plays? Bond, the maverick Marxist, feared so.

LOOT

Seldom can a play acclaimed as a comic masterpiece in its own day, and often revived since, have had such a difficult birth. When the first production of Joe Orton's subversive farce went on tour it got terrible reviews, one Cambridge critic pronouncing it 'very bad, shapeless and without style, inexcusably vulgar and even boring'. Yet when another production opened in London there was applause even from papers whose readers were the natural enemies of a dramatist who loved to bait the respectable. *The Daily Telegraph* decided *Loot* showed an 'impressive command' of style and plot, *The Sunday Telegraph* that it was 'the most genuinely quick-witted, pungent and sprightly entertainment by a new young British playwright for a decade'.

This wasn't just critical waywardness. All those involved with the version Orton wrote in 1964, himself included, became convinced that the success of his wickedly funny *Entertaining Mr Sloane* wouldn't be repeated. '*Loot* takes a farcical view of things normally treated as tragic,' he had said, meaning death and grief. But the plot, in which Hal McLeavy and his gay lover use his mother's coffin to hide the proceeds of a robbery while shoving her body in a cupboard, clearly needed rejigging, recasting and restaging if anyone was to be entertained by Orton's assault on the taboos he hated.

'A coffin is only a box,' Orton said, adding that he had no reverence for 'the little dust of a corpse'. The Lord Chamberlain didn't agree, his Assistant Examiner objecting to 'a mixture of filth and blasphemy' and, especially, to the 'repellent' scene in which Fay, the religiose nurse who has murdered Mrs McLeavy, 'undresses the corpse and describes it in callous and indecent language to Hal the son'. Yet he ended up licensing *Loot*, having insisted, among other things, that the corpse must be a dummy, must stay clothed and couldn't be seen falling from the wardrobe where it's concealed.

The producers largely acceded to the censor's demands, for instance by having Fay look inside the wardrobe, scream and, saying 'she's standing on her head', bang the door shut. But greater problems loomed. Peter Wood, who directed the first version, opted for a far more mannered production than Orton wanted, suggesting Congreve's *The Way of the World* and even

Tom and Jerry as models. Also, he cast Kenneth Williams as Truscott, the detective based on the real-life Sergeant Challenor, who had been suspended from the police in 1965 for planting evidence and assaulting suspects. Williams jubilantly caricatured a detective Orton wanted to exude genuine menace as he harassed other people, took charge of the stolen money, and arrested the play's only innocent character, Hal's ultra-conventional father.

But then nobody knew the correct style for a play that Orton kept rewriting during the cataclysmic tour that started early in 1965. After Cambridge Williams foresaw 'an endless round ahead of putting patches on a leaking hulk that will never be right'. In Oxford, Orton reported that everyone was 'on the verge of a nervous breakdown', with Geraldine McEwan, who played Fay, shaking and sobbing so much she had to be taken home and sedated. 'Bournemouth Old Ladies Shocked', declared a *Times* headline after a mass exodus from another theatre. And in Manchester, where I myself reviewed a play that seemed offputtingly facetious, Wood reportedly asked Williams and McEwan to agree that the production shouldn't go to London: which it didn't.

Yet Manchester rescued *Loot*. Braham Murray directed a more naturalistic revival of a greatly sharpened play at the University Theatre in 1966, and that emboldened the director Charles Marowitz to stage another on the London fringe. His production transferred to the West End, won the *Evening Standard*'s Best Play award, and brought Orton a memorable soubriquet from *The New Statesman*'s Ronald Bryden. He was 'the Oscar Wilde of Welfare State gentility': a reference to the fun engendered by characters who say outrageous things in mundane or banal ways.

Certainly, Orton mocked the pretension he saw everywhere: justice as delivered by Truscott, piety as expressed by Fay, even McLeavy's affection for a wife who, it's hinted, was far from a gentle helpmate. In the words of his biographer, John Lahr, he liked to 'goose' his audiences and not only his audiences. As Hal, the actor Kenneth Cranham had to click his dead mother's false teeth like castanets while he talked of opening a brothel called the Consummatum Est. As himself, he was presented by Orton with the teeth that had belonged to the dramatist's own mother, who died during *Loot*'s run. According to Orton, Cranham 'looked very sick' despite being assured it would add reality to his performance.

Eight months later Orton himself was dead, his skull smashed open by his envious flatmate and jealous lover, Kenneth Halliwell. He left

behind the unrevised *What the Butler Saw*, a farce much admired by his aficionados but one I've yet to see fully succeed in the theatre. *Loot* is surely the play for which Orton's mischievous, callous, hilarious talent will be best remembered.

ROSENCRANTZ AND GUILDENSTERN ARE DEAD

OLD VIC, LONDON, APRIL 11 1967

This was the play that made Tom Stoppard's name and remains more studied in Britain's schools than later, more exhilaratingly imaginative works, notably *Jumpers* and *Arcadia*. Indeed, I'd better admit that its revival in 1995 by the company which gave it its first professional production, the National, disappointed me, even though Simon Russell Beale and Adrian Scarborough gave fine performances as the embattled title characters. I found the evening over-long and even found myself quoting Stoppard's weightiest enemy, Robert Brustein, whose reaction to its Broadway production was to dismiss *Rosencrantz and Guildenstern* as a philosophically spurious, cute and whimsical rip-off of *Waiting for Godot*.

I regret that, because I've always thought Brustein unfair to a play that has its depths as well as its refreshingly witty moments. Moreover, the basic idea is strikingly bold. What happens to the attendant lords in *Hamlet* when they're not ineptly deducing the prince's secrets, or tracking Polonius's body, or leaving for England with a death warrant for Hamlet which their one-time university friend transforms into their own death-warrant? Stoppard's answer is that they talk and behave rather as if they were indeed younger versions of Beckett's bored and frustrated tramps.

Speaking modern colloquial English instead of the Elizabethan verse they use for the authentically Shakespearean scenes in which they appear, they amble, loiter and amuse themselves with word games and other such diversions. They chat with the only other visitors to Elsinore, the players. They also desperately try to decode the incongruities of the bewildering and frightening Shakespeare tragedy into which they've been unknowingly plunged, deciding (for instance) that Hamlet himself must be 'stark raving sane'. And they end up going to a fate, their deaths in England, that they foresee and accept. Whether they're the victims of some incomprehensibly

vengeful order or of the blind drift of a meaningless universe, they feel resistance is no use. There's a melancholy here that characterises more of Stoppard's work than is usually recognised, a darkness behind the verbal fun that makes it impossible to dismiss a dramatist who never actually went to university as (Brustein's phrase) a 'university wit'.

Moreover, the play was the fruit of long, hard work and much revision. It began as a short burlesque written at a colloquium for aspiring writers in the Berlin of 1964, a time when Stoppard, a journalist lately moved from Bristol to London, saw his future primarily as a novelist. In this, Rosencrantz and Guildenstern came to England, only to encounter a madly garlanded King Lear shouting 'kill, kill, kill' as he scampered about Dover. A new, expanded but still incomplete version, now set in Elsinore, was sent to the RSC, impressing both its artistic director, Peter Hall, and the fast-rising Trevor Nunn. Had funds not run out, Nunn would have staged *Rosencrantz* on the London fringe, using actors from the Stratford *Hamlet* that starred a brilliant young David Warner.

So it's a myth that the play arrived totally unheralded in a church hall on the fringe of the 1966 Edinburgh Festival. However, that's where a more definitive version was first staged, thanks again to Nunn, who had recommended it to Oxford Playhouse, which in turn had handed it to student players, the Oxford Theatre Group. It was all pretty chaotic, with the director failing to turn up in Edinburgh, Stoppard taking over, sightlines hopeless, and audiences dismally thin until Ronald Bryden published a rave review in *The Observer*. 'The most brilliant debut by a young playwright since John Arden's,' he wrote, 'an erudite comedy, punning, far-fetched, leaping from depth to dizziness.' At that the National made its move, with Kenneth Tynan, then the company's literary manager, asking Stoppard by telegram for the script – and, eight months later, Harold Hobson was calling the now complete play 'the most important event in the British professional theatre of the last nine years.'

It certainly launched an important career and itself won awards galore, including a Tony when it was staged on Broadway. And there were times even in that 1995 revival when it did more than glitter. Russell Beale caught the curiosity and mental energy that characterises Guildenstern, Scarborough Rosencrantz's passivity and panicky wimpishness, and both of them the play's distinctive mix of humour and grief.

'What's it about?' a woman asked Stoppard in New York, getting the wickedly evasive answer 'it's about to make me rich'. Actually the dramatist

has said that what's written over its door is 'no symbolism admitted, none denied', which allows each spectator to reach a personal conclusion. For me, it's about being lost in an unaccountably hostile world, one in which free will is either non-existent or useless, yet achieving value by the persistence with which we try to make sense of it and ourselves. And whatever the reservations, those aren't ideas that date.

A DAY IN
THE DEATH OF
JOE EGG

CITIZENS THEATRE, GLASGOW, MAY 9 1967

When Peter Nichols's first full-length play moved from Glasgow to London, Irving Wardle wrote in *The Times* that it was one of those occasions when audiences 'can feel the earth moving under their feet', adding that the thirty-nine-year-old dramatist had 'significantly shifted our boundaries of taste'. Indeed it was. *Joe Egg* had taken a taboo subject – how to cope with a profoundly brain-damaged child and your own and others' reactions to that child? – and hadn't whined, pined, raged, got sentimental or melodramatic, struck social attitudes, promoted an agenda or descended into psychobabble. The play had done a radical thing, which was to tell the truth, and an original one, telling it in a style that treated its audiences as acquaintances who could laugh as well as learn.

The play came from personal experience. Peter and Thelma Nichols's first child, Abigail, was born so disabled in 1960 that, in his words, 'she didn't really exist as a person at all'. But in the eleven years before she died her parents dealt with her helplessness and their pain largely through jokes and play-acting in which they imagined her doing or saying impossible things. That's the strategy of Bri and Sheila in a play that Nichols would have preferred to call *Funny Turns* – which is what Abigail seemed at first to be having – but took its title from a children's song: 'Joe Egg is a fool, he tied his stockings to a stool. When the stool begins to crack, all the beetles run up his back.'

Nichols found the play's creation cathartic: 'I've experienced the cliché that by writing about experiences that trouble you, you can reduce them.' Yet the first version was, he admitted, 'savage, sentimental and overdone' and its style naturalistic, with parents 'bitter stereotypes' and their child kept offstage, suggesting she was 'a mad creature raving in the west wing'. The play was universally rejected before Michael Blakemore, a friend who

was running Scotland's leading rep, got Nichols radically to rewrite it and persuaded doubting employers and a worried Lord Chamberlain that it could be staged without financial or moral disaster.

What opened in Glasgow was, Nichols felt, 'more Noël Coward than Strindberg'. It also owed much to his love of vaudeville and his decision to acknowledge the presence of a live audience. Bri and Sheila act out their memories of ineffective professionals and use direct address to share their thoughts, as do characters who include his insensitive mother and a guest who recommends euthanasia for 'weirdos'. And in comes Jo or Joe in her wheelchair, twitching, moaning, fitting – but also, in a moment that dramatises Sheila's wishfulness, skipping like any normal ten-year-old as she announces the interval.

'If that moment's performed right it's pretty certain half the audience will be in tears when the lights come up,' Nichols has said, and that was regularly the case in Glasgow. The Scottish critics were impressed, as was *The Observer*'s Ronald Bryden, who applauded the play – 'one of the funniest and most touching I've seen' – for finding a modern means of tackling 'a suffering as timeless as any the Greeks knew'. Offers followed from those initially sceptical London producers, including one from the National Theatre that might have cast Maggie Smith and Robert Stephens in the leading roles created by Joe Melia and Zena Walker. However, Nichols felt a loyalty to Blakemore's production and was rewarded when its West End transfer won the *Evening Standard*'s Best Play prize – and, with Albert Finney replacing an indisposed Melia, moved to Broadway, where it received critical acclaim, four Tony nominations and a Tony for Walker.

Revivals in both cities have left audiences wincing when Bri calls Joe 'a living parsnip' or jokes that she's a 'tap dancing champion' and moved when Sheila calls her 'my blossom' or recalls her high hopes when the child knocked over a pile of coloured bricks. By the play's end it's evident that the marriage between a nurturing woman and an immature man is doomed, which wasn't the case with Peter and Thelma, who had three more daughters. But by then it was also clear that Nichols had discovered the distinctive style that would sustain him through *The National Health, Forget-Me-Not Lane,* and *Privates on Parade.*

That's funny but basically serious. In Nichols's words it uses laughter 'to give audiences a glimpse of things they wouldn't have seen if they hadn't gone to the theatre' and encourages them to leave feeling 'stirred, not indifferent'. But he acknowledges that the play's success was a surprise and

his own career a close-run thing: 'People say talent will out but I'm not sure. It was a very tricky subject. It exemplified the limits of comedy: how far can you go without losing your audience or becoming avant-garde and eccentric? Michael Blakemore once said that if *Joe Egg* had died in Glasgow, Peter Nichols might never have been heard of again. I think he was right.'

THE LAWRENCE
TRILOGY

ROYAL COURT, LONDON, MARCH 14 1968

Almost forty years after his death, over fifty after his remarkably moving *The Widowing of Mrs Holroyd* had been staged and then forgotten, Britain belatedly realised that D.H. Lawrence hadn't only been a novelist, essayist and poet. The director Peter Gill presented in tandem the three plays he had written between 1909 and 1914 and set in a Nottingham mining village very like Eastwood, where he'd grown up. And the critical consensus was that Gill's meticulous staging of *A Collier's Friday Night*, *The Daughter-in-Law* and *Mrs Holroyd* justified Seán O'Casey's claim that 'had Lawrence got the encouragement [his work] called for and deserved, England might have had a great dramatist'.

The young Lawrence felt that audiences were 'sick of the rather bony, bloodless drama we get nowadays'. It was time for a reaction against 'the rule-and-measure mathematical folk': Shaw, Galsworthy and Granville Barker. Why, he asked, shouldn't there be an English audience for his stuff, just as there was a Russian one for Chekhov? Later, he argued for a 'people's theatre', one where seats were cheap and plays were for people about people, meaning drama involving 'men who are somebody, not men who are something', whether lords, bishops, co-respondents, adulteresses, white rabbits or presidents.

Though few listened at the time, one does indeed feel that the people in those three early plays are emotionally real 'somebodies', not types. *A Collier's Friday Night* is an ultra-naturalistic piece involving the same characters – embittered miner, precocious son, and possessive, ambitious mother – who would appear in Lawrence's semi-autobiographical *Sons and Lovers*. *The Daughter-in-Law*, too, involves a proud woman married to a miner, but they are younger and the play is subtler, richer, more sophisticated. Marital conflict also marks the third play, but this time the title character is about to abscond with a young electrician when her coarse,

tipsy husband is brought home dead, killed in a pit accident, giving us a final scene in which both wife and mother wash his corpse.

'It's the producer that's lacking, not the audience,' wrote a frustrated Lawrence, who tried to get all three plays staged, but was successful only with *Mrs Holroyd*, which was presented first by amateurs in Altrincham in 1920, then by the Stage Society in 1926. During the opening acts *The Times* critic felt 'in the presence of a potentially great dramatist' but ended up disappointed, and the play was forgotten until a television production in 1958 impressed Gill. But when he approached a theatrical library for a copy he was sent *A Collier's Friday Night* instead, and made his debut as a director by giving that play a Sunday showing at the Royal Court in 1965, following it two years later with the world premiere of *The Daughter-in-Law*. When *Mrs Holroyd* was added in 1968 the Lawrence Trilogy was complete.

Gill took his cast to Eastwood to meet miners and visit the sort of cottages the designer John Gunter was to recreate onstage. According to one actor, both men's attention to detail made for unusually exacting rehearsals. 'Whatever the crisis, the hardships, the dramas encountered by these working-class people, the practical, everyday duties still had to be performed and were the cornerstone around which these plays were built,' recalled Edward Peel. 'Water steamed when it came from the hob, meals steamed and there was a wonderful smell of freshly baked bread and Yorkshire pudding.' The result, wrote Irving Wardle, was to rivet the attention by telling the truth about ordinary life, meaning one could breathe a room's air, 'with its gaslight and threadbare gentility, its atmosphere of simmering warfare held in check by the domestic discipline that enables families somehow to survive'.

At root, Lawrence was confronting his past, his still potent ghosts, his sense of emasculation and loss. That led to some remarkable encounters. The scene in *The Daughter-in-Law* in which the young wife lambasts her husband as a slobbering, loveless mother's boy has a visceral power without parallel in the British theatre of 1912. Then came the final moments of *Mrs Holroyd*. 'I never loved you enough, it was a shame,' says the newly widowed protagonist as she washes the face of the man she's wished dead. And such simple expressions of contradictory feelings have an extraordinary impact.

The academic critic Raymond Williams argued that the same climax in Lawrence's short story *Odour of Chrysanthemums*, was stronger, deeper. Well, he hadn't experienced what Lawrence called 'the keystone of the

play' in the theatre. Neither Judy Parfitt, playing Mrs Holroyd, nor Anne Dyson, playing Holroyd's mother, could stop crying far more than the stage directions demanded. It was the same with the spectators at the run-through and, indeed, the paying spectators who followed. The scene 'left the audience stunned with admiration and emotion,' reported the *Sunday Times*. How many other dramatists could achieve that, in 1914, 1968 or now?

HAIR

SHAFTESBURY THEATRE, LONDON, SEPTEMBER 27 1968

There was a point in the London production of New York's megahit, *Hair,* when the cast of shaggy hippies and hirsute druggies literally let it all hang out. They shed their flowers, feathers, American football tops and spoof GI uniforms and faced the audience in Adam and Eve's pre-figleaf mode. And that was important for the British theatre, because it definitively signaled that Britain's Lord Chamberlain had lost the power over the theatre he had wielded for centuries. A show he'd previously banned because it 'extols dirt, anti-establishment views, homosexuality, free love and inveighs against patriotism' could at last be staged.

Oh, and it was important for me, too, because it changed my appearance for good. Only weeks after the censor had been sent packing, I sat in the Shaftesbury Theatre's dress circle, surrounded by people watching *Hair* through binoculars that I disdained, thinking that my actual as well as my critical vision was 20-20. But then came the interval. 'When are they taking their clothes off,' I asked a friend. 'They just did,' he replied. It seemed that the nude scene had passed, if you'll forgive me, in a flash. Next day I joined the spectacle-wearing classes, and have been a member ever since.

Today it seems pathetic that *Hair* should have caused such voyeuristic fuss. After all, there was more to the 'tribal musical' that Gerome Ragni, James Rado and Galt MacDermot created for Manhattan's Public Theater. It was an attempt to evoke a counter-culture whose hope was to stop a Vietnam War in which 'white men are sending black men to fight yellow men in defence of a country stolen from red men'.

That was the relevance of hair that came bushy and fluffy or lank and oily-looking or in fair rolling curls, variously mimicking Hendrix, Jagger, the Laughing Cavalier and Goldilocks. The social enemy, whose number was legion and whose name was often the American Legion, more or less defined itself by threatening to cut it off and, in the case of a hippie called Claude, actually did so. He was shorn like a lamb, stuffed into a khaki straitjacket, packaged for shipment to the Asian jungles, and deserted by his horrified friends.

He ended up hairless on the floor, the sacrificial victim of a system represented by censorious parents, drab schoolteachers, militaristic puppets and police vindictive enough to break up a harmless 'suck-in' outside City Hall. The show wasn't subtle and tended to sentimentalise dropouts who, for all their brashness and exuberance, sometimes seemed not just vulnerable but comically touchy. A hippy had only to reject the gift of a yellow shirt from a girl for her to launch into an agonised song about injustice, indignity and several other human evils.

Still, MacDermott's songs – abrasive, rhythmic and as original as only a salute to the impending Age of Aquarius or an ironic number beginning 'welcome sulphur dioxide, hello carbon monoxide' could be – did much to save *Hair* from mawkishness. It was the dialogue in between that seemed self-pitying, rambling and inconsequential. Unsurprisingly so, for the show's origins were chaotic, with stoned actors and hippies meandering through the Public Theatre and the designer receiving a script on which a single word, 'hair', was written again and again.

Yet *Hair* was clearly so much of its time that a transfer uptown and a long Broadway run followed. Actually, it was only then that its celebrated nude scene was added, provoking Groucho Marx to say that he could have stayed at home, stripped in front of the mirror and saved himself the price of a ticket. The composer Richard Rodgers left at the interval, having mournfully decided that a show seemingly free-associated by beatniks had made his kind of carefully structured musical obsolete.

Well, *Hair* hasn't achieved that, but it continues to be revived, with mixed results. Myself, I reviewed the original London production respectfully, even calling it 'a sung eucharist in praise of the secular gods', but five years later, perhaps influenced by the cynicism that had replaced 1960s optimism, I found it a witless celebration of 'drivelling parasites who drift from half-felt experience to half-felt experience, half-formed belief to half-formed belief'. I thawed to a 1993 revival that left me feeling that *Hair* had become a historical curio akin to a freaked-out *Salad Days*, hated a coarse, angry 2005 updating that took Claude to Iraq and used the human pyramids of Abu Ghraib prison as a nude scene, yet felt that the energy and ebullient dance and song of a 2010 Broadway transfer compensated for the intellectual sloppiness and slovenly dialogue.

I don't know what to conclude from this except that, like *Hair*, I can be quite muddled of mind. But at least I have reliable specs.

PARADISE NOW

Have you ever seen men, naked to their G-strings, wandering through an audience blessing and laying hands on the assembled bodies? In some eastern ashram, maybe, but probably not in a London theatre. But that was the central event when New York's Living Theatre brought *Paradise Now* across the Atlantic. 'Holy forehead, holy nose, holy moustache,' murmured one of these amateur priests as he stroked me, ending rather optimistically on an upper lip that hadn't yet sprouted to the impressively bushy length it now boasts.

The wandering guru then turned, I thought rather sadistically, to my elderly and improbably blimpish neighbour. This gentleman had been puzzled enough by the Living Theatre's habit of opening shows with half an hour's cross-legged meditation onstage. 'Haven't they got a prompter?' he kept asking, not realising that they were trying to levitate: a feat which, if successful, would have inspired them to cancel the performance. But the Living Theatre hadn't soared that evening, which was why my neighbour was subjected to a different surprise. 'Holy cheek, holy teeth, holy gums,' whispered the intruder, and, unable to bear the conversion of these prompterless actors into a pack of inquisitive, prowling dentists, the old man upped and left.

Still, these cenobites packed out the Roundhouse with no less than four shows. This was, after all, the era when the American theatre had cast off its naturalistic shackles and was surprising the world with pieces like Jean-Claude van Itallie's *America Hurrah,* in which big, coarse puppets, parodies of the bourgeoisie, wordlessly wrecked a motel room. But the Living Theatre was the most famous of the tribes that had been bred by the counter culture and politicised by the Vietnam War.

I myself had seen and admired their early work in New York. *The Connection* was an ultra-naturalistic picture of druggies waiting for the arrival of the genie with the needle, and *The Brig* was a brilliantly choreographed evocation of a marine prison and, by implication, a regimented America. But trouble with the tax authorities led to the closure of the company's

Greenwich Village theatre and the imprisonment of their guiding lights, Julian Beck and Judith Malina. And they had clearly emerged from their ordeal determined to express a more explicit hostility to a world of laws, rules, police and money. Drama, for them, was now a mixture of hieratic ritual and bald assault on the political conscience: a liturgy of the barricades.

Their version of *Antigone*, though far cruder than Sophocles's original, did have some dramatic integrity, but there and elsewhere their prime aim was to preach anarchy. 'I am not allowed to travel without a passport,' they collectively wailed in *Paradise Now*, 'I am not allowed to smoke hashish.' As for Beck, he intoned 'free the blacks', 'abolish the police' and so on. Some of us chanted back 'down with money' and 'feed all men' and a few seemed ready to go along with the tribe's one practical suggestion, which was to start the revolution by marching on London's Holloway Prison and liberating its women inmates. I tagged along to see how the police state would deal with this challenge to its authority, joining a forlorn cluster of Beck affiliates in the rain outside the Roundhouse, but we went nowhere, and the Bastille remained intact.

Another of their shows, *Mysteries,* started with the communal drill that supposedly symbolised an over-disciplined society, and, after a lot of hooting, squawking and bird-like flapping, ended with the mimed death of the whole cast. Sticks were burned, incense rose and an ersatz spirituality infused the evening. Yet *Paradise Now* seemed more characteristic, because it mixed self-pity with aggression. At its climax we were denounced as capitalists, exploiters, living corpses, motherfuckers and 'bourgeois intellectuals getting your bourgeois thrills out of tickling your brains'. Some riposted but the performers weren't listening. Anyway, how do you answer the anarchic counterpart of a hell-fire sermon?

Were these the same actors who had influenced the Open Theater, the Bread and Puppet Theatre and other avant-garde troupes? Yes, and they simply seemed older and crankier when I next encountered them in something called *The Archaeology of Sleep* in New York in 1984. It was a piece I remember for two things: first, a scene about an experiment, symbolic of society's callousness, in which a cat was disoriented by the disruption of its brainwaves and had sex with a feline corpse; then, an assault on *The New York Times* critic, Frank Rich.

The Living people had gone on their customary walkabout, stroking spectators and, in Frank's case, giving him a retchy kiss on the ear. But then

Beck shot his hand between the Rich legs, pausing for a quick, intimate fumble. The assembled critics were appalled, but Frank was wry. 'It was the intellectual assault I really minded,' he said, grinning all the way from the contaminated ear to the uncontaminated one.

THE CONTRACTOR

In the first two acts a large tent, complete with dance floor and coloured awnings, was painstakingly raised. In the third act it was lowered, looking the worse for wear. What would probably have been the central event in another person's play, a rowdy reception after the marriage of the contractor's own daughter, occurred during the interval. David Storey meant it when he said that he wanted to avoid plot and conflict, focusing instead on the men arranging the canvas, pulling the ropes, fitting the shiny wood and the decorations – and presenting the director, designer and actors with quite a challenge.

The Contractor was the strikingly unconventional creation of a playwright who was far from conventional himself. The son of a Yorkshire miner who had given him a middle-class education, Storey did odd jobs galore before winning a place at London's Slade School of Fine Art and commuting to Leeds, where he was a professional rugby player. Since his fellow-students thought him 'a bit of an oaf', and his fellow-footballers posh, it added to the strong sense of dislocation, even fragmentation that would mark many of his plays. He was happiest, he said, on the train between London and Yorkshire, because it let him quietly write novels, though all were rejected until *This Sporting Life*, which involved the private and public vicissitudes of a rugger player, was published in 1960 and, with Lindsay Anderson directing, became a successful film.

What Storey called his 'almost mystical association' with Anderson and the Court, where Anderson was an artistic director, became key to the success of a man who had seen only some six plays in his life but, despairing of his prospects as a novelist, decided to try his hand at drama. And after the success of his first play, *The Restoration of Arnold Middleton*, Storey said that 'a dam burst', and he wrote six more in as many weeks, completing the first of these, *The Contractor*, in five days. It was, he once said, more as if they were writing him than he was writing them. He could labour on a carefully planned novel for years without bringing it alive, but if he gave a novel or play its freedom, it seemed 'develop its own organic life'.

His finest plays, all directed by Anderson, have derived from personal experience: his own family's divisions for *In Celebration*, the Slade for *Life Class*, rugby for *The Changing Room*, a stint as an agricultural labourer for *The Farm* and another as a tent erector for *The Contractor*. They're a motley lot, that particular play's characters. The contractor himself, a bluff Yorkshireman called Ewbank, likes to employ misfits: 'miners who've coughed their lungs up, fitters who've lost their fingers, madmen who've run away from home.' And the gang onstage comprises two garrulous, feckless Irishmen, a mentally backward boy, a dour labourer soured by his wife's infidelity, and a foreman who has been in prison for embezzlement. That produces taunts and jokes, sly cruelties and small kindnesses, bickering, tension and the danger of violence – but also subtle, telling revelations about character and relationships.

That was sufficient for a play Harold Hobson called 'as exquisite as Keats's Grecian Urn'. But the staging demanded manual effort and meticulous timing. The designer, John Gunter, recalled that his tent refused to stay up during the first dress rehearsals but on the final one it did, 'and it was miraculous'. The result was indeed what a stage direction required, a strangely beautiful structure 'with a gentle radiance coming through the drapes'.

It was also, of course, a temporary structure: here today, gone tomorrow, as if to parody and reflect the characters' lives. It's not only the workers who are restless and pretty much rootless. So is the uneducated Ewbank's educated son. And just about everyone seems dissatisfied, down to the 'happy couple' and Ewbank himself. Though he feels his plays 'live almost in the measure they refuse definition', Storey has agreed that *The Contractor* is open to several interpretations. That tent may be seen a metaphor for the impermanence of artistic creation, the obsolescence built into modern society, the frivolity of much contemporary work, or the vanity of achievement itself.

'All my plays ask for a more whole, grander view of life,' Storey has said, adding that 'self-division seems to be a theme' and that 'there's always a sadness at the end'. It's that which led Dominic Dromgoole, who staged a touring revival of *The Contractor* in 2001, to compare him with Chekhov and wonder if there's been a greater play written since the war. 'Posterity is our last resort of trust,' he wrote, 'and if posterity is true, it should reveal a giant in David Storey.'

OH! CALCUTTA!

Kenneth Tynan's first plans for the erotic revue whose title came from the French 'quel cul t'as', meaning 'what a bum you have', came to very little. There was no 'sexy Batman film', no nun raped by her confessor, no 'Black Power striptease', when the show opened in New York in 1969. A sketch by Tennessee Williams about a couple who could only excite each other by fighting had been dropped, along with a prison fantasy by Edna O'Brien. And the surviving numbers, which were by Jules Feiffer, Sam Shepard and others, failed to please the reviewers. 'The kind of show to give pornography a dirty name,' wrote the *New York Times*. 'All the sophistication of a men's room wall,' said a television critic. No wonder Tynan, who had wanted 'a cool, witty and sophisticated tease', regarded his London opening with foreboding.

He was right and wrong to do so. Though there was much prurient pre-publicity, with a *Times* columnist describing the revue as the sort of voyeuristic show once available to the sexually warped 'in a certain kind of sea-port', the Attorney General didn't bow to those urging him to prosecute Tynan. There were police outside the Roundhouse on opening night and sly men in raincoats, one of whom I actually heard saying 'what about a nice ticket for tonight, sir, lots of slap and tickle?'. But if pornography is 'doing dirt on sex', as Lawrence claimed, the show was too keen to communicate a rather naïve delight in the sheer fact of sex to be offensively pornographic.

However, the reviews weren't exactly orgasmic. Critics rather comically paraded their highmindedness by declaring they hadn't been corrupted, depraved or even excited. If few fly-buttons had hit the Roundhouse ceiling, few minds had been rattled. 'In many ways a ghastly show,' opined Irving Wardle in *The Times*, 'ill-written, juvenile and attention-seeking.' That still seems a fair assessment of a revue at its most appealing when Clifford Williams's cast were innocently, gracefully and, let's add, wordlessly dancing naked.

True, we laughed at a sketch in which the Lone Ranger interrupted a group love-in and another in which a fastidious couple tried a little wife-swapping, only to be breezily manhandled by a bawdy, beer-swilling pair

twice their age. That was a classically farcical confrontation between the prim and the grotesque, akin to a dainty tea-party invaded by a loudmouth comedian in cap and braces. But elsewhere *Oh! Calcutta!* just wasn't much fun or very funny.

Even Joe Orton's contribution, in which an upper-class breakfast was transformed into a gleeful orgy, seemed repetitive and silly. And a parody of Masters and Johnson, whose *Human Sexual Response* had not long been on the shelves, seemed to assume that topicality was enough to sustain a sketch. All it proved was that putting two naked people into a bed, spoiling their enjoyment by attaching wires to their loins, and then having the assembled doctors and nurses writhe with vicarious glee, was a lazy, dull idea.

Yet *Oh! Calcutta!* thrived, more so than Tynan, who was to die more or less ruined ten years later. He got some £150,000 from a show that notched up 4,000 performances in London and still more on Broadway, making many millions for the producers to whom he'd sold his rights. And his attempt six years later to achieve a comparable hit with a similar revue, this time called *Carte Blanche*, did nothing for his finances. Some of us admired an Ionesco sketch in which a tattered crone prinked herself into a gilded courtesan, and then deprinked herself back into a crone, so demonstrating the superficiality and transience of beauty. But a geriatric gangbang in which oldsters shrieked 'mind my colostomy bag' left me wondering what had happened to Tynan's taste and, indeed, mind.

He had, after all, been the wittiest of theatre critics. Some of us still remember that and often reread his reviews. But to the public at large, he became the man who had first said 'fuck' on television and gone on to produce a revue about sex. Along with his debts, he left behind a reputation for sleaziness.

A MIDSUMMER
NIGHT'S DREAM

ROYAL SHAKESPEARE THEATRE, STRATFORD, AUGUST 27 1970

I s it hypocritical of me to keep recording, nose in the air, the errors that critics have made? After all, I'm not immune to misjudgement myself. Who wrote that a farce called *No Sex Please, We're British* was so stupid it couldn't run a week, only for it to break every British record for its genre? Well, me. More seriously, who was one of a tiny fistful of reviewers to resist Peter Brook's famous production of Shakespeare's *Dream*, a revival that restored the RSC's fiscal fortunes and was feted all over the world, Clive Barnes of *The New York Times* declaring that it was 'without any equivocation whatsoever the greatest production of Shakespeare I have seen?' Yes, the benighted Nightingale, as a correspondent wittily called me.

What was my problem? Why did I sneer that the mountainous Brook had laboured and absurdly brought forth Mickey Mouse in the form of a Bottom with a black bulb for a nose, small black ears instead of the usual ass-head, and black clogs for feet? Well, this was a period when directors had begun regularly and strongly to impose their own personalities on Shakespeare, sometimes updating him to his benefit (Robin Phillips's Rimini-beach *Two Gentlemen of Verona*, also in 1970), sometimes concentrating so much on one aspect of a play that others were neglected (the first of Jonathan Miller's two colonial-era *Tempests* the same year). I decided Brook's *Dream* was similarly at fault, imaginatively catching the play's air but not its earth nor its fire, not its comedy nor its danger.

Brook declared himself much influenced by the Chinese circus, which explained why a Puck in billowing silks and a blue skullcap swung on a trapeze, at one point using a steel wand to twirl the steel plate that was his magic flower and tossing it to a similarly swaying Oberon. Indeed, the big white box in which the production occurred was in effect a gymnasium. There were actors on stilts, others who noisily made rough music by waving big blunt saws and hurling shrieking silver-and-blue torpedoes at one

151

another. There were vertical iron ladders that led to a high platform on which performers not onstage scraped and banged at their rails. It was a bizarre, metallic business: Shakespeare as he might have been conceived by a sci-fi addict or, indeed, performed by Bardophiles from another galaxy: *The Dream 2001 AD*.

The trees in that Athenian forest had become enormous springs bouncing down from aluminium fishing rods. The characters delivered some lines like pop songs and some songs like Indian ragas. Fairies with names like Cobweb and Moth were chunky males whose baggy silver pyjamas made them look like Japanese wrestlers. And, I suppose, why not? After all, the romantic imagination nowadays isn't filled with visions of spotted snakes, luscious woodbine and the other fauna and flora invoked in the play. Fairies aren't necessarily twee charmers who flit about to Mendelssohnian hums. A rethink of *The Dream* was (and is) fine, provided it embraced more of Shakespeare's original than it lost.

But there, for me, was the problem. The effect of all that inventive skylarking and feel-good athleticism was to deprive *The Dream* of the darkness that Brook's friend, influence and protégé, Jan Kott, had seen in the play and recorded in a particularly brilliant essay in his *Shakespeare Our Contemporary*. My fault was perhaps to have gone to Stratford with the Polish critic's words – in no other Shakespeare play 'is eroticism expressed so brutally' – ringing in my head and exacerbating expectations I should have left in London. But I was still disappointed to find so much arbitrary decoration substituting for the suffering, lust and terror that can and should coexist with humour and merriment in what's surely a funny, sinister, complex and contradictory play.

Well, other directors have given less partial readings since then, notably the RSC's Michael Boyd in 1999. His rude mechanicals were genuinely comical, which Brook's weren't, not even when performing *Pyramus and Thisbe*. His Puck, like his anarchic fairies, had a gloatingly malicious side, which Brook's didn't. And Josette Simon's Titania unforgettably combined the fierce, magnificent, sweet, sinuous, torrid and feral. Her squirming, leggy affair with Bottom caused some teachers to remove their charges at the interval, appalled to discover that an encounter usually as erotic as a teddy bear's picnic had become a bit of an orgy. But this was a *Dream* for grown-ups – which Brook's barely was.

ABSURD PERSON SINGULAR

CRITERION THEATRE, LONDON, JULY 6 1972

There's Eastbourne. There's Sittingbourne. And somewhere in the part of Britain where the nation's most prolific and commercially successful dramatist sets most of his plays – that's to say, the commuter area south and south-east of London – perhaps there's a town called Ayckbourne or even Ayckbourn. It's not a very happy place. Human effort goes unrewarded or punished. Nice, considerate people wreak unwitting havoc. Relationships, and especially marriages, are so unfulfilling that children are sometimes left wondering which of their parents is planning to poison the other, father or mother. Everyday objects – cars, do-it-yourself furniture, electric gadgetry – seem part of a conspiracy to frustrate and dismay. And don't mention Christmas. It's as much an institutionalised misery as the wet bank holidays that keep the good people of Ayckbourn edgily at home.

I don't think Alan Ayckbourn himself would resist the analogy. He's on record as saying that his aim is to write a 'completely serious play that makes people laugh all the time', and especially in the 1970s he wasn't understating the case. Though he fully acknowledged the wry, droll and funny, his take on life became more sombre, his work darkened. The extreme example came in 1976 with *Just Between Ourselves*, a comedy that ends with a harmless wife in a catatonic stupor, little more than a human vegetable, thanks to the offhand enmity of her jealous mother-in-law but, more, to the insensitivity of her relentlessly cheerful but hopelessly myopic husband. Insensitivity rather than evil often does the damage in Ayckbourn's plays, and evil tends to be an unthinking callousness.

But an even more successful attempt on Ayckbourn's part to deepen his comedy, or at least prove that human disaster could have its hilarious moments, came with *Absurd Person Singular*, which had opened to admiring reviews just four years earlier.

Technically the play demonstrated another of its author's strengths, the daring ingenuity that in 1973 would produce *The Norman Conquests*, three interlocking but self-sufficient plays, each covering the fraught events of the same weekend from the stance of a different room. Who but Ayckbourn would set a domestic comedy on three consecutive Christmas Eves – last year, this year, next year – in three different kitchens? Who else would allow much of the action of *Absurd Person Singular* to occur unseen and (bar the occasional burst of boorish laughter) unheard in living rooms offstage?

And who else would give us that second act? Neurotic Eva, who has despaired of her architect husband's fidelity and describes herself as 'an embarrassing smudge on a marriage license', makes a series of botched suicide attempts, only for them to be misinterpreted by the other characters. They variously clean the gas oven into which she's putting her head, press a glass of gin into the hand about to dunk bleach down her throat, fix the sink in which she's scrabbling with pills, and end up half-electrocuted as they helpfully mend the light from which she's trying to hang herself. Her self-destructive fury isn't funny but, yes, the contrast between that and everyone else's kindly imperviousness certainly is.

But the play wasn't just a black comedy. Its undeniably serious subject was social change. Richard Briers brought point and purpose to the character most obviously embodying it, a property developer called Sidney, a man at first insecure and desperately keen to impress his supposed betters but by the end rich, confident and utterly in control of people who now needed his money and influence. And as he rose, those representing an older world and older values inexorably declined. Sheila Hancock's Marion, initially all upper-crust squawks of 'soopah' and 'enchanting' as she patronised Sidney, became a hopeless victim of the gin bottle. And David Burke's Geoffrey, the shopping mall he unwillingly designed now in ruins, was reduced to haplessly imploring Sidney to offer him the projects he once patronised as 'squalid'.

A play for the 1970s? Well, it ended with that period figure, the unscrupulous property speculator, invading the others' Christmas gathering, forcing them to play humiliating games, cramming apples beneath their chins and tea cosies on their heads, and yelling 'dance, dance, dance' as they caper round a drunken Marion's kitchen. But *Absurd Person Singular* is more durable than that. As often in Ayckbourn, time itself is the foe.

JOSEPH AND THE AMAZING TECHNICOLOUR DREAMCOAT

ASSEMBLY HALL, EDINBURGH, AUGUST 25 1972

We've got so used to thinking of Andrew Lloyd Webber in terms of the lavishly staged shows which restored the British musical's international reputation that it's good to remember that his career began with a jaunty Biblical micro-cantata sung in a London school for seven to thirteen-year-olds. Myself, I'd better admit that, much as I've enjoyed *The Phantom of the Opera*, *Evita* and that improbably bold salute to the feline classes, *Cats*, I've a special affection for the mischievously titled show he created with the librettist Tim Rice for Colet Court at a time when both men were unsure what form their incipient collaboration should take.

The inspiration came from Alan Doggett, a friend of Lloyd Webber's parents and Colet Court's choir director. He'd already made a demo record of songs from *The Likes of Us*, a musical about the philanthropist Dr Barnardo created by the young Rice and the still younger Lloyd Webber. That got nowhere, but Doggett's request for a fifteen-minute piece for an end-of-term concert did. In March 1968 about sixty parents heard the first version of *Joseph* in a school hall too small for any accompanying instruments except a piano and a cello played by Andrew's brother, Julian.

The parents clearly enjoyed the jokily colloquial but not irreligious oratorio that the collaborators had drawn from the Genesis story about Jacob's favourite son, the jealous brothers who sell him into slavery, his misfortunes in Egypt, his dreams, his rise to fame and power and his reconciliation with those treacherous siblings. But that seemed to be the end of *Joseph* until Andrew's father, himself a musician, ensured that the Colet boys sang an expanded version as part of a concert he'd organised

at London's Central Hall. The influential music critic Derek Jewell wrote a review in *The Sunday Times* – 'bristles with wonderfully singable tunes', 'a considerable piece of barrier-breaking' – that gave *Joseph* a future and, eventually, the permanence it now enjoys.

The score was published, the songs recorded, the show itself lengthened, lengthened again, and at long last staged: at the 1972 Edinburgh Festival by Frank Dunlop and his Young Vic company as part of an evening which began with an updated version of medieval Wakefield's miracle plays. That's when I first encountered it, and in a sceptical mood, as I had thought Rice and Lloyd Webber's first London success, *Jesus Christ Superstar*, soupy and overblown. However, I found *Joseph* simple and sweet, naïve and enchanting.

Jewell had especially admired 'Close Every Door to Me', which Joseph delivers after Potiphar's lecherous wife has had him thrown into prison. That looks forward to the haunting melodies Lloyd Webber was to compose for *Evita* and *Phantom*. But I fell for the show's sprightly tunes and bright, clever lyrics. It was fun to hear Potiphar boasting of being one of Egypt's millionaires, a man who had made his fortune buying shares in pyramids, or the narrator singing that, though Egypt endured seven years of famine it didn't mind a bit: 'the first recorded rationing in history was a hit.' And it didn't matter that occasionally there were the off-rhymes that meticulous American lyricists deplore. We all chuckled when Joseph was interpreting the Pharoah's troubling nightmares: 'All those things you saw in your pajamas / Are a long-range forecast for your farmers.'

The show transferred to the West End, where it has frequently been since; in 1991 with Jason Donovan as Joseph and in 2007 with the same role taken by Lee Mead, an actor chosen by public vote in a TV competition that I found faintly sadistic but had to admit produced the right result. The real problem was the size of the London theatres in which they appeared and, inevitably, the bulk of each revival. *Evita* needed a big, imaginative Argentina onstage, and *Phantom* gained hugely from Maria Bjornson's exotically designed Paris opera. But though I still relished Rice and Lloyd Webber's amusing parodies of calypso, reggae, western, Piaf ballad and Elvis rock, I thought the Palladium and the Adelphi made *Joseph* look bloated, slick, vulgar and everything it originally wasn't.

Why did Joseph's prison teem with bopping beauties who had clearly been shopping in ancient Alexandria's Carnaby Street? Or he himself make a climactic entrance in a primaeval Batmobile and take his final bow from

a fireman's ladder which trailed rainbow-coloured silk over the stalls? Lloyd Webber himself once said the show was best served small and simple. He was right.

NOT I

When I was a boy I often saw an old woman in a rough brown smock, her arms working like pistons as she hurried to Tonbridge station. There, she was planning to meet her husband, who had been killed in the First World War. In time her obsessive bustle became a doleful trudge, and then she disappeared from the roads. I don't know her ultimate fate but I do know that she came back to my mind when I saw Samuel Beckett's seventeen-minute monologue. If the spotlight that isolated the speaker's mouth had spread to reveal her body, I'd have expected to see the ragged figure of Old Susie, as she was known in rural Kent.

And if Old Susie had spoken, I daresay much the same anguished gabble would have poured from her as it did from the character Beckett simply called Mouth. Which was little help to me as I struggled to understand what still seems the least reviewable of the ultra-imaginative, ultra-short plays the old fatalist wrote in later life. Driven to desperation by the breathless pace with which already incoherent thoughts were being delivered by the actress Billie Whitelaw, or rather by the tongue behind the palpitating lips that were all we saw of her, I returned to the Royal Court to see the piece again, read the script – and only then felt able to write a review.

Later I talked to the actress about the play and realised that my desperation hardly compared with her own. Whitelaw found the lines hellish to learn and her reduction to that spotlit mouth hellish too. Strapped into a chair with her head held still by clamps, a mask over her eyes and everything including her teeth blacked out, clutching a bar that was so hard it rubbed skin off her palms and talking so fast she hadn't time to swallow her spittle, she felt she was teetering on the edge of an abyss. It was much the same with Jessica Tandy, who created the role in America. She stood, clinging to two iron bars. 'I was black all over,' she said. 'Black gloves, black hat. I felt like an old English hangman.'

Nor did Tandy get much help from Beckett when he was asked to explain the play. 'I'm not unduly concerned with intelligibility,' he said. 'I hope the piece will work on the necessary emotions of the audience rather

than appealing to their intellects.' However, my own reading convinced me that there was sense in the seeming senselessness of a woman who babbled out a fragmentary story, only to interrupt it with regular cries of 'What? Who? No! She!' in what a stage direction calls a 'vehement refusal' to relinquish the third person she uses. As the play's title suggests, she must distance herself from suffering she can't, won't admit is her own. This wilderness of a life belongs to someone else: Not I!

Mouth, it seems, was deserted by her parents, raised in a loveless orphanage, and has become a lonely, frightened adult, forever wandering the countryside, avoiding others. Occasionally she was found in public lavatories, spouting distorted vowels. Once she was taken to court, but couldn't speak there. Once, and only once, she wept. Otherwise 'nothing of note' happened until, at age seventy, she had a strange mystical experience in a field, after which feeling came back to a body she had experienced simply as an inefficient machine – and her mouth jabbered out the same words it's presumably also delivering in the theatre.

Beckett said that he got the idea for the play partly from watching a Moroccan woman in her burka, crouched, peering out, intermittently flapping her arms against her sides, then hunkering down until the appearance of a child ended her wait. But he also said he knew Mouth because he'd seen many women like her in his native Ireland, beside the hedgerows, in the ditches, stumbling down the lanes: 'and I heard her saying what I wrote in *Not I*. I actually heard it.'

Though *Not I* comes across as pain, denial, hopelessness and grief distilled, its meaning remains much debated, as does that of the 'auditor' who stands beside Mouth, a dimly lit figure who intermittently raises his arms and lets them fall 'in a gesture of helpless compassion'. What, this father confessor seems to ask, can you, I or anyone do, given the predicament of a piece of human driftwood that cannot admit it exists at all? A whole life has been reduced to a pair of lips, bulging and writhing like some blubbery sea-creature ('a crazed, oversexed jellyfish,' said Whitelaw when she later saw her Mouth on TV) gasping its last on the hook. All Beckett's plays are laments for human waste, but few are as extreme and none as theatrically startling as this.

THE MISANTHROPE

Where to begin? Perhaps with Tony Harrison's witty translation. Or with his and the director John Dexter's sophisticated updating of Molière's original. Or with the performances of Alec McCowen, curmudgeonly yet humane as the title-character, and Diana Rigg, mischievous yet touching as the coquette whom the misanthrope can't help loving. Together, they proved that Molière, so often so clunky on English-speaking stages, could be as elegantly entertaining as any of our contemporaries – and, in the process, gave the National Theatre company one of its greatest successes and the playwright a wonderful 300th birthday gift.

That was because Dexter and Harrison set the play in 1966, when de Gaulle was in the Élysée Palace and seemed almost as powerful as Louis XIV had been when the play first appeared in Paris in 1666. Back then it was no great commercial success, for there's no broad comedy in it, but it was much admired by the cognoscenti and came widely to be seen as its author's finest work. Certainly Molière created no more complex character than Alceste, who can be seen as a truth-teller of rare integrity, an arrogant egoist, and many things in between. Some say he was the self-portrait of an irritable author beset by troubles, including a painful marriage to a wayward woman much younger than himself. Some say Molière drew on the cantankerous Duc de Montausier who, told by gossips that he was the model for Alceste, threatened to beat Molière but, after seeing and liking the play, invited him to dinner. Who knows?

Whatever the answer, McCowen didn't fall into the error of Baron, the handsome Palais-Royal actor who succeeded Molière as Alceste within weeks of the dramatist's death and clearly softened the character. McCowen was choleric, affectionate, fastidious and narcissistic. There was a self-consciously aloof expression on his face, a tiny swagger in his walk, all of it coming with a slightly puffed out chest, eyes apt wearily to close, his hand and mouth sometimes joined in thin-lipped prayer. This unsentimentally conceived yet oddly likable Alceste clearly enjoyed the wrath he felt at a society he'd decided was uniformly spoiled, silly, hypocritical and corrupt.

He itched for the fray and would, one felt, have been disappointed if a bad world were to catch up with his good sense and virtue.

Take the famous moment when the fatuous but socially influential Oronte insists on reading him his sonnet. Arms folded, face puckered, McCowen squirmed in a desperate attempt to say something uncontentious about the banal verse, only to burst out in obvious relief with 'Jesus wept! It's bloody rubbish, rhythmically inept, Vacuous verbiage, wind, gas, guff. All lovesick amateurs churn out that stuff.' It was glorious, hilarious, both because of the immaculate acting and because of the translation. Martin Crimp, Ranjit Bolt and others have anglicised Molière's rhymes to fine effect, but none as daringly as the Harrison whose epigrams embraced references to Le Figaro, the Metro, Malraux, the Special Powers Act, the Prix Goncourt and an eminent host who 'tells a boring story and you'd swear The Château Mouton Rothschild's ordinaire'.

That quip came from Rigg's wickedly enchanting Célimène, the young scandalmonger Alceste unwillingly adores and madly hopes to marry, reform, and take to some rustic wilderness, only to get the irredeemably metropolitan reply: 'I'm only twenty, I'd be terrified, Just you and me and all that *countryside*.' Madly, because she's incorrigible, having badmouthed him and even written a duplicitous love letter to the awful Oronte, something that reduced McCowen's Alceste to a gulping, gobbling, boggling half-lunatic. He wept at the language's inability to produce words strong enough to express his outrage and, when he did speak, it was in a voice that was now hoarse and breathless, now a roar or a screech, now an abject plea: 'try to convince me you're faithful, please, please.'

Here was Molière's misanthope in all his contradictions: absurd in his self-righteousness yet impressive in his passionate sense of what *was* right, a man to admire yet one who might become the sort of paranoiac you see on buses, haranguing the empty air for imagined slights or supposed injustices. And as such McCowen, that superb and often underrated actor, and Dexter's brilliant production left you asking and not quite answering questions that traverse the centuries. At what point does 'frankness' becomes bitchy, scurrilous, prurient, cruel and/or smug? What is honesty and when and why is it unavoidable?

SIZWE BANSI IS DEAD

ST STEPHEN'S HALL, NEW BRIGHTON, SEPTEMBER 1974

The key date might be October 1972, when the South African theatre's most famous attack on apartheid was staged before a multi-racial audience in Cape Town. Or September 1973, when *Sizwe Bansi* opened in London to acclaim from the critics and complaints from the South African embassy. Or December 1974, when it went to Broadway and won Tony awards for John Kani and Winston Ntshona, the black actors whose improvisations had done much to create the play. But their self-professed 'scribe', Athol Fugard, has spoken and written so vividly about the play's airing in a shabby hall in a desperately impoverished township outside Port Elizabeth that it surely counts as the key or even great moment.

Their play stirred an audience that knew how easily black people could be arrested, imprisoned and deported for lacking up-to-date 'passbooks'. That's the fate faced by Sizwe Bansi – Xhosa for 'broad nation' – until a friend urinates on a pile of rags, realises it's a corpse, and donates Sizwe the dead man's papers and identity. Unsurprisingly, there was what Fugard later called a near-riot as spectators reacted 'with disbelief, panic and fear that these things were actually being spoken about out loud – and then joy, that this was a celebration of small things in their lives'.

Fugard had concluded that apartheid was 'systematically evil', and had himself defied taboos against interracial casting by appearing onstage with Zakes Mokae in his own *Blood Knot,* when he was approached by aspiring performers from New Brighton, among them teachers, servants and a bus driver. Hence the birth in 1965 of the Serpent Players, so-called because they performed in what had been the snake pit of Port Elizabeth's zoo. Soon they were joined by Kani and Ntshona, respectively a janitor in a Ford factory and a laboratory assistant – and, felt Fugard, 'whole' men 'not yet defiled by bitterness and hatred'.

By the time they began work on *Sizwe Bansi* the Serpent Players had presented a diversity of drama and encountered plenty of trouble. Special Branch had made itself felt from the very start, interrupting a reading of

Machiavelli's *Mandragola*, and had arrested several actors, including the star of Brecht's *Caucasian Chalk Circle* just before its opening. And Kani and Ntshona, themselves later imprisoned for 'slandering' the system, registered as Fugard's servants in order to evade the segregation laws.

They rehearsed in Fugard's garage and in the boys' and girls' lavatories of a derelict school, evolving a two-hander inspired by both his and the actors' experience. He had briefly been a clerk in a court trying passbook cases – 'a nightmare, awful and ugly' – but they understood black life as he obviously couldn't. Hence the opening, in which Kani described Henry Ford II's visit to his factory in subversive detail. The words, actions and mime were often hilarious but also punchy, as when Kani, who played several characters, including the canny operator who gets Ntshona's shy, bumbling Sizwe that passbook, delivered his warning. 'Stay out of trouble,' he said. 'Impossible, our skin is our trouble,' came the reply.

An invitation from the Royal Court, which had previously staged Fugard's *Boesman and Lena*, brought them and Fugard, whose passport had been confiscated and then restored, to London for runs that led to a transfer to the West End. Then came that township showing. Special Branch lurked outside while the excitement grew inside. The hall was so full that young men scaled the walls and sat in the fanlights. Everybody greeted the opening monologue with gales of laughter, and one man went further. He pushed his way into the acting area, raised Kani's hand like a boxing referee, and declared that he'd 'knocked out Henry Ford the Junior.'

When Ntshona proudly posed for a photograph, a cigarette in one hand and a pipe in the other, one youth laughed so much he fell out of his fanlight, but a stunned silence greeted the revelation that the photo would go into another man's passbook. 'Don't do it, brother,' a voice shouted, 'they'll catch you.' 'To hell with it,' replied another. 'Go ahead and try. They haven't caught me yet.' Cue a prolonged and passionate debate during which Kani and Ntshona sat and listened. It all ended with everyone singing the anthem of the banned African National Congress.

Fugard has said that he prefers subtler drama to a play 'that walked the tightrope between poetry and propaganda', but he's also said that on this occasion he was 'watching a very special example of one of theatre's major responsibilities in an oppressive society: to try to break the conspiracy of silence that always attends an unjust social system.' For him, theatre is a civilising influence because it provokes people to think and feel, sometimes about 'things they don't want to think and feel'.

For Kani, like Ntshona an honoured citizen in the new South Africa, the theatre is 'a powerful weapon for change'. So it certainly was when *Sizwe Bansi* made its long journey, bearing witness, stimulating minds, emboldening hearts.

COMEDIANS

Trevor Griffiths got the idea for his best-known play after hearing that a retired comedian was holding classes for aspiring comics above a pub in his native Manchester, the city where the piece is set. Myself, I saw its premiere in Nottingham, where Richard Eyre, later the National Theatre's artistic director, had turned the Playhouse into the nation's finest regional rep, staging exciting new work by David Hare and Howard Brenton and assembling equally strong companies to perform it. The cast of *Comedians* included Stephen Rea and Tom Wilkinson – and made the name of Jonathan Pryce, who brought a ferocious charisma to the role of a young man who sees humour as verbal TNT.

The nature, quality and effect of humour are the play's most obvious subjects. Which of the five men – no funny women back in 1975 – being trained by a retired comedian called Eddie Walters will impress Bert Challenor, the London agent who has come to audition them? Those who stick by their teacher's idealistic view, which is that comedy is 'medicine, not coloured sweeties to rot the teeth with' and that it can undermine bigotry, relieve tension and heal damaged spirits by telling the truth about things that hurt, worry or frighten people? Or the men who try to buy the cynical Challenor's favour by telling what Walters calls 'stereotype jokes', meaning ones that pander to prejudice?

Out come the jokes and quite a few involve nagging wives, insatiable women, lazy blacks and clueless Irishmen. To Walters, to Griffiths and presumably to the bulk of theatre audiences they're mostly coarse and obnoxious. At Nottingham nobody much laughed when Rea's George McBrain started by saying he'd seen a 'coloured feller' on his way to work, adding 'don't you think that's funny?' Nor when James Warrior's Phil Murray told of the Pakistani who was put on an identity parade after denying accusations of rape and shouted 'she's the one' when the victim appeared? But the men who churned out such cracks were indeed the ones Challenor accepted on his books, while he rejected Wilkinson's Mick Connor, whose jokes involved the frustrations and repressions of the Irish.

So the class was divided between the caring liberals and the cheesy opportunists of laughter, the one faction as eager to improve the world as the other was to exploit it. And that Griffiths had used comedy as a microcosm for much broader attitudes shouldn't have surprised anybody who knew his previous work. He was the author of *Occupations* and *The Party*, two plays concerned with the possibility of political change. He had also described himself as a Marxist in a continuing debate with other Marxists and with himself. So it was clear that something was missing from that emblematic audition – and that was the revolutionary spirit as it was brilliantly embodied by Pryce.

After humour-as-therapy and humour-as-product his Gethin Price offered humour-as-scourge, dressing himself as a football hooligan and bringing onstage two well-dressed dummies and insulting them with such venom – 'there's people would call this envy, it's not, it's hate' – that both Walters and Challenor were appalled. I myself had mixed reactions. I wondered if the act was particularly funny and if it was consistent to condemn caricatures of blacks and Irishmen while reducing middle-class people to suave, silent dummies. But I was exhilarated by the energy of the performance, as were other critics in Nottingham, London and even New York, where Pryce won his first Tony Award.

And revivals of *Comedians* have left reviewers feeling that Griffiths had written a fine play, one that brought maximum inventiveness to tensions and conflicts in a society whose so-called 'underclass' gets larger and more alienated by the day, and created a thrilling part for an actor. Tom Stoppard, who is some way to his right, once publicly wondered if his close contemporary, Trevor Griffiths, wasn't the most talented dramatist of their generation. And certainly his sophistication, his powers of analysis, his sheer intellectual trenchancy make almost every other playwright of the Left look amateurish by comparison.

NO MAN'S LAND

He looked like the sort of ragbag bohemian you can still sometimes see padding about Hampstead, or the kind of ferrety intellectual who once haunted left-leaning bookshops on London's Charing Cross Road, his head full of memories of little magazines and the Spanish Civil War. Certainly the man he played couldn't have been more different from Hamlet, Richard II and the other roles he had filled with such distinction. For John Gielgud, Spooner in Harold Pinter's *No Man's Land* was a major breakthrough, a definitive answer to those who saw him as a classical actor with a voice like a cello but a body as wooden as, well, a cello. It proved that he had a remarkable capacity for the detailed impersonation of a fascinating modern character.

'I wish Pinter would write a part I could do,' Gielgud had said after seeing his *Caretaker*. And though he was troubled by the swearwords in *No Man's Land* – 'my parents would have been horrified at my performing in it' – he found that part in the shabby drifter who inveigles his way into the mansion of Hirst, a wealthy alcoholic played by Ralph Richardson. 'I think Auden, don't you?' he said to his director, Peter Hall, remembering he'd once shared a platform with the poet: 'When this creature came down the stairs with this extraordinary wrinkled face, with his tie hanging out, awful sandals and a terrible soup-stained suit, I was absolutely fascinated.' Everyone liked that idea, provoking Gielgud to reply 'yes, now all I have to do is find a performance to go with it.'

That was clearly a struggle. Hall felt that Gielgud was over-experimenting in rehearsals: 'playing it humble, playing it conceited, playing it creepy, playing it arrogant' and not capturing Spooner's hardness. And both actors were having trouble with those moments when, in true Pinter fashion, the text became silent subtext, leaving each of them wondering if the other hadn't forgotten his lines. Irritated by Pinter's refusal to change any of them, Richardson said: 'in that case, sir, could you tell me how many pauses make a silence?' 'About three, sometimes four, depending on the speech,' replied Pinter in what, to the actors' frustration, was virtually his only comment on his play.

But eventually Hall was able to write that 'today John really broke through and became an arrogant and unpleasant man' or (the view of Michael Feast, playing one of the heavies protecting Hirst) 'a vicious old sponger'. And now it wasn't only sandals, socks you could almost smell, rimless specs, floppy hair, an orange shirt, a grubby grey suit and a slightly bulging stomach that made Gielgud's Spooner distinctive. He also caught the old predator's preciosity – his body bristling, wincing and mildly writhing, as if he'd ants in his armpits, his mouth pinched into an inverted U as if he'd discovered his teeth were made of soap – and the furtive, wily menace the play demanded. 'He always seemed to be acting with every fibre of his presence,' said Pinter, noting the tiny, mordant touches expressing everything from diffidence to bravado, mockery to a fastidious pique.

The result was a performance that worried Hall only because it was so adroit that critics overlooked Richardson's contribution. He felt that other actors could play Spooner – and Paul Eddington was to prove the point in a fine revival at London's Almeida Theatre – but that no one 'could fill Hirst with such a sense of loneliness and creativity as Ralph does'. Actually, Gielgud had originally told Pinter and Hall that it was vital that the actor playing Hirst should not be weaker than himself, 'and with Ralph you'd be getting a stronger one'. And, yes, there was a glassy, lumbering grandeur, a dignity that commanded respect even when his Hirst was begging for his bottle or crawling drunk from his magnificent drawing room.

Though it was Gielgud who won the awards, the two knights had enough rapport onstage for them to run up a total of 378 performances in England and America. Together, they reinforced Pinter's reputation as a specialist in sly, sinister conflict and established his play for what it surely is, a most unusual study of human greed and territorial acquisitiveness. The intruder, it seems, is exploiting all his victim's traits and weaknesses – his isolation and drunkenness but also his memories, his fantasies, his nostalgia for half-forgotten, half-imagined times past – in hopes of taking control of his mind and, hence, his house. 'Funny, menacing, poetic and powerful' was Gielgud's summing-up of *No Man's Land* in a letter – and that judgement seems equally apt today.

MACBETH

I've almost always disagreed with my fellow-critics when we've reviewed the Shakespeare play I know best, having taught it line by line to graduate students and played the Third Witch so definitively as a twelve-year-old that the schoolmaster responsible insisted on our delighting the assembled parents by performing our key scene twice. Though Antony Sher is a wonderfully bold actor, his Macbeth struck me (but not my colleagues) as too energetically extroverted, while Simon Russell Beale's version seemed to me (but not them) to have the inwardness the role demands.

But the acclaim for Ian McKellen's Macbeth was almost universal and Trevor Nunn's revival remains remembered as the deepest and most intense of the last few decades. Admittedly, that was largely because of the intimacy of Stratford's Other Place and, thanks to a budget of just £250, a rough-theatre approach which meant the set consisted of a few crates and the usurper wore a cast-off fire officer's uniform. For once, the actors were within whispering distance of the furthest spectators, encouraging us to feel we were 'supping full with horrors' rather than trying to hear after-dinner speakers at a Burns-night banquet somewhere on the horizon – but nobody shared that sense of horror more than McKellen and his queen, Judi Dench.

McKellen has talked about the role with characteristic lack of pretension. For him, Macbeth is the hugely successful warrior whose ambition impels him to make what's always an error in Shakespeare, 'go into civilian politics'. But slaughter on the field is very different from stabbing to death a sleeping old man who loves him and to whom he owes allegiance. And he has the intelligence and imagination to see the practical and moral ramifications of this. Hence the guilty, accusing visions that so troubled McKellen's Macbeth: the spectral dagger, a ghostly Banquo that not even the audience saw. Hence apparitions that were also invisible to us but not to his own poisoned brain.

So the production's centre was the observing, calculating, remorseful, agonised, hardened and finally severed head that was brought onstage by Bob Peck's superb Macduff. And McKellen's success was that he let us see

its stealthy secretiveness. As Macbeth's darker longings overwhelmed him, he seemed to be watching himself, sometimes with the irony and rueful wit he reported seeing in the character. There were many memorable moments, too, including a feast that became a mix of laughing bravado, foaming rage in which (McKellen later said) unwanted snot invariably poured from his nose, and a grotesque mimickry of the genial host that ended with a woozy wave at the departing guests.

However, my main memory is Act Five, which is surprising, since McKellen has called it 'not very good', yet not surprising, since Nunn cut some of the army scenes that distract from Macbeth's disintegrating psyche. There, McKellen was waxen, blinking, more corpse than man, reviving only for the occasional, seemingly random outburst of disgust, anger or violence – and making you feel that, even though he has said he believes it lacks a metaphysical dimension, the play is about suicide of the soul.

Judi Dench's Lady Macbeth committed a sort of suicide, too, but more unwittingly, since she lacked both imagination and foresight. That the murder wouldn't be the simple affair she thought was shown by the moments when, having to summon evil spirits to bolster her strength, she ran from the very thought of them in sudden dread. She was proposing an act that her mind but not her far weaker psyche could sustain. And her wifely devotion became part of the problem. As often in modern revivals, Nunn emphasized the Macbeths' sexual bond, often putting them in each other's arms. But also as often nowadays, Macbeth's retreat into himself was a rejection, this time so clear that he deliberately turned his back on her, leaving her to weep alone.

Dench wept, screamed with horrified disbelief at the prospect of more murders, yelled at the thanes waiting to kiss Macbeth's hand at the end of the giveaway feast, and, in the sleepwalking scene, rubbed at her hands almost endlessly and gave a sigh which took so much breath from her shaking body that one night she momentarily blacked out. The Lady Macbeth who had begun by girlishly trembling at nothing worse than what she saw as an X-rated movie ended up a broken animal, capable of little more than a thin, grating yowl of protest at what Nunn's production unforgettably involved: self-destruction.

THE PASSION

COTTESLOE, NATIONAL THEATRE, LONDON,
APRIL 19 1977

When I saw Bill Bryden's revival of the York Crucifixion Play on or around Easter Day, I was left in no doubt that, 200 years before Shakespeare lifted a quill, its unknown author or authors had written the British theatre's first masterpiece. And was it anachronistic for actors dressed as modern squaddies or labourers to go about the business of killing Christ, as happened at the National Theatre? No more so than when members of York's Pinners and Painters Guild arrived on medieval carts and in medieval clothes to stage what would surely still have come across as a painstakingly recorded documentary from Calvary in AD 33.

It was as sickeningly, instructively, unforgettably horrible as, say, a burying and stoning to death in Iran today or a sadistic hanging, gassing or shooting in Nazi Germany. Jesus's sinews had shrunk, or the carpenters had got their measurements wrong, or both: which meant that his hands and feet fell short of the holes prepared for the nails and the executioners had to stretch his limbs with ropes. When that and the nailing were complete, they sweatily raised the cross and dropped it into its mortice, giving his bones an agonising jolt. But now the mortice was too wide, so they hammered in wedges, mockingly asked Jesus how he liked their work, gambled for his clothes, and sauntered off.

Certainly, time hadn't made the killers less recognisable. Indeed, it sometimes seemed that only the absence of a tea break between their hammering sessions separated the fourteenth century from the twentieth. They were phlegmatic, self-righteous and hostile to strangers, especially those of a messianic appearance. They botched the details of crucifixion, complaining about the effort demanded of them and blaming their mistakes on each other, yet they took a glumly vindictive satisfaction in the finished job: 'yea, let him hang there still and make mows on the moon.'

A key strength was Tony Harrison's translation, which succeeded in retaining us the alliterative verve of the original while sometimes updating it. 'This bargain buggers me, I'm proper out of puff,' moaned a soldier as he struggled to get a heavy cross upright: surely a fair Yorkshire equivalent –

and Harrison was born and bred in working-class Leeds – for 'this bargayne will noght bee, for certis we want wynde'. And would a senior killer really call a junior one a 'young gormless get'? Well, that seemed absolutely right to me as I stood within a few feet of them and their cross, for this was a pioneering example of the 'promenade production', meaning that the audience thronged round the Crucifixion, as perhaps the voyeurs did 1,950 years before.

So we were present when Jesus cried 'My God, my God full free, wherefore forsook thou me?' and then promised to 'uprise' on the third day after his death. We had also been present when Judas grumbled in a sort of adenoidal staccato 'to see spikenard so slopped, sir, sears my soul sore' and Pilate sidled onstage in the guise of a sottish, sneaky Yorkshire mayor to deliver the death sentence. And some of us we would be present again when Harrison and Bryden revived *The Passion* in 1985, adding other updated mystery plays to create a remarkable trilogy: the *Nativity*, which began with God in a miner's helmet creating the world from the top of a forklift truck, and *Doomsday*, which ended with God the father and God the son promising some people that they'd sing 'of sorrows sere' and others that they could expect eternal bliss.

But it was *The Passion* that haunted the mind. At any rate, I ended up feeling that I'd been present at the British way of Auschwitz, with solid, dogged, yeomanly members of the Torturers' Trades Union looking forward to ending the day with a pint and a pipe after a rather tedious day spent stoking the ovens or ripping the joints. It was Good Friday as it realistically was and, in other guises, has been since and will doubtless be again.

PLENTY

J ust before I sat down to fete *Plenty* I opened my evening paper, and
there was a long, impassioned article by David Hare deploring an
educational system he felt was more about preparing students for a
slot in society than sharing knowledge, provoking questions and
creating a curiosity that might eventually help to change the world. It was
a happy coincidence. It reminded me, first, that Hare is more concerned
with more aspects of public life than any other living dramatist. Second,
that idealism and disillusion have often been his subjects, notably in the
play some still think his best: *Plenty* itself.

And who else gets as much attention from critics, pundits, even
newspaper editors as Hare regularly does and certainly did when the
National Theatre staged what became known as the Hare Trilogy in 1993?
Three plays that respectively looked at the Church of England, the law-
and-order system, and the Labour Party's problems, were reviewed by
politicians and hailed as 'constructive' by a *Times* leader. The National,
many felt, was doing what its name promised, and both before and since
then it and other theatres have encouraged Hare to treat matters of national
and, indeed, international moment: journalism in *Pravda*, the Iraq war in
Stuff Happens and *The Vertical Hour*, economic collapse in *The Power of Yes*,
political corruption in *Gethsemane*, the problems of Israel in *Via Dolorosa*,
even the woes of British railways in *The Permanent Way*.

Hare's plays have also often shown the impact of public events, the
national zeitgeist and history itself on private lives, sometimes with more
intricacy than *Plenty* but never with such power. Here was a piece that
introduced us to a nervous young British agent in Nazi-occupied France in
1943, ended with her exulting in France's liberation a year later, and in the
scenes between showed her decline from optimism to despair in a post-war
Britain seemingly trading moral victory for spiritual defeat. The English
emerged from triumph in battle expecting the land to flow with milk and
honey, only for it to flow with marketing men, advertising agencies and
profiteers; or so Hare and his protagonist, Susan Traherne, believed.

Hare's portrait of post-1945 Britain struck some as excessively negative, reminding them of the grim warnings delivered by Portable Theatre, the turbulent troupe he and other young radicals formed in the 1960s. But few could quarrel with Susan's outrage at Britain's Suez misadventure in 1956. Still fewer could deny that she was one of the most fascinating characters created by Hare, one of whose strengths is writing rich roles for actresses: Helen Mirren in *Teeth 'n' Smiles*, say, or Judi Dench in *Amy's View*.

There Susan was, moping over the advertising copy she'd been hired to write, ruining the career of her Foreign Office husband, smashing china and tearing off wallpaper in mad, impotent protest against the wealth she thinks is sapping her happiness, firing a gun at the affable Cockney who has failed to make her pregnant, and having a forlorn one-night stand with a man who, like her, had found fulfilment in Special Operations. Her war behind the lines had left her yearning for a nation fit for heroes. It had also made her aloof, self-absorbed and callous, terminally trapped in what Hare called a 'struggle against a deceitful and emotionally stultified class'. He acknowledged and embraced those contradictions, as did Kate Nelligan, who created the role, and the Susans who followed: Meryl Streep on the screen, Cate Blanchett in a 1999 West End revival.

The play was also much admired in America, Frank Rich calling it 'relentlessly gripping', others seeing Suez as an analogue for Vietnam. By then, I had decided that my original review was carping, a self-accusation that Hare perhaps endorsed when he wrote to me mildly inquiring why I had been charming to him in person but rude about him in print. I apologised, drawing from him an anecdote about Winston Churchill, who was approached in the gents by a contrite MP and said: 'Frankly, I'd rather you apologised in the House and attacked me in the urinal.'

Well, Hare is a controversial figure, as is anyone who puts their head boldly above British parapets. He has, he's written, been abused for being hysterical, strident and obscene when he's only been observing the passing scene. He's said he's been accused of being a know-it-all when he's trying to ask pertinent questions. I think he's right. Here's a man who continues to demonstrate that the theatre, sometimes derided as socially marginal, can influence public debate. Next time I'll attack him only in the gents, but I hope there's no such next time.

SWEENEY TODD

He's the laureate of disenchantment, the composer who in *Company* wrote that it was 'the concerts you enjoy together, neighbours you annoy together, children you destroy together, that keep marriage intact'. He's the bard of emotional ambivalence, the lyricist who in *Follies* had a wary lover singing 'I've got those tell-me-that-you-love-me-you-do?-I've-got-to-run-now blues'. He created *Assassins*, that jeremiad for no-hopers brimming with rancorous frustration as each prepared to murder yet another American president, and, boldest of all, he created *Sweeney Todd*.

Stephen Sondheim has been feted and execrated, accused of turning the Broadway musical from celebration into desolation, admired for raising it from mindless fun into abrasive art. But fans and foes would surely agree that he outdid himself when he tackled the tale of the barber who cuts throat after throat, dispatches body after body into the kitchen mincing machine below his trick chair, and is himself jugulated by the boy his unorthodox business practices have driven mad. For me, a fan, he proved it possible to write a popular musical about obsession, revenge and some sickening varieties of evil.

Sondheim's inspiration was the British dramatist Christopher Bond's adaptation of a Victorian potboiler about Sweeney's quest to kill the corrupt judge who has raped his wife, stolen his daughter and had him transported. He saw it in east London's Theatre Royal, thought it an 'elegantly written' blend of 'charm and creepiness', acquired the rights, and, with Hugh Wheeler as librettist, found that songs flowed easily. If there was a problem it was that Hal Prince, who directed, persuaded Sondheim, who had seen the show as a chamber piece with fog and street lamps for visual effects, to make full use of a large stage.

The idea was to suggest that Sweeney was partly the victim of the brutalising inequalities created by nineteenth-century capitalism and the class system. Hence a vast, clanking set, constructed from parts of an old foundry, which evoked the Industrial Revolution yet proved too heavy and awkward to move easily. But the technical troubles afflicting the previews didn't worry the show's first audiences. Far from finding the murders silly,

as Sondheim feared, they responded to the initial bloodletting with a loud gasp and, when the prospect of human pies was mooted, entered into the black comedy with 'a satisfying laugh, the like of which I've rarely heard'.

Not that Sondheim and Prince underplayed the Grand Guignol. The opening was filled with foreboding, including (as it did) a terrifying screech from a factory whistle, sombre organ chords, intimations of the *Dies Irae* from the Requiem Mass, and the composer's ominous ballad: 'Attend the tale of Sweeney Todd, he served a dark and hungry god.' And the numbers that followed were daringly various. Here was Len Cariou's Sweeney, serenely singing a love-song as shaving became slashing. Here were Cariou and Angela Lansbury's Mrs Lovett, pastry-cook extraordinary, swapping recipes for their cannibal cookbook: 'Have you any Dean?' 'No, but if you're British and loyal, you might enjoy Royal Marine, though of course it tastes of everywhere it's been.' Here was this grisly parable's Brechtian moral: 'the history of the world, my sweet, is who gets eaten and who gets to eat.'

The show ended with the cast pointing at the audience and chanting 'Sweeney' as they accused it of sharing his crazed vindictiveness. Unsurprisingly, that irritated some critics, but the overall reaction was positive, the *New York Times* lauding *Sweeney* as 'a glittering, dangerous weapon'. Many revivals, among them stagings for New York City Opera and London's Royal Opera House, have justified the enthusiasm. But it's noteworthy that the best non-operatic productions have occurred in the shrunken spaces Sondheim wanted.

The London premiere came on a Drury Lane stage that lacked Broadway's elaborate factory set and so looked merely oversized and empty. It seemed underpopulated even when scores of madmen, released from their asylum by the young hero, scampered around its ample acres gibbering about the end of the world and contriving to remind me of distraught tourists failing to find their way from Soho to Whitehall. But that was corrected in 1989 by Susan Schulman's revival at New York's Circle in the Square, by Declan Donnellan in the National's Cottesloe auditorium, and in 2004 by John Doyle with a highly original production – actors doubling as musicians – that opened at Newbury's tiny Watermill, moved to small theatres in the West End and then won two Tony awards in New York.

Immediacy and danger had been restored: the very qualities that make *Sweeney Todd* Sondheim's most striking creation.

NICHOLAS NICKLEBY

Dickens's novels were regularly adapted for the stage in his own day, though not always to his satisfaction. *Nicholas Nickleby* appeared in London, complete with ultra-sentimental ending, while it was still being serialised and a dramatisation of *Oliver Twist* so dismayed its author that he spent most of the evening lying on the floor of his box. So could the RSC create a version of *Nickleby* that would have kept Dickens upright? Since its directors, Trevor Nunn and John Caird, decided to include both plot and subplots, meaning the novel would be divided into two four-hour segments, could it even keep a contemporary audience awake?

Indeed, Nunn's hopes went further. Could he, Caird, the adaptor David Edgar and a cast that included Ben Kingsley, Timothy Spall, Edward Petherbridge and John Woodvine prove that Dickens, who was fascinated by the theatre yet never wrote an original play of note, was the mighty dramatic talent that nineteenth-century Britain lacked?

Well, they succeeded, despite a rehearsal period so fraught and tricky that the opening night of *Nickleby Part Two* was also its first proper run-through, with actors delivering lines that, thanks to constant rewriting, they barely had time to learn. As Nunn told me later, 'I've never felt with greater certainty that I was leading lemmings over a cliff.' And the initial reviews were mixed and the public reaction cautious until Bernard Levin, then a *Times* columnist, wrote that not for years had London's theatre seen 'anything so richly joyous, so immoderately rife with pleasure, drama, colour and entertainment'. What followed was immoderately rife with signs of success: 200-person queues and even campers with stoves outside the box office and awards galore, including an Olivier in London and a Tony when the show transferred to Broadway.

And it was all deserved. The production wasn't just remarkably faithful to the original but theatrically imaginative. How could it be otherwise when forty-four actors were taking nearly 150 roles? They had to keep changing character in full view of the audience, sometimes in a twinkling. They brought on their own props and mimed the scenery – a carriage, a bus, a sinister house – and created such sound-effects as a seagull, an owl,

the wind and rain. But what was truly innovative, and has been much copied, was the decision to make the company 'the collective storyteller', meaning that actors divided up the narrative, switching to the third person to evoke events in their own lives or, indeed, in that of the tale itself.

At the centre was Roger Rees's sensitive yet sturdy Nicholas, along with David Threlfall's touchingly vulnerable Smike, the boy whom he rescued from Kingsley's malicious Wackford Squeers and who turned out to be the illegitimate son of Woodvine's money-loving Ralph Nickleby. But all Dickens's creations were there, from the idle Mantalini to the fearsome Mulberry Hawk, from the philanthropic Cheeryble Brothers to the Crummles clan, roving actors who came complete with an amusing addition to Dickens's original, a last act of *Romeo and Juliet* that ended happily. And none were played as mere caricatures, since Nunn and Caird felt that some film or TV adaptations had too often reduced Dickens's characters to lovable or unlovable eccentrics, losing dramatic plausibility as well the Victorian novelist's outrage at greed, poverty and the abuse of children.

The result had epic sweep but also moral focus. It embodied a conflict between the cynicism of Ralph Nickleby, who sees human existence as nasty, brutish and short, and the optimism of Nicholas, who thinks that evil will triumph only if good people do nothing. However, the RSC's ending was rather less festive than Dickens's, partly because of Edgar's shock on hearing that Nunn's house had burned down while he was at a Christmas Eve celebration with the actors. He got thinking and decided that Nicholas should finally be seen cradling a starving child: a reminder, he said, that 'there will always be another Smike and Nicholas will always bring the dying boy back to the party even if it ruins it'.

Were audiences, living in an era of moral relativism, refreshed by a vivid evening's defiant rejection of evil and bold belief in the power of goodness? Whatever the explanation, *Nicholas Nickleby* did so much for the RSC's reputation and fortunes that a hoaxer, later revealed as the comic actor Ken Campbell, sent out press releases and letters signed 'love, Trev' claiming that it was changing its name to the Royal Dickens Company. And the show was so good that people half-believed it.

MACBETH

Let's be unkind for a minute but not too unkind. Let's first agree that Peter O'Toole has given some terrific performances in his time and that *Macbeth,* that unlucky play, has tripped up more actors than he's had hot toddies. Let's remember the mix of humour, wistfulness and deep melancholy he brought to the aging Soho roué who gave Keith Waterhouse's *Jeffrey Bernard is Unwell* its title. Let's not forget that the great Ralph Richardson was so hapless as Macbeth that Kenneth Tynan dubbed him 'a sad facsimile of the Cowardly Lion in *The Wizard of Oz*' and that he himself asked his fellow actors if anyone had seen his talent – 'not a very big one but I seem to have mislaid it'.

But the conjunction of O'Toole and *Macbeth* produced a memorable fiasco, as I discovered at a second-night performance that ended with the director, Bryan Forbes, going onstage to denounce the first-night reviewers and his other foes, among them the Old Vic's top management, which had presumed to suggest changes to a production that was clearly careering off the road. As Forbes spoke darkly of 'Judas', his supporters slithered into the seats behind me shouting 'bravo' and 'fuck 'em'. The next night it was a bomb threat that intervened, briefly emptying the theatre. 'Perhaps it was a critic,' remarked O'Toole ruefully.

He had some reason to wonder. The critics variously described O'Toole's Macbeth as 'heroically ludicrous', 'as subtle as a battering ram' and 'Wolfit on a bad night', wondered if the actor was 'taking some kind of personal revenge on the play', and talked of 'Hollywood at its most hilariously self-parodying'. And they weren't exaggerating. 'Don't trust those reviews,' wrote James Fenton in *The Sunday Times.* 'The spectacle is far worse than has hitherto been made out, a milestone in the history of coarse acting.' O'Toole, he added, seemed 'deranged'.

Did the actor really try to walk through what Fenton called scenery that might have been loaned by a minor public school in a costume that, like others, could have been cobbled together by the masters' wives from a pile of old curtains? Maybe. But there was certainly a comically long pause before his Macbeth confided that, yes, he'd 'done the deed'. Nobody

could doubt he'd killed Duncan since he appeared dripping buckets of bright scarlet gore, though admittedly not as much as Banquo's ghost, who appeared to have swum two lengths in a pool of red paint. As yet another critic wrote, there was enough stage blood on show to 'service a transfusion unit at a twenty-car pile-up on the M1'.

And 'confided' wasn't right either. Far from confiding, O'Toole part-barked, part-bellowed, part-chanted out hoarse iambs in an actorish staccato, so that 'Duncan' became 'Dun-ken', 'no one' 'no wan' and 'but here' 'bat hair'. And everyone and everything were similarly hectored: wife, Macduff, Dun-ken, Banquo's ghost, the invisible dagger, hell, some witches who appeared to have sauntered out of a Pre-Raphaelite painting, and Macbeth's own conscience. Was this a primal Scots version of the *Monty Python* loudmouth with the knotted handkerchief over his head? Did he think he was 'addressing an audience of deaf Eskimos who have never heard of Shakespeare', as still another reviewer claimed? It seemed so.

Anyway, O'Toole lolled and swaggered in apparent pursuit of an interpretation that saw Macbeth as a surly, brutalised oaf who changed not one jot between Duncan's inexplicable description of him as a 'worthy gentleman' and his own overdue death. And the actor's riposte to it all? He brazened it out to excellent effect, for the production and performance became notorious enough to play to packed houses wherever they went, reportedly getting the biggest advance sale the Bristol Hippodrome had seen in its long history.

O'Toole had behaved eccentrically from the start, demanding and receiving total artistic control over the production, wanting but not getting Meryl Streep as Lady Macbeth, refusing to set foot in Old Vic offices he inexplicably called The Gas Light and Coke Company; and he didn't get less so. 'What's all the fuss about?' he asked at a press conference. 'It's only a bloody play.'

Macbeth, he added, was very funny: 'They didn't laugh enough. They didn't get the jokes'. Well, only the unintentional ones.

THE ROMANS
IN BRITAIN

OLIVIER, NATIONAL THEATRE, LONDON,
OCTOBER 16 1980

For Peter Hall, then the National Theatre's artistic director, Howard Brenton's *The Romans in Britain* was 'a strong indictment of imperialism that touched a contemporary nerve'. But for the nervous and squeamish it was all about a bizarre-sounding yet undeniably ugly event in the first act. Three young druids were playing and swimming in the forest when they were attacked by three of Caesar's soldiers. Two were casually murdered – and the third was fairly graphically sodomised.

It was the sex and not the violence that caused the trouble. Sir Horace Cutler, the leader of the Greater London Council, sent a telegram to Hall declaring that the play was a 'disgrace' whose staging 'shows a singular lack of judgement on your part' and threatening the National with financial sanctions. There were tabloid headlines: 'Fury Over New Sex Play', 'Take Off This Nude Shocker' and so on. A group of hecklers threw eggs, bags of flour and even fireworks at the actors. The police came to observe, but took no action.

However, that wasn't the end of the matter. The GLC did indeed fail to raise the annual grant it gave to the National. Still more seriously, the nation's self-appointed moral guardian, Mary Whitehouse of the National Viewers and Listeners' Association, launched a private prosecution against the play's director, Michael Bogdanov, for 'procuring an act of gross indecency', only to withdraw it after the case had come to trial at the Old Bailey and Bogdanov had spent many months fearing a heavy fine or even imprisonment.

The irony was that what was really provocative, or at least intended to startle conservative minds and ruffle patriotic feathers, was the analogy that the left-leaning Brenton was drawing between the Roman conquest of England and the British presence in the deeply divided Ulster of 1980. That was why the play ended with an SAS major lurking in an Irish field,

improbably disguised as a yokel and incoherently accusing himself of wielding 'a Roman spear, a Saxon axe, a British Army machine gun' as he prepared to lure an IRA godfather within range of his pistol.

But as Hall feared when he unsuccessfully urged Bogdanov and Brenton to conceal it behind a tree, the rape got more attention than Caesar himself. He dismissed the Celts as 'a wretched bunch of wogs', boasted of crucifying an entire people, ordered the quiet murder of an irritating aide-de-camp, and, with a macho twist of a dagger, yanked out one of his own teeth – and reappeared as the commander of twentieth-century British soldiers who yelled 'fucking, bogshitting mick' as they shot dead a slave girl threatening them with stones.

At the time I felt that oppression, like dentistry, had got a lot subtler since the days when *veni, vidi, vici* were the world's most troubling four-letter words. And now? Well, Howard Brenton has written better, notably his 1974 *Churchill Play*, which reflected the edginess and paranoia of its era by forecasting the creation of a British gulag for unruly social elements, and, in 2008, *Never So Good*, a surprisingly sympathetic play about the former Conservative prime minister, Harold Macmillan.

Nevertheless, *The Romans in Britain* was a big, brave, if slightly mad play which seems now to show how far both political theatre and our tolerance of stage sex have moved since its staging. Yet its very presentation made a lastingly important point. Notwithstanding its name and its reliance on public subsidy, Britain's relatively new National Theatre was an independent organisation that wouldn't shy from tackling controversial subjects – or offending its audiences.

QUARTERMAINE'S TERMS

QUEEN'S THEATRE, LONDON, JULY 30 1981

At his best Simon Gray burrowed into the emotional interstices of people, examining their yearnings, griefs, treacheries, self-deceptions, cruelties, resentments, feelings of failure and (sometimes) clumsy kindnesses with humour and incisiveness, and at a depth few modern British dramatists could touch. But which of the forty-odd plays he wrote before his death in 2008 to commemorate here? *Otherwise Engaged*, that devastatingly funny portrait of a man trying to maintain his detachment while being bombarded with furious demands? Or *The Rear Column*, which involved the same colonial atrocity Conrad treated in *Heart of Darkness* but, thought Gray, couldn't be revived today because the characters made free with the n-word? Or even *Cell Mates*, famous because Stephen Fry, playing the spy George Blake, fled the production and went to Bruges disguised as a Gallic peasant after receiving an unflattering review from *The Financial Times*?

It could be any of those, or *Butley* or *The Common Pursuit* or *Hidden Laughter*, but I've opted for a play that showed Gray could be gentle and touching as well as wry or sardonic. A sort of hilarious melancholy permeated *Quartermaine's Terms*, the play he set in the 1960s in a language school somewhat like the one where he himself taught foreigners during his student years. Harold Pinter's trenchant production left me feeling that it couldn't be easy being a character in a Gray play – you'd soon apply for an exit visa to Bond, Brenton or somewhere less gruelling – but also that the dramatist had rare fellow-feeling for the loser, the flop, the defeated and quietly despairing.

Put yourself in the position of those language teachers. If your beloved mother isn't driving you to murder with her ugly accusations, your spouse is leaving or two-timing you. If your favourite child isn't going mad, your best and most influential friend is refusing to publish even a short extract from the novel that has obsessed you for years. If you aren't forced secretly

to take a menial job to supplement wages so low you can't afford to marry a woman who will probably destroy you, the police will arrest you because your students have taken your lecture on Elizabethan cuisine so literally they've tried to cook a royal swan.

But there in the staffroom, slumped in the central armchair yet peripheral in all other ways, is St John Quartermaine, an affably inept teacher tolerated by the kindly old gays who run the school but shamelessly exploited by the agonised heterosexuals all around him. If they need a babysitter or an uncontroversial guest at a sticky dinner party, they turn to him. If they seem interested in a play at the local theatre, he'll buy them the tickets, which they'll duly neglect to use. Mostly he's left to fester in his bachelor digs, wondering how he'd get through the weekend or, worse, the holidays.

Edward Fox, who played Quartermaine, spent the play smiling uncomprehendingly from inside his little world and visibly wilting, withering, shrivelling as he approached an ending that left him not just isolated but doomed. It was a moving portrait of a man whose flaw was to be emotionally tone-deaf. He heard the music others played, so to speak, but couldn't make out the tunes. He asked solicitous questions, said extravagantly nice things, might even have laid down his life for his supposed friends, yet had only the vaguest sense of who, what and why they actually were. It was like watching a tremendously enthusiastic explorer as he ventured into the jungle without compass or binoculars to help him find his way past engulfing, bewildering, sometimes menacing flora and fauna.

Did the rueful ennui that characterised Gray mean that he lacked sympathy with his creations, as some claimed? *Quartermaine's Terms* proved not. As he once told me, 'One sometimes feels one's writing from the trenches: I don't think anybody can get through life without being deeply hurt.' Certainly, I and others sensed what Gray called his 'deep personal attachment' to Quartermaine, a man 'who embodies for me aspects of a world that vanished so poignantly before I'd even finished making fun of it'.

But what of another accusation, that his plays lacked scope, since many of his characters were literati or, as here, teachers? Well, he had an answer to that too: 'The varieties of experience in education or publishing are as great as anywhere else. I guess I write about them because it's easier for me to establish a context to tell my stories. And I notice my critics don't ask why D.H. Lawrence didn't write about publishers or professors.'

Yes, and in *Quartermaine's Terms* he didn't merely define a rumpled Englishness that many will still recognise. He showed he was master of the ironic imps and cynical demons that sometimes set up shop in his urbane head. It was apt that the theatre Quartermaine's 'chums' failed to attend was staging *Uncle Vanya*. Chekhov himself would have admired Gray's unsentimental yet forgiving portrait of a man as uncomfortable in the modern world as any in *The Cherry Orchard* or, indeed, *Vanya*.

GOOD

C.P. Taylor – C for Cecil, P for Philip, Taylor because that was the family's trade when it fled Russian anti-Semitism – had a particularly keen eye for people's capacity for self-deception. As he said, his principal theme was 'the conflict between man's ideals and his limitations'. That was evident in his shrewd comedy, *The Black and White Minstrels*, which involves a group of liberal friends trying to maintain their self-esteem while evicting a black fellow-lodger, but nowhere more so than in the masterpiece that was still running when Taylor died, aged just fifty-two: *Good.*

This was the Holocaust play of a Glasgow-born Jew who, as he wrote in a note to the text, 'grew up during the war under a deeply felt anxiety that the Germans might win the war, over-run Britain, and that I and my mother and father would end up, like my less fortunate co-religionists, in a Nazi death camp'. But *Good* was very different from the kind of didactic melodrama that's packed with sadists in jackboots. It attempted to understand how the nation of Beethoven and Goethe could perpetrate our era's greatest crimes. As Taylor – a compassionate man whom I knew, liked, and saw teaching young people with learning difficulties – also wrote: 'There are lessons to be learned if we can examine the atrocities of the Third Reich as the result of the infinite complexity of contemporary human society and not a simple conspiracy of criminals and psychopaths.' Its inhumanities, he added, 'seem to me only too human.'

Hence John Halder, who starts the play a harmless professor of literature in Frankfurt, birthplace of his beloved Goethe, and ends up an SS functionary in a hell analogous to the one that ingests Marlowe's Faustus: Auschwitz. Some critics found the transformation too extreme to be plausible but most agreed that Taylor had the narrative logic, psychological insight and theatrical skill to win our belief in Halder's moral journey.

When we meet him it's 1933 and he's very much the harassed husband and son. The task of helping his senile, demanding mother has impelled him to write a novel tacitly recommending euthanasia, and this wins the attention of the new regime, with even Chancellor Hitler scribbling

'written from the heart' in the book. And his chaotic wife persuades him that joining the Nazi Party will protect his university career. No matter that his best friend is a Jewish psychiatrist, who begs him to use his growing influence to get him an exit visa. Halder is too weak, too nervous, too frightened even to maintain contact with a desperate man who, it seems, disappears into an extermination camp.

Careerism and fear combine with the joy an insecure man finds not only in the company of the relatively sophisticated Nazis who befriend him but in the SS uniform that's eventually thrust upon him. Halder becomes the 'humane' face of a party his flattering chums admit is regrettably prone to thuggish 'excesses'. Now he's persuading the head of an asylum to ensure the 'procedure' occurs in a chamber disguised as a bathroom, thus making people's last hours 'absolutely free from anxiety'. Now he's overseeing a book-burning, telling himself that universities too often rate reading over experience. And now it's 1941, and Eichmann is asking him to bring 'the same humane without sentimentality approach that's your particular strength' to the task of banishing 'unnecessary cruelty' from camps containing 'the enemy within'.

What makes this illuminating and, I think, credible is that Halder has a sadly human ability to rationalise the evil into which he slowly slips. At first he excuses the Nazis' anti-Semitism as a politically expedient aberration that will pass. Later he's arguing that the Jews are a remarkable people but that they've shaped a literary tradition too fixated on the individual. Later still he's half-defending Kristallnacht as a helpful warning to Jews that they must leave Germany and, later, blaming them for not taking the hint. And all along he convinces himself that he's basically 'good' – good in any case not being an absolute.

So would we behave much better, given such pressure to compromise? That's what Taylor finally asked in a play that criss-crosses time and imaginatively combines naturalistic dialogue with music in the form of songs that fill Halder's head and distract him from a reality he acknowledges only at the end, when he's greeted by a marching band of camp inmates. It was no great success on Broadway in 1982, some say because it was tactlessly promoted by advertisements crammed with swastikas. But Clive Barnes was only echoing the London critics, and foreshadowing *Good*'s successful revivals on both sides of the Atlantic, when he wrote in *The New York Post* that it was 'a play for the mind and heart, an incandescent evening in the theatre that lights up the conscience'.

NOISES OFF

I went to the premiere of Michael Frayn's *Noises Off* in a bleak state of mind, since I wasn't only suffering from a dreadful cold but had just had a tiff with my wife, who had objected to some minor offence, such as absently locking the children in the cellar while watching football on television. I wasn't in the mood to laugh and, in fact, I badly wanted not to laugh, since laughing was agony: a matter of wheezing, hiccoughing and gasping for breath, followed by great explosions of coughing or, worse, implosions of trying-not-to-cough, during which the chest heaved, the face reddened and swelled, the eyes twirled in their sockets, and (sorry for the details) the nose began to suppurate liquid that looked as if it belonged in the poison labs at Porton Down.

Yet I couldn't stop laughing. I laughed until my pique had shifted from my wife, who was in stitches beside me, to Frayn himself. He had been callous enough to create a piece to shatter the defences and possibly the health of myself and many others, including *The New York Times*'s Frank Rich, who called *Noises Off* 'the funniest play written in my lifetime' when it was successfully staged on Broadway two years later.

It all started in 1970, when Frayn observed Lynn Redgrave and Richard Briers frantically changing clothes as they played five characters in one of the four playlets about marriage that constituted his *The Two of Us* and found their backstage pantings, sprintings and attempts to make calm-looking entrances far funnier than anything occurring onstage. And twelve years later came *Noises Off*, which involved the tribulations of a company touring Frayn's imaginary version of one of the genuinely dopey farces that have long appealed to the English taste for falling trousers, sexual innuendo and general silliness: *Nothing On*.

Act I was comic enough, with a panicky, last-moment rehearsal interrupted by actors earnestly asking for the right Stanislavskian motivation for confusing exits in which they had to carry off barely explicable props, such as a plate of sardines. But Act II blissfully took us backstage for a performance reduced to madness by the tensions that had evolved on tour. Furious dumbshow – the juvenile lead in a frenzy of jealousy, his mistress

in tears, a fellow-actor, who had been caught with her in his digs, in fear of his life – was contrasted to hilarious effect with the precisely timed, jaunty entrances the characters were supposed to make.

Act III, which showed the chaotic closing night of *Nothing On*, had been much revised by Frayn before the National clinched the reputation of *Noises Off* by reviving the play in 2000. But even in 1982 it reduced me to further agonies of laughter and left me feeling that Frayn had cracked the conundrum of farce. It's always funny to see people trying to behave nervelessly in unnerving circumstances. But how to show this in a permissive age, when it's not enough to hide a half-clad mistress in a husband's closet? Well, here were these inept, angry, terrified thespians desperately trying to ensure that the mechanics of *Nothing On*'s absurdly elaborate plot somehow survived everything from falling doorknobs to shoelaces vengefully tied together.

'Getting on, getting off,' wailed the director. 'Doors and sardines. That's farce, that's theatre, that's life.' And, yes, almost all Frayn's plays, comic or serious or both, involve our vain attempts to impose or create order and find meaning in a disorderly and maddeningly complex world. *Copenhagen*, which many think his masterpiece, is largely about the inscrutable motives of Heisenberg, discoverer of the uncertainty principle and the physicist who was directing but possibly subverting Hitler's nuclear programme. Likewise the superb *Democracy*, whose central character is that fascinating but equally unreadable German leader, Willy Brandt.

But to plant such thoughts in our era's funniest farce? That was quite an achievement.

TOP GIRLS

It has been called a feminist critique of feminism, which is true but too abstract a description of the play that established Caryl Churchill as the most brilliantly inventive dramatist of her time. After all, who else would open proceedings by bringing onstage guests ancient and modern, real and fictional, for the sort of dinner party you might conjure up in a spectacularly fanciful game of Consequences? Who else would then give us ultra-naturalistic scenes set partly in an East Anglian council house, partly in a slick London employment agency called, tellingly, Top Girls? Yes, and all to suggest that women may almost literally be throwing their babies out with all that old, cold bathwater.

At first you ask why Marlene, who has just got the top job at Top Girls, is celebrating her triumph with her A-list of remarkable women: Lady Nijo, a medieval emperor's courtesan who became a Buddhist nun and spent years traversing Japan on foot; Isabella Bird, who defied Victorian convention by making intrepid journeys to exotic places; Pope Joan, who occupied St Peter's throne in 854; Patient Griselda, who provided a moral tale for Chaucer by taking conjugal obedience further than modern minds can reach; and Dulle Griet, whom Breughel painted in apron and armour leading a charge of women into Hell.

Well, it becomes clear as they excitedly pour out their stories that most suffered, either personally or through the abuse of their children. All confronted period prejudice with exceptional valour. And Marlene has the arrogance to compare herself with them, toasting the gathering with 'here's to our courage and the way we changed our lives and our extraordinary achievements'.

Her 'extraordinary achievement' turns out to be banal. She has beaten a male colleague to her new post, which seems fine since he's clearly a rather pathetic person whose sense of entitlement becomes doubly apparent when his wife comes to beg Marlene to stand down since he's 'a man'. But it's not fine in other ways. Marlene has mutilated herself in order to escape an oppressive working-class background and take power in an office that specialises in slotting women into a male-dominated business universe.

This has entailed the loss of love and specifically of motherhood, not only through the odd abortion but through one big rejection.

This is revealed in a moment so surprising and so morally effective that maybe you should skip a paragraph if you aren't familiar with a play that's now regularly revived. Marlene's impoverished sister Joyce is bringing up an awkward, backward girl called Angie as her own when she's actually Marlene's child and not, as Angie believes, the enviably glamorous Marlene's niece. Not that a visit from her daughter stirs Top Girls' new managing director. 'Packer in Tesco more like,' Marlene tells the go-getting colleague who has asked if Angie will join the firm. 'She's not going to make it.'

The words chill, clinching Churchill's attack on a kind of feminism that rates success in the marketplace above warmth, care, nurture. And there, surely, is the answer to those who find the play dated, citing Marlene's admiration for Margaret Thatcher's policies and Joyce's description of the lady as 'Hitlerina'. Have women fully succeeded in reconciling the demands of the workplace with those of parenthood without damaging themselves and their children? Come to that, have men?

'She reinvents herself every time,' Max Stafford-Clark once said of Churchill, and he should know because he's directed many of her plays, including *Serious Money*, an anti-capitalist burlesque in verse, and *Cloud Nine*, which moved from Victorian Africa to modern Britain and used cross-dressing to explore sexual totems and taboos. And her imaginative restlessness has variously led her to collaborate with a dance group, take students to Romania to research a play about the Ceausescu regime, introduce a malevolent shapeshifting fairy into contemporary London, and dramatise British evasiveness by bringing onstage people who end up substituting two meaningless words, 'blue' and 'kettle', for threatening nouns and painful verbs.

I'm talking of *Hotel*, *Mad Forest*, *The Skriker* and *Blue Kettle* but could as easily cite *A Number*, a play about cloning in which Daniel Craig played several copies of himself, and *Far Away*, which postulated an apocalyptic war in which every nation, every animal and bird, everything vegetable and mineral is in mortal combat with everything else. They all seize and startle, asking key questions in dramatically daring ways, but none more than that modern classic, *Top Girls*.

FOOL FOR LOVE

S am Shepard once said he was indifferent to 'ideas that speak only to the mind', and after being pulverised by Kathy Baker's performance in his play about the unruliness of love I realised what he meant. Yes, the American dramatist has plenty to say about the unreliability of observation, the elusiveness of truth, the search for personal fulfillment, the decay of the West, the encroachment of a 'civilisation' so gruesomely awful he evoked it in his *Angel City* as green ooze inhabited by fanged men with green skin, and so on and so on; but to see this actress rise to stage directions that ask her to utter 'agonising mournful wails' and her very body to 'weep' was to feel I was witnessing an American Phèdre.

'That's fine, but take it further, still further,' Shepard reportedly said when he himself directed her and Ed Harris, and they did, capping each piece of emotional testimony with another and then another. She was May, who had escaped to a room in a desert motel as stark and tacky as a Central American prison cell, and he was Eddie, the cowboy and stuntman who had followed her there. They wanted each other but, especially in her case, didn't want to want each other. Though this was disputed by their bigamous father, who sat on the sidelines observing them from the surreal stance of his own home, they were half-brother and half-sister.

This wasn't something Shepard concocted in tranquility. He grew up the mid West 'in a condition where male influences around me were primarily alcoholic and extremely violent', with a father who fled to the desert on whose edge *Fool for Love* is set, explaining that he didn't fit in with people. He's said that there's no escape from that 'disaster', the family, and 'absolutely ridiculous' to think you can. So it's unsurprising that many of his plays and screenplays involve the chaos and fragmentation of the American family and, indeed, of the self: 'We're split in a much more devastating way than psychology can ever reveal. It's not some little thing we can get over. It's something we've got to live with.'

He's also said that *Fool for Love* 'came out of falling in love. It's such a dumbfounding experience. In one way you wouldn't trade it for the world. In another way it's absolute hell.' And hell certainly sums up the pit in

which May and Eddie are floundering. At one point she tells him to go, and he briefly does, leaving Baker howling his name. She flung herself against the door, hugged the walls, sank to her knees in a display of feeling that could have seemed absurd yet didn't. *Fool for Love* flirted dangerously with melodrama, but never did flirtation become consummation or the play seem anything but blazingly real.

Nor was May and Eddie's incestuous bond Shepard's only tribute to erotic desperation. Suddenly there was a glare of lights outside the motel, a screech of brakes, the bang of a gun, a crash of glass. Eddie's jealous mistress was making herself drastically felt, and did so again later, setting fire to his trailer and sending the somewhat symbolic horses inside screaming and galloping madly away. Meanwhile, Shepard was giving Eddie and May the long monologues for which he's famous, and they revealed yet more devastation. Both their father's wives were abjectly obsessed with him, and one shot herself dead.

The script says the play should be performed 'relentlessly, without a break'. So it was in New York, more powerfully than when it appeared in London, perhaps demonstrating that British actors find it harder than their American counterparts to abandon themselves. They don't often hurl everything from larynx to fists to knees into a performance, as Kathy Baker did. Yet *Fool for Love* had its subtler notes, for instance when Eddie started impotently to lasso a bedpost, as if to show that the strength of the West, the ability to capture living animals, had drained from him. And that was what the play finally expressed: thwarted passion, frustration, dislocation, loss.

GLENGARRY GLEN ROSS

COTTESLOE, NATIONAL THEATRE, LONDON,
SEPTEMBER 21 1983

It seems amazing now that David Mamet wasn't sure if his tale of real-estate predators in his native Chicago was stageworthy. But when he sent the script to his friend Harold Pinter, asking for advice, the reply was simple. All the play needed was a production. A first one duly followed, but in Britain and at the National Theatre, where Pinter had been an associate director. Not until spring 1984 did America catch up with what's widely regarded as Mamet's best play – and a year-long run on Broadway was the result.

It's a terrific piece, a scathing, darkly hilarious portrait of a mini-jungle within the urban jungle: that's to say, a tacky office very like the one in which Mamet worked as a young man and has described as 'a fly-by-night operation selling worthless land to elderly people who couldn't afford it'. Here, as there, the law is fiercely Darwinian. Eat or be eaten. Sell and thrive. Falter and be fired. A Cadillac is the prize for the most successful of the four salesmen seen chivvying, browbeating, and sweet-talking gullible locals into buying bits of Florida sod or swamp with misleadingly exotic Scottish names. The next best will get a set of steak knives but the two losers must start searching for some new lair from which to hunt for prey.

'Those guys could have sold cancer' was Mamet's memory of his own fellow-salesmen. 'They were amazing, a force of nature.' And that was true of the actors at London's Cottesloe and then at New York's Golden Theatre, and especially of the English Jack Shepherd and the American Joe Mantegna, each of whom created the character of Richard Roma in his own country. Each verbally ducked, jabbed and weaved as this Capone of the Cadillac contest delivered some of the dramatist's most brilliant dialogue. Each was heard mesmerising a stranger in a restaurant into signing away a fortune, and then, when the poor patsy had second thoughts, improvising

a hologram of deceit so dazzling yet solid-seeming that surrender became almost inevitable.

Glengarry Glen Ross certainly confirmed what Mamet's earlier *American Buffalo* suggested. The dramatist was, is, the bard of streetwise barbarism, the laureate of the four-letter word, a writer who creates a brazen, swaggering poetry out of everyday speech that still somehow manages to remain everyday speech. It was enough to win credibility for a thinnish plot whose key event occurs in the interval between the play's two acts. A desperate salesman robs his own office for 'leads' to sell to a competitor and then, a bit implausibly, owns up to the robbery. But who cared about minor improbabilities given the verbal, human and dramatic energy on show in both London and Manhattan?

That energy made Mamet's point more compelling. He once said that 'three cheers for me, to hell with you' was the 'operative axiom' of American business. Again: 'Sharp practice inevitably shades over into fraud. Once someone has no vested interest in behaving in an ethical manner, and the only bounds on his behaviour are supposedly his innate sense of fair play, then fair play becomes an outdated concept.' Yet again: 'If you don't exploit the opportunities, not only are you being silly, you're being negligent.' As in the subtler *American Buffalo*, so in the scorching *Glengarry Glen Ross*: crime and business are virtually synonymous.

Yet Mamet once said he had never created a character he hated. These real estate piranhas may despise the people they lure into their pool. Their myth may be that they are 'men', perpetuating America's frontier spirit in a world of 'faggots', 'fairies', 'children', and people whose 'broads all look as if they got fucked with a dead cat'. Yet at least they feel they must find some rationale for unscrupulous dealing which itself is the result of an insecurity, a vulnerability which means that, say, a beloved daughter will suffer the consequences of a salesman's unemployment. The victimisers are victims themselves: of the agency's ruthless owners, of common commercial practice, of an America that Mamet has called 'spiritually bankrupt'.

Here was the paradox of *Glengarry Glen Ross*. Mamet wrote of his embattled hucksters with an appalled sympathy, combined with a certain admiration for their imaginative wizardry, buccaneering pluck and dramatic skills. Yet never has he written more cynically about what he feels they represent: his nation.

DEATH OF A SALESMAN

Y ou don't often hear the sound of sniffing, gulping and suppressed sobbing from a rapt theatre audience. You certainly didn't expect to hear it on the Broadway of the 1980s, where and when serious plays were seldom to be seen and such noises might betoken a decidedly unrapt despair at yet another big, goofy musical. Yet I swear that was the sound provoked by Dustin Hoffman, playing Willy Loman, and John Malkovich, playing his disappointing son Biff, as they hugged each other for the first and last time in Michael Rudman's revival of Arthur Miller's finest play. And I should know, because some of those unmanly gulps were probably coming from me.

It was a magical moment, and a surprising one, because Hoffman's portrait of Miller's faltering salesman had sometimes seemed over-calculated and external. His Loman had been too little the doomed drudge, too much the chirpy vulgarian. True, that had brought its rewards. When Hoffman exuberantly brandished his bottom at his long-suffering wife Linda, or jokily tweaked her breast on the line 'you're my foundation and support', you felt you were looking beyond this run-down replica of a man and seeing the cocky hustler Loman had been in happier times: gabbing unstoppably away, swapping risqué jokes with the buyers, flirting with the secretaries and, at times, seducing them. Warren Mitchell was somewhat similarly peppy and punchy when he played Willy at the National Theatre in 1979, and, as the dramatist told me, Miller was impressed.

But the interpretation also brought its problems. Even though Hoffman began by waddling exhaustedly into his tiny house, a dumpy little penguin that looked as if it had yet to recover from a losing encounter with a shark, he wasn't a man who was thinking of suicide, as Willy supposedly is. For all the distraught and sometimes desperate moments that followed, his keynote was resilience in adversity. Indeed, maybe Hoffman's most original touch came right at the end, when Willy does go out to kill himself. Miller's stage directions ask him to exit with 'a gasp of fear', but this time that final

exit came with a smile, a skip and bounce of the feet, and another feisty clap of the hands. His 'accidental' death in a car crash will, he thinks, bring Biff the insurance money he needs to succeed – and, as played by Hoffman, an act that most people would regard as the ultimate manifestation of despair became a jubilant salesman's last big deal.

That was clever, too clever, yet not without meaning and purpose. Moreover, a performance that had threatened to become mannered was never lacking in warmth and, as it turned out, depth. The same was true of Malkovich, an actor who can sometimes become fussy, over-clever, mannered. His Biff was wan and woebegone, pretty clearly the failure that his father can't face him being, yet within that wispy, willowy frame there was an extraordinary intensity of devotion. Or so it appeared at that strikingly climactic moment.

The two men, so terribly at odds for so many years, at last managed their stricken, fumbling yet forgiving embrace. Willy cradled Biff for longer than Miller can have dreamed of, on his face the sort of incredulous tenderness you expect from a father when he holds his newborn baby for the first time. And he blushed, choked and inarticulately gurgled in surrender to what was, you realised, the primary relationship of his life.

This not only helped to justify that somewhat revisionist ending. It greatly helped the play as a whole. After all, Miller's point is that, though he's slipping, sliding, plummeting into the American trashcan, this American dreamer still worships the false gods that have betrayed him. He's been sucked and suckered into a world where big ads promise a reliable fridge, backslapping a lasting friendship and boyhood popularity adult achievement. He's mistaken show for substance, appearance for reality, conspicuous consumerism for success in life.

At any rate, that's what his mind says. But it was clear here that his heart didn't agree. Hoffman unforgettably showed that what the salesman valued and what gave him value, in each case without him knowing it, was something simpler, something greater: love.

LES MISÉRABLES

BARBICAN THEATRE, LONDON, OCTOBER 8 1985

D o you recall the scene in *Close Encounters of the Third Kind* when François Truffaut and other earthlings gape at the landing of a majestic alien spaceship? Well, halfway through the first night of the RSC's staging of *Les Misérables* I glanced at the stranger to my right and she, too, looked that way. Her eyes were bulging in unabashed wonder, as I daresay mine had been too. Trevor Nunn and John Caird's production had transported us into a world of treachery and self-sacrifice, evil and a heroism not exactly common in central London.

Picture my surprise, then, when I read the very different reactions of all but a few reviewers. One view seemed to be that Victor Hugo's novel had been horribly cheapened, another that the novel was such a bore it wasn't worth cheapening. 'A load of sentimental old tosh,' wrote a well-known British critic. 'Like eating an artichoke,' declared another, 'you have to go through an awful lot to get a very little'. No fewer than two rudely rechristened the show *The Glums*. Thank God I hadn't read the original book, or maybe I too would have been supercilious and sneery at the expense of a musical the audience itself clearly loved.

And not just that audience. To call Alain Boublil and Claude-Michel Schönberg's show a success is like calling a hurricane breezy, since it has blown record after record away, becoming London's longest-running musical ever and, at the time of writing, still going strong in the West End. Indeed, it has done so well that it's hard to believe that its co-producer, Cameron Mackintosh, hesitated before transferring it from the Barbican to the Palace, actually phoning his backers to ask if they'd like half their investment returned rather than risking it all on a show that had alienated the critics, had virtually no advance at the Barbican box office – and, as Nunn said when the show celebrated its twenty-first birthday, had a wilfully depressing title, contained twenty-nine onstage deaths, was presented by a Shakespearean company, involved French history, and lacked dance routines, tap shoes, fishnets, chimney sweeps, cowboys, wizards and a reality TV show to galvanise public interest.

So what was and is the improbable appeal of the tale of Jean Valjean? For a start, it's the sort of large-hearted epic not often found in our cynical, stingy times. Here's an embittered felon who breaks his parole and, stunned by the forgiveness and generosity of the bishop whose silverware he steals, evolves not just into a solid citizen but into a near-saint. He helps the rejected and dispossessed and refuses the opportunity to destroy Javert, the relentless pursuer who plans to return him to the chain gang. It's gripping. It's so moving that, at the risk of sounding wet in every sense, I must admit it has had me battling my tears on each of the five occasions I've seen it. And it's more.

More in what in some respects is an obvious sense. Schönberg's sung-through score had tremendous energy, as did a production that originally featured Colm Wilkinson as Valjean, Roger Allam as Javert and Alun Armstrong as the scavenging opportunist and all-round ratbag, Thénardier. At the Barbican and in the West End the revolve seemed always to be on the go, bringing us new faces, new incidents, new places that the designer John Napier furnished with rare inventiveness. I especially relished the moments when two bizarre timber structures, all barrels and wheels and broken chairs, trundled onstage to be linked by a walkway or to clank together, like sci-fi monsters copulating. Here were the Paris slums in impressionistic miniature. Here was a street barricade that only needed a topping of youths with flags to evoke the uprising of 1832.

Yet I found the show equally effective when I saw a touring production that used projections of Hugo's own paintings for décor. So what does fully explain the success of a show that won eight Tony awards when it started its long Broadway run, has played in over forty countries and three hundred cities, and been seen by some sixty million people worldwide? Obviously it compares Javert's rigid justice with Valjean's pliant mercy. But it goes further. It has what it doesn't seem excessive to call soul. *Les Mis* forthrightly declares that that forbearance, love and goodness exist. And isn't that a refreshing message in our spiritually dilapidated world?

ENTERTAINING STRANGERS

ST MARY'S CHURCH, DORCHESTER, NOVEMBER 18 1985

David Edgar is as prolific as he's incisive. He's the author of over seventy plays, varying from the agitprop work of his radical youth to his two-part version of *Nicholas Nickleby* to *Written on the Heart*, which celebrated the 400th anniversary of the publication of the King James Bible. He once told me he was a man who loved committees and, yes, he's taken particular interest in the political process, the workings of power: *Destiny*, about the rise of the extreme right in Britain; *The Shape of the Table* and *Pentecost*, which involved turbulence and change in, respectively, central Europe and the Balkans; *Continental Divide*, twin plays about a gubernatorial election in a western American state.

That double bill took me to Ashland, Oregon, where it had its premiere in 2003, but it was a shorter journey, a drive to deepest Wessex through a rainy autumn night eighteen years earlier, that has left me with the memories I can't shed. Not that I can recall why I went to Dorchester at all. The prospect of a 'community play' in a chilly church wasn't inviting, even though Edgar had been commissioned to write it. Everything suggested the sort of project critics receive respectfully but their readers cannily shun: worthy, earnest, dull, the theatrical equivalent of a working breakfast in an antique vicarage.

But *Entertaining Strangers* turned out to be as moving as it was riveting and eventually made its way to the National Theatre, where Judi Dench and Tim Pigott-Smith took the leading roles in a story that had been researched by the Dorchester townspeople themselves. What, Edgar had asked them, would make a dramatic local subject? Not Thomas Hardy, about whom they knew almost too much. Not the local farmworkers who were transported for the crime of organising a trades union and became enshrined in working-class legend as the Tolpuddle Martyrs. But Henry Moule, the hellfire vicar who was the model for Angel Clare's doughty father in *Tess of the D'Urbervilles*, and Sarah Eldridge, founder of a brewing

dynasty – now there were characters worth plucking from their nineteenth-century graves.

She was a canny businesswoman with what, in 1985, seemed like proto-Thatcherite convictions. He was the sort of Victorian best described in geological terms: flinty integrity, granite determination, rock-like obduracy. He alienated the poor in his new parish by refusing to continue paying worshippers who swigged the communion wine with cries of 'Cheers, Lord!' and he drove away the rich by inveighing as fiercely against their gambling and blaspheming as against whores and drunks. 'Sin is sin,' was Moule's blunt message, 'its wages death.'

The result was what Edgar called 'a titanic twenty-year contest of wills'. *Entertaining Strangers,* he wrote, is 'about the attempt to impose two eminently Victorian values on an English county town in the process of transformation from an essentially rural to an urban society.' And the big test comes when cholera strikes the new slums. Moule almost singlehandedly halts its spread, refusing to take his family to safety, collecting clothes from the dead, boiling them clean, and bringing the sick and dying his uncompromisingly tough love. Meanwhile, Sarah proves unable or unwilling to stop her daughters taking her great brewing vat and using it to disinfect what's been ripped from the corpses and near-corpses.

Both principals change or at least evolve. Moule becomes more discriminating about the nature of sin, publicly denouncing the cause of the plague, which is effluent from the royal estate surrounding the hovels into which its labourers are crammed. The vicar who sermonised about the scriptural duty of servants to obey their masters is left thinking rather more of masters' obligations to their servants. And far from 'suspecting people who have more time for the needs of utter strangers than for those they know', as she initially does, Sarah comes to think that maybe strangers should be rescued, 'snatched from the very jaws of Hell' – and entertained.

It sounds didactic, but it wasn't. How could it be when a whole town seemed to be in that church nave, telling their ancestors' story? The cast numbered 180. Their ages ranged from three to eighty-five. And together they kept the action moving from platform to platform as they enacted harvest parades, Dorchester races, a fairground, a circus, as well as scenes in Sarah's pub, Moule's vicarage or a dying prostitute's shack. The piece was always busy and energetic, often festive and at times more. When Sarah's girls were at work, volunteer laundresses seemingly transformed into white-clad angels: it was magical.

DANCING AT LUGHNASA

LYTTELTON, NATIONAL THEATRE, LONDON,
OCTOBER 15 1990

There's an unforgettable moment in Brian Friel's *Dancing at Lughna-sa* when the quintet of sisters at its core start to dance. It's 1936 and the women are living in genteel poverty in a tumbledown mansion on the outskirts of Ballybeg, the imaginary Donegal town where the great Irish dramatist has set play after play. They're isolated, they're frustrated, and their little world is even closer to collapse than the large one outside. But when a céilí band starts to play on the kitchen radio, they're one by one on their feet: leaping, clattering, whirling, singing, breathlessly whooping and shouting in a sudden display of defiance, momentary enchantment and glorious wildness.

For Friel, who was born in 1929, it's a moment and a play with deeply personal echoes. His dedication reads 'in memory of those five brave Glenties women', Glenties being the small Donegal town where his mother and her sisters were brought up and he himself spent happy summer holidays. But what impelled him to write *Lughnasa* was a less pleasant memory. He and his fellow-dramatist, Tom Kilroy, had just left the National Theatre, which was staging his adaptation of Turgenev's *Fathers and Sons*, when the sight of homeless people in cardboard shacks reminded him of two of his aunts. They had suddenly left Glenties, where their sisters were battling bravely on, and ended up destitute in London. 'Why don't you write about that?' asked Kilroy. Hence a denouement as packed with wistfulness, respect for human resilience and intimations of death as any in Chekhov.

Actually Friel loves Chekhov and has adapted several of his plays, giving an Irish flavour to dialogue that most translations have left sounding, in his words, 'as English as Elgar'. He can, he has said, identify with nineteenth-century Russian characters who cling on to the old certainties while 'knowing in their hearts that society is in meltdown'. He also shares Chekhov's ability to see people cooly from the outside while feeling them

sympathetically from the inside, and might have given *Dancing at Lughnasa* a subtitle like *The Five Sisters*. As its premiere showed, and a revival at the Old Vic confirmed in 2009, there's melancholy, humour, nostalgia, a sense of dislocation, unease, loss, waste, and many other Chekhovian qualities here, as there is in most of Friel's finest plays: *Translations, Molly Sweeney* and *Faith Healer*, which involves an Irish shaman whose frustrations and restlessness end with a terrible death in, naturally, Ballybeg.

No wonder *Lughnasa* was named Best Play in both London's Olivier and New York's Tony awards. Yet it's also distinctively Irish. Like Hugh Leonard's *Da* or Friel's own *Philadelphia Here I Come!*, it's a memory play, told by sister Chris's love child, who ruefully watches his seven-year-old self from the stance of the future, along with his aunts, his mother and the feckless father who occasionally visits him. But it's Irish in a deeper sense. Friel has said there's 'a need for the pagan in life', adding that it's wrong to suppress 'the grumbling and dangerous beast that's below the ground'. Hence the primal longings that exist beneath the Christian surface and are reflected in Lughnasa, the harvest festival fair that dates back to the Druids and is occurring outside, as it still does every September in Glenties. Hence the sisters' brother, Father Jack: a Catholic missionary who has just returned from Africa and appals sister Kate, who is desperately trying to keep the family fed and respectable, by commending witchdoctors, polygamy and ritual sacrifice. He's gone native, perhaps meaning that he's gone natural.

And hence a dance which the stage directions say has a 'pounding beat' and radiates 'a sense of order being consciously subverted'. It's dangerous, it's exhilarating, it's infectious, and it leaves you, like the sisters, with feelings of release. But then the play itself leaves you feeling that nobody can write as wrenchingly as Friel about the ache of the soul and its yearning for ecstasy. As we left the National my wife said something she's never said before or since: 'If you give this play a bad review I'll never speak to you again.' There was no chance of that.

DEATH AND
THE MAIDEN

Talk about acorns becoming oaks. Ariel Dorfman's play about torture, justice and revenge began its existence with a poorly received workshop production in his native Chile and a reading in London before an audience that included Harold Pinter. Hearing that the Royal Court planned a season of international political drama but couldn't find enough good work, Pinter recommended *Death and the Maiden* to its directors. The piece was duly staged in the Court's tiny attic, received ecstatic reviews, moved to the main theatre downstairs, into the West End and on to cities in some forty countries, including New York, where the cast consisted of Glenn Close, Gene Hackman and Richard Dreyfuss. That production was disgracefully misconceived but didn't prevent the play becoming a film, with Roman Polanski directing Sigourney Weaver and Ben Kingsley.

Why the impact? Well, the play was the deeply felt, hugely intelligent creation of a writer who was a cultural advisor to Chile's Salvador Allende in 1973. Dorfman should have been summoned to the presidential palace at the time of Allende's overthrow, found later that the phone call went to a friend who was then tortured and killed, and himself went into exile in America. He's said that he can't sit in a dentist's chair without thinking of those whose teeth were extracted without anaesthetic, and, when he returned to Chile in 1990, he found plenty of reasons to remember and honour them. In his words, 'you have to make amends to the dead – there are people who died so that you could be alive'.

A fragile democracy had returned, but General Pinochet, who had led the coup, was still army chief and ominously powerful. A commission of inquiry had been set up to investigate past wrongs, but had no power to name or punish. 'Everywhere I turned,' wrote Dorfman, 'I saw victims and tormenters living side by side, drinking at the same bars, jostling each other on buses and streets, never acknowledging the pain and the guilt, not to themselves, not to anybody.' It was because he hated that silence, and

wanted to see how it was possible to coexist with 'someone who has done us grievous, perhaps irreparable harm', that he wrote *Death and the Maiden*.

The title, like the play, is resonant but refers to the Schubert quartet played while the protagonist, Paulina, was blindfolded, raped and tortured years ago. When her husband Gerardo, a member of the commission examining past atrocities, brings home Roberto, who has helped him with a burst tyre, she decides he's the doctor who sadistically oversaw those sessions. She threatens him with a gun, ties him up and, to Gerardo's dismay, puts him on a trial whose ending Dorfman leaves uncertain. As was often the case in Chile, we're never sure of the accused's guilt. As in Chile, nothing is fully resolved.

And not only in Chile. Dorfman raised questions that speak to any country whose people have endured political evil and, indeed, anyone pondering dilemmas as old as those Aeschylus dramatised in *The Oresteia* and as fresh as those thrown up by the Arab Spring of 2011. Has revenge a place in civilised society? Isn't there a danger of victims, like Paulina, becoming victimisers? Yet isn't there something bloodless in the disinterested justice espoused by Gerardo? As Dorfman variously put it, 'how to seek justice without lapsing into violence'? How to 'keep the past alive without becoming its prisoner'? How to find 'a way out of the endless cycle of hatred and retribution in which our species seems to be trapped'? How to 'heal a country traumatised by repression'?

Death and the Maiden was a cry from the soul but also a meditation and a thriller. A meditation, for instance, on the meaning of trust. How can we be sure that some kindly stranger isn't harbouring terrible secrets? A thriller, because Lindsay Posner's original production kept one wondering what Gerardo's fate would be. That was largely due to its Paulina, Juliet Stevenson, who swung from rage to irony to hysteria to tenderness to vindictive glee. How different from Glenn Close and her fellow-stars in an American premiere, costing seventy times more than at the Theatre Upstairs, that glaringly illustrated Broadway's limitations.

The director, Mike Nichols, bizarrely saw the play's subject as 'the intimate lives of three people and the ways in which their sexual natures are intertwined', causing *The New York Times*'s Frank Rich to dismiss his production as 'a fey domestic comedy, Broadway's first escapist entertainment about political torture'. When I saw it the audience actually laughed at Paulina's threat to sever Gerardo's testicles, clearly thinking it hilarious that Glenn should badmouth Gene. But then Close resembled a

housewife thinking of suing a dentist for stinting on novocaine, Hackman a medico flustered by a nuisance lawsuit, and Dreyfuss, playing Gerardo, a forlorn attorney who couldn't find the courthouse.

Oh well. A major production succumbed to terminal blandness, but the play remains: articulate, clever, dangerous and as urgent as ever.

THE NIGHT OF
THE IGUANA

LYTTELTON, NATIONAL THEATRE, LONDON, FEBRUARY 6, 1992

Like just about everyone else, I revere Judi Dench for her emotional power, her versatility and much else, but I sometimes worry that one of her great strengths, her ability to empathise with every character she plays, can become a limitation. Isn't she a bit lacking in some of the qualities that make her fellow dame, Eileen Atkins, as fine an actress as Britain possesses?

I mean a strange and silvery glint in the eyes, a sly and subtle sense of danger, a feeling that she has looked into the abyss of others and herself and knows what lurks there. In 2003 Atkins transformed an unremarkable play about a husband's adultery, Joanna Murray-Smith's *Honour*, into a far more cutting portrait of a woman's pain, disbelief and bitterness than was the case when the same piece was revived in the West End three years later. However, it was a much quieter though equally incisive performance that still haunts me.

Actually, 'haunts' isn't adequate to describe the effect she had on me, and surely on others, in one particular scene in Richard Eyre's revival of Tennessee Williams's *Night of the Iguana*. When asked for prime examples of theatrical magic, meaning times when a performance casts such a spell on its audience that it leaves you feeling you've been transported into a strange new planetary system, I always cite just three. One I've already described in this book: the fumbling embrace of Dustin Hoffman and John Malkovich, father and son in Arthur Miller's *Death of a Salesman*. Another I've mentioned in my preface. That time, the actress responsible was Barbara Jefford, whose blazing performance as Racine's Phèdre I caught on tour in a wintry Salford in 1965.

But the third was the quiet apotheosis of Atkins's Hannah Jelkes, the New England spinster who spends her impoverished and seemingly sad life carting her grandfather, a ninety-seven-year-old poet, round the globe.

Somewhere in the Mexican outback she falls into late-night conversation with a spoilt priest, Shannon, a character Williams admitted was largely autobiographical. He's addicted to drink and casual sex with young people, as the playwright was. He's also troubled in spirit, as the playwright certainly was when the play had its out of town tryout in 1961, raving, raging, shooting a sort of speed cocktail into his raddled veins – and accusing his long-term lover, Frank Merlo, of having incited a dog called Satan, given him by Anna Magnani, to bite him so badly he had to be hospitalised.

But, like many of Williams's protagonists, Shannon is split between the pull of the flesh and the cravings of the spirit. His feet are stuck in the mire but his eyes are on the stars; and there's no star in all Williams's work quite like Hannah, a woman the stage directions describe as 'a Gothic cathedral image of a medieval saint'. And she opens her heart to Shannon. First, she recalls visiting a house of the dying in Shanghai, then she describes going out at night in a Singapore sampan with a dowdy salesman who asked her to let him hold an unspecified piece of her clothing while she turned her head away and heard him 'make sounds like he was dying of asthma'. It was, she insists, poignant and not dirty, delicate and not revolting: 'a love experience', maybe the only one she has had.

Back in 1992 Atkins's Hannah convinced you this was true. Throughout, she had managed to be astringent without becoming austere, rigorous but not cold, grave but not sententious, precise but not severe, unsmiling yet outgoing, emotionally generous and humane. But at this point she seemed to move into another dimension, her long, pale face shining in the moonlight as she said, and meant, that 'nothing human disgusts me unless it is unkind or violent'. She had plumbed the depths, seen the darkness, and emerged with a hard-won charity, resilience and belief in endurance. The oddball mystery of the moment, seeming as it did to reconcile the two sides of Williams's own divided psyche, held the first-night audience rapt. As it did me.

AN INSPECTOR CALLS

LYTTELTON, NATIONAL THEATRE, LONDON,
SEPTEMBER 11 1992

Who would have dreamed that a moral thriller that had bored many of its original reviewers could be so transfigured by an imaginative director that it would become one of the biggest hits of the 1990s and beyond? 'Could be stripped to half its length,' wrote *The Observer* of J.B. Priestley's *An Inspector Calls* in 1946. 'A pitiful play' declared the *Daily Mail*. The London impresarios had agreed, which is why Priestley sent it to Russian theatres, with the result that the play received simultaneous premieres in Moscow and Leningrad before it was apologetically slipped into the Old Vic's repertory for a brief run.

The presence in the original cast of Ralph Richardson and Alec Guinness – one as the inspector who comes to accuse a rich, smug Edwardian clan of destroying a trusting, helpless girl, the other as the spoiled boy who has seduced and rejected her – didn't help much. It took Stephen Daldry, a rising young director in the 1990s, to see the possibilities of a play that had often been revived by repertory companies but never highly regarded by critics. To them, there was something heavy-handed and melodramatic in the relentlessly unfolding revelation that each member of the Birling family had been part of a chain which had led to an impoverished but clearly good-natured woman being sacked from two jobs, forced into prostitution, made pregnant, denied charitable help and driven to an agonising suicide.

Indeed, Daldry himself had thought the play 'terrible' when he read it after a rep company in York asked him to stage it in 1989. But then he learned that it had been performed by politically aware soldiers in the North African desert at the time of the election of a Labour government committed to creating a welfare state. Wouldn't a production which acknowledged that fact serve the purposes of a playwright who once said that only an idiot would consider him a naturalistic dramatist, since he was 'a wild one pretending to be tame'?

Moreover, wouldn't Priestley's indignation at the cruelties of the past and craving for a juster future prove as topical as it had after victory over the Nazis? When Daldry said that the play 'reflects the upsurge of optimism

at the end of the war and the belief that it was right and possible to create a better world', he was repeating the dramatist's own views. I myself recall a conventional London revival, staged way before Mrs Thatcher's divisive reforms, that ended with the aged dramatist trundling onstage to tell the audience that the play 'was more relevant than when I wrote it'.

The York production, which brought tanks onto a desert stage, made no special impact, but it left Daldry wanting a more ambitious go at the play. So when Richard Eyre, then the National Theatre's artistic director, asked him if there was anything he itched to stage, the surprising answer was, yes, *An Inspector Calls*. But the decision to go ahead, worryingly quaint though it seemed, was as richly rewarded as any in recent theatrical history. Daldry's production transferred to the Aldwych Theatre, went on tour, and, even before a West End and regional revival in 2009, had run up a National Theatre record of 5,000 performances.

It also won awards galore in London and on Broadway, where the play was received equally warmly, justifying Daldry's claim in *The New York Times* that American audiences would respond to a plot 'about a family tearing itself apart, with huge, deep, true emotions unleashed as they do so'. But it was clear in both cities that the production's success had as much to do with the staging as the play. In Ian McNeil's design, that Edwardian mansion became a cut-off doll's house, poised above a bombscape, a surrealist wilderness overrun by scurrying urchins and visited by crowds of grave onlookers in modernish dress, suggesting a blend of 1992, 1945 and 1912, the seemingly safe but actually ominous year in which Priestley set several plays.

Somehow everything overblown and preachy in Priestley's thunderer seemed sombre and momentous. An antiquated thriller had become a modern morality play that showed how avarice, pride, lust, envy, anger, gluttony, sloth and an eighth deadly sin, complacency, had brought about an exemplary disaster. *An Inspector Calls* had become an indictment of the sins of the twentieth century and, maybe, our own.

THE WEXFORD
TRILOGY

Which dramatist most appealed to me when I first encountered him or her during my twenty-one-year stint as *Times* theatre critic? A tricky question, with Joe Penhall and Lucy Prebble emerging in Britain, Brad Fraser, Tony Kushner and Neil LaBute coming from North America, and the acerbic Yasmina Reza crossing the Channel. But Ireland has produced the strongest candidates, notably the London-based Martin McDonagh, the Dubliners Conor McPherson and Sebastian Barry, and Wexford's Billy Roche. And I don't think it was just because of a glorious, beery weekend in his native town that I've a special affection and regard for that unassuming dramatist, Roche.

Mark you, it was quite an event. I dimly recall singing 'Molly Malone' with Wexford's mayor and a crowd of others, encouraged by pints that were slipped first under, then round, the wire mesh supposed to close a hotel bar. I certainly remember Roche himself talking of his love-hate for Wexford at a symposium devoted to his work and then leading a tour past snooker halls, dance halls and pubs, and onto the waterfront of the town that has fed lively tales and unforgettable characters into work that came to include the superb *Cavalcaders* as well as the painfully elegiac *Amphibians*. But it was the day-long performance of the trilogy first staged in London's little Bush Theatre that gave the Roche celebrations their meaning.

Each play is set in a place that's at once obscure, unpretentious and precisely evoked: a tacky pool hall in *A Handful of Stars*, a messy betting shop in *Poor Beast in the Rain*, the belfry of a church in *Belfry* itself. And the characters who haunt them are equally unremarkable. A young tearaway, bored with the dull friend who yearns for acceptance, tries to reinvent himself as a bank robber, not realising that all Wexford will recognise the face under the stocking he's shoved over his head. Danger Doyle returns briefly to town, sadder and wiser than when he scandalised it by absconding to England with a friend's wife. A sacristan also launches into an adulterous

affair and, though this ends unhappily, is happily transformed from the nerd whose twin horizons were a flummoxed priest and an ailing, possessive mother into a 'boyo' not wholly unlike his wild father.

Here, elsewhere, Roche comes across as a miniaturist or microbiologist studying the urban counterpart of a drop of water and finding that it teems with life. For him, small is often beautiful, always fascinating, and has a significance way beyond its size. His work is about disappointment, decline, decay, defeat, yet there's resilience, warmth, even goodness on show too. It's also crucially concerned with a subject of obvious concern in a world where rootlessness is increasingly the norm.

'A man without a home town is nothin',' agree two Wexford characters in *Poor Beast in the Rain*, but one is a cuckolded husband whose ambition is 'to slip through life unnoticed' and the other the braggart who continues stupidly to mythologise Danger Doyle as the wild boyo he once seemed. Stupidly, because Danger's mistress is now precariously subsisting on tranquillisers in a country where she doesn't belong. Roots, it seems, bring both gain and loss. Roots trap and limit, yet their lack can destroy. Roots bring camaraderie and community and roots bring stagnation and erosive boredom. You feel that Roche's characters can't live with or without Wexford, making the town a microcosm for needs and frustrations that extend to Britain, America, all over the West.

And such thoughts come not only from Roche's observation of a place he knows intimately – and how many other contemporary dramatists can claim that? – but from a generous mind and heart. Almost more than Brian Friel, Roche strikes me as the Irish Chekhov: a dramatist who sees people from the outside while feeling them from the inside, can be funny or sad or both at once, laments yet tries to understand the changes he sees in his society, and relishes the quirky and incongruous. And, without succumbing to softness, he manages to explain the worst of his characters.

'I've done some queer things in my time, I've a lot to answer for,' says the master-cobbler Terry in *Cavalcaders*, a damaged, bitter man whose cruelty has driven a vulnerable girl to suicide. 'Show me the man that hasn't' comes the answer. That's Billy Roche for you: unsentimental yet forgiving.

ARCADIA

LYTTELTON, NATIONAL THEATRE, LONDON,
APRIL 13 1993

When the prepublicity for Tom Stoppard's *Arcadia* first appeared, some of us thought that even his energetic brain might have set itself too daunting a task. How could he pack subjects as different as landscape gardening and adultery, Romantic poetry and iterated algorithms, academic research and the end of the world, into a comedy that the man on the Clapham omnibus, meaning anybody with a little curiosity and sophistication, might understand and enjoy?

I should have been more trusting. After all, Stoppard wrote *Travesties,* which brought Lenin, James Joyce and the Dadaist Tristan Tzara to 1917 Zurich for a debate about art that also embraced songs, limericks, striptease and snatches from *The Importance of Being Earnest.* Also *Hapgood,* which involved quantum mechanics, Heisenberg's uncertainty principle and the world of double agents, and left the impression of a Le Carré novel rewritten by Stephen Hawking and Groucho Marx. And, yes, *Arcadia* might almost have been jointly created by Oscar Wilde and the founding fathers of chaos theory. Nevertheless, I found myself urging that passenger to hijack that bus and drive it to the National box office.

Stoppard didn't just integrate all those topics, and more, into a lively, funny and finally moving plot; he whisked us to and fro between 1809 and 1989, using the same room in the same great house, Sidley Park, to show us different generations of its ancestral owners, the Coverly family. Now a Regency tutor is evading the questions of the brilliant but innocent Thomasina Coverly – 'Septimus, what is carnal embrace?', 'It is the practice of throwing one's arms round a side of beef.' – and now an arrogant academic is concluding that Byron fought a duel with the minor poet whose wife he had seduced while he was visiting Sidley Park, killed him, and made his hitherto unexplained exit from Britain as a consequence.

The academic is wrong about that, as cocksure characters tend to be in the work of a dramatist who relishes incongruity and contradiction and once said that his distinguishing mark was 'an absolute lack of certainty about anything'. Since his name is Bernard Nightingale that led to

speculation that there was a connection between him and another critic capable of embarrassing errors, namely myself. But when *The New York Times* asked Stoppard if this was so, he replied that 'nobody was further from my mind than Benedict', a denial I found discomforting in another way. However, it's clear that, as he said, he needed another bird name to clinch a characteristically elaborate joke involving the satirist Thomas Love Peacock.

Anyway, the fun proliferates, the stories grip, the connections between the play's various ingredients become apparent. Thomasina doodles on her graph paper and somehow doodles the death-dealing Second Law of Thermodynamics. Elsewhere, too, classical order and Newton's certainties are breaking down. Passion rules in verse, illogic in scholarship, unpredictability in maths, a frenzy in human relationships that's wittily defined as 'the action of bodies in heat'. *Arcadia* is Stoppard's salute to the complexity, unpredictability and inscrutability of the world: favourite themes since *Rosencrantz and Guildenstern Are Dead*.

And in the grounds outside the mansion itself Capability Brown's exquisite vistas are being reduced to a fashionable Gothic wildness that will come complete with a hermit: a man whose identity is at first unclear but whose subtle unmasking is one of the elements that bring poignancy as well as tension to a play Stoppard has described as 'a thriller and a romantic tragedy with jokes'.

Tragedy? Well, there's a melancholy in the play which is understandable, given revelations both human and scientific: the precocious Thomasina's premature death, the despair and crazed obsessions that then destroy Septimus's mind, and their realisation that the universe is inexorably running down, like an old grandfather clock. Stoppard was once accused of being an intellectual prankster who lacked ordinary emotion. *Arcadia*, perhaps his best play, proved that this was far from the case.

It's a brilliantly structured, intellectually elegant piece, with references to items as insignificant as a rice pudding or a tortoise turning out to have unlooked-for significance half an evening later. It comes as near as any of Stoppard's plays to achieving what he once said was his artistic aim, 'the perfect marriage of ideas and high comedy'. But there's feeling here as well as humour. There's heart as well as mind, and plenty of it.

OLEANNA

Who could have imagined that *Oleanna* would create such ado? At its premiere in Cambridge, Massachusetts, a row of Harvard professors stood and booed instead of applauding; or so the play's author recalled. 'We had actors yelled at when they left the theatre, fistfights on the sidewalk and screaming arguments between men and women,' David Mamet told me. 'People got very angry.' So angry that there were cries of 'kill the bitch' when *Oleanna* transferred to New York, and in London male cheers when 'the bitch' was physically attacked by the professor she'd asked for help.

The 'bitch' was Carol, a student terrified of failing a course in an unspecified subject which maybe was education itself. The professor, John, seemed to respond sympathetically to her pleas but, thanks mainly to the comforting arm he put on her shoulders, was accused of sexual harassment and worse. He ended up ruined and, goaded to violence when Carol reproached him for calling his wife 'baby' over the phone, perhaps facing prison.

After hearing several accounts of the excesses of 'political correctness' in American universities, Mamet determined on 'a fantasy about an interchange between a young woman who wants her grade changed and a professor who wants to get her out of the office so he can go home to his wife'. He wrote two of the play's three acts, but then abandoned it as far-fetched. However, he changed his mind in 1991 after the confirmation hearings of Clarence Thomas, whose appointment to the Supreme Court was endangered when he was accused of making sexual remarks to an attorney called Anita Hill.

Mamet knew he was tackling a particularly touchy subject: 'From the time I started writing plays, I thought they would throw me in the clink, because I used very vicious, I thought very funny language. When we did *Oleanna*, I thought they were going to burn crosses on the grounds of the theatre.' Again, it was 'like staging *The Diary of Anne Frank* at Dachau'.

For Mamet, though, *Oleanna* wasn't a didactic play, still less an attack on radical feminism. He's insisted that it's 'structured as a classical tragedy',

with John's hubris bringing him low. He has also said it's more even-handed than has been acknowledged: 'I agree with what she says as much as what he says. She may do some things that are dishonourable, but so does he. For me, it's a play about the uses and abuses of power, and the corruption is on both sides.'

In Harold Pinter's London production David Suchet's John certainly seemed to have been hideously wronged, yet his performance was subtle enough to leave one seeing how unprofessional, arrogant, self-absorbed and patronising the character is. Here's an insecure, vulnerable young woman who initially wants only to understand what the evidence suggests is his pretentious, narcissistic, sometimes obscure rhetoric. He airily dismisses education, which she desperately craves, as 'hazing'. He says he'll give her a better grade because he 'likes' her. He persistently interrupts her. He launches into aggressive phone arguments about the house he's buying, notably when she's about to respond to his professed sympathy with a confidence that may explain her damaged psyche.

But if John abuses power, so does Carol, and in a way that's similar if more deadly. At first he dominates her largely through a command of language she finds daunting. Towards the end she is linguistically as perverse and controlling, defining both his casual sexism ('have a good day, dear'} and his attempt to stop her leaving his office as 'rape'. And at the ending that was used in Massachusetts and in Pinter's London production Carol, encouraged by the sinister-sounding 'group' that has espoused her cause, forces a broken John publicly to denounce himself and his books, like a dunce-hatted penitent at a Maoist rally.

Mamet's New York ending, the one ensconced in the published text, simply has a cowering Carol saying 'yes, that's right' after John has struck and obscenely insulted her. The meaning of this remains debatable – is she now surer or less sure of her stance? – but it doesn't lessen the play's force. In London Pinter had to comfort Lia Williams, whom he found 'very thrown, deeply distressed' by the hostility her Carol provoked. In New York, Mamet feared that someone would vault the footlights and attack Rebecca Pidgeon, who is his wife as well as the original Carol.

The play has its flaws. How can the uncomprehending Carol of Act One become so articulate later? And hasn't a mellowing of feminism dated the play? But whatever the reservations, *Oleanna* proved that drama can stir, and stir more than measured debate.

ANGELS IN AMERICA

COTTESLOE, NATIONAL THEATRE, LONDON, NOVEMBER 20 1993

When Kenneth Tynan became the *New Yorker* theatre critic in 1958 he found an ingrowing theatre, 'an island of shuttered anxieties, unrelated (except cursorily) to the society that created it', and a 'one-eyed drama with a squint induced by staring too long down domestic microscopes and never looking out of the window'. Well, there was an explosion of angry work in the Vietnam War era – Arthur Kopit's *Indians*, Jean-Claude van Itallie's *America Hurrah*, Edward Albee's *American Dream* – and, later, David Mamet certainly seemed to acknowledge the big, bad world beyond that window. Yet when I joined the *New York Times* for a stint as its Sunday theatre critic in the 1980s I found myself echoing Tynan. Why were so many gifted American dramatists so absorbed with fetid relationships on and around the back porch, so uninterested in what was and wasn't happening in their own society and the planet beyond?

If that's no longer the case it's largely due to Tony Kushner, whose *Millennium Approaches* was staged in 1991 and was followed in 1992 by *Perestroika*. The title of their seven-hour amalgam, which appeared in London just before its Broadway opening, was *Angels in America* and its subtitle 'a gay fantasia on American themes'. It was a piece that restored imaginative size and social scope to a theatre which scarcely noticed such things were missing, leaving the *New York Times*'s Frank Rich declaring he'd encountered 'the most thrilling American play in years', the work of a visionary dramatist with the promise to change the world and revolutionise the theatre.

If the British critics were marginally less welcoming it was perhaps because they'd had a surfeit of worthily social and political drama. Yet even the less enthusiastic acknowledged Kushner's imaginative daring, and the influential Irving Wardle wrote that the playwright had created 'a vision of America at large, pulsating with energy and appetites in the shadow of history and the sense of oncoming disaster'. Here were three plots linked not only by homosexuality but by self-deception, intolerance, betrayal and a moral confusion supposedly afflicting the nation as it neared the

twenty-first century. As Kushner himself said, his treatment of those stories reflected 'the combination of rage and grief and optimism' that marked the end of the Reagan and the start of the Clinton era.

A legal clerk, Lewis, abandons his AIDS-afflicted lover, Prior, when the symptoms of the sickness become graphically ugly. Eventually the left-leaning Lewis takes up with Joe, a right-wing Mormon and docile young lawyer whose initial failure to come out of the closet has half-destroyed his wife, Harper. Meanwhile, Joe has been feted by a character Kushner extracted from recent history: Roy Cohn, famous as one of Joseph McCarthy's sidekicks, the lawyer who helped get the Rosenbergs executed as traitors, a ferociously aggressive wheeler, dealer and fixer, and a gay man who, even when he was dying of AIDS, refused to acknowledge his nature. Homosexuals, he says in *Millennium Approaches*, are men with 'zero clout', so he's a heterosexual who happens to have sex with guys.

As David Hare has remarked, there's a fascination in malign energy. And that, along with febrile glee and demonic bluster, was what Henry Goodman brought to Cohn when *Millennium Approaches* arrived at the National, as did David Schofield when *Perestroika* was added to a mix that possessed the real yet surreal feeling Kushner said he'd found in 'the city of the Apocalypse', New York. Angels appear over Prior's bed. He himself gets a sneak preview of a neon Heaven that's been abandoned by a despairing God, but somehow survives AIDS. The hallucinating Harper takes a parallel trip through the broken ozone layer. Cohn rages, gets disbarred, weasels himself a cache of AZT, isn't cured and, watched by Ethel Rosenberg's ghost, disappears into Hell barking promises to represent Satan.

The consensus everywhere was that *Perestroika*, which Kushner agreed he found hard to get right, was less effective than *Millennium Approaches*. Perhaps that was because it lacked the sense of danger of its predecessor but, if so, that was the intention. Though Kushner had let Lewis attack America as 'selfish and greedy and loveless and blind', he himself acquired 'this wild-eyed notion that Mikhail Gorbachev was going to make the world a different place'. Hence a denouement which celebrates healing, interconnectedness and life, with a visionary Harper declaring that 'in this world there's a kind of painful progress'. A wishful conclusion? Perhaps, but a big, bold, sprawling play preceded it.

A MONTH IN
THE COUNTRY

ALBERY THEATRE, LONDON, MARCH 29 1994

Has Helen Mirren given a finer performance than as a contempo-
rary monarch doughtily but uneasily reacting to the accidental
death of her difficult daughter-in-law? Or as another queen, this
time a mythic Greek in love with her haughty, rejecting stepson? Or as a
police detective battling to suppress her femininity in a coarse male world?
Well, yes. Though she was brilliant in the film *The Queen*, the play *Phèdre*
and the TV series *Prime Suspect*, it was her Natalya Petrovna in Turgenev's
A Month in the Country that best displayed her technical prowess, her emo-
tional daring, her wit, her sense of human complexity – well, her every-
thing.

Natalya is a Russian Phèdre, only without the taint of incest or the
danger of full-blown tragedy. At any rate, she's another case of troubled
love, thwarted sexuality, emotional frustration verging on devastation.
There she is, a married woman idling her life away in the Russian outback
when, without meaning or wanting to, she falls for her son's handsome but
absurdly young tutor. And, again without wholly meaning or fully wanting
to, she proceeds to play devious, destructive games with everyone – but
above all with herself.

It was this ambiguity that Mirren caught so well. Her Natalya was a
jealous monster, treacherous enough to lure her seventeen-year-old ward
into confessing her love for the tutor and then to marry her off to a bloated
goon several times her age, yet as hapless a victim of Eros as Racine's doomed
heroine. She refused to acknowledge her feelings, faced them, renounced
them, embraced them, denied them, then tried to fulfil them; and all, it
seemed, within a few sentences.

Turgenev often forced Natalya to use that unnatural form of address,
the monologue, yet Mirren seemed perfectly natural as, for instance, she
imagined tutor Belyaev and ward Vera in one another's arms. Indeed, she
carried us with her as she engineered the most mercurial switches from pain

to canny calculation, from rapture to self-loathing, from hope to a despair that was simultaneously self-dramatising and genuine. One moment she was throwing herself onto a sofa wailing 'I'm going out of my mind, I'd be better off dead', the next stoutly declaring 'oh, stop exaggerating'. One moment she was tearfully admitting 'for the first time I'm in love', the next briskly announcing that the love-object must go. Add fear of aging and a gasping girlishness that was both sweet and embarrassing, and we'd a performance that was troubling, moving and, as if that weren't enough, wickedly funny too.

As such, she reinforced the sense of misdirected feeling and human absurdity conveyed by Bill Bryden's tough-minded yet sensitive production and surely in keeping with its author's wishes for a play that's still too little regarded and revived. Turgenev called *A Month in the Country* a comedy, as Chekhov was to dub his great plays comedies. As in Chekhov, love is pretty much a disaster. As in Chekhov, retainers and landowners and other representatives of rural Russia drift in and out, exuding their mandatory boredom and ennui. In Rakitin, Natalya's would-be lover, there's one of those ineffective swains who were regularly to meander through Chekhov's work, complete with capes, canes and sunken cheeks. There's even a self-hating doctor whose cynicism extends to his own medical skills, rather as in *The Three Sisters*. Chekhov declared *A Month in the Country* 'not at all to my taste', which seems a perverse, unfilial judgement, since the play Turgenev wrote in 1848 has pre-echoes galore of the work he, Chekhov, was to pen fifty years later.

There were many fine performances in Bryden's revival – Joseph Fiennes a bashful, vulnerable Belyaev, for instance, John Hurt's Rakitin radiating both sadness and ironic exhaustion – but it's the woman self-indulgently, cruelly yet pathetically trying to manipulate them all who sticks in the memory. There were moments when you felt that all Mirren's inner armoury, from heart to stomach to the less mentionable glands, were overwhelming the parts above the neck. And others when you saw the sharp, shrewd mind and mourned its abuse and waste.

MOSCOW STATIONS

I s there an actor who can match Tom Courtenay when it comes to displaying an unaffected openness of heart, suggesting a vulnerability of soul, or exuding a wistful ennui? I once asked him what had made him take the part of the doomed working-class poet John Clare in Edward Bond's *The Fool* back in 1975. I can still recall his very un-English reply. 'I read the play,' he said in that mild, grieving voice of his, 'and it made me cry.'

Well, he brought similar qualities, and more, to the role of the Russian dissident and soak Venya in Stephen Mulrine's adaptation of Venedikt Yerofeyev's autobiographical novel, first on the Edinburgh Fringe, then in the West End. Where other actors might have fretted and wailed, blubbed and raged, fallen to the ground, gnawed the rushes in agony, and generally given a wild display of fake-Slavic pyrotechnics, Courtenay kept his monologue touchingly yet unsentimentally simple. And that was apt, for passivity and helplessness was Yerofeev's condition, as it was for many sensitive people in Soviet times. The original version of *Moscow Stations* had to appear in samizdat, when the writer was thirty-two, and the final novel was not published until 1989, when he was fifty-one, dying of throat cancer and forbidden to seek medical help abroad.

But Ian Brown's production made you laugh, though often ruefully. On lurched Courtenay's Venya, wearing a blend of tatty browns and grubby greys, his face mottled and flummoxed, his long, lank hair incongruously turning white as it hit his shoulders, and gave us the recipe for his favourite drink, Spirit of Geneva. Mix beer, distilled varnish, white lilac toilet water and sock deodoriser. Marinate for a week in cigar tobacco. Swallow in large gulps – and you won't care if another sad Russian spits in your face.

The dramatic recipe of *Moskva-Petushki*, as the novel was called, was equally unusual. Mix quirky human observation, comic anecdotes and memories, dark philosophising and Christian comfort. Add fatalism and despair. Ingest in a single evening, and you won't care if you don't see another solo piece for a decade. There's even the bonus of a little lecture on the physiology of hiccups, with Venya telling us that believers in Divine

Providence will find them more manageable than will 'grim-faced, ugly and tormented, hiccupping atheists'.

Though the play randomly buckled, swerved and swivelled this way and that, rather like the protagonist himself or the crazy world he inhabited, there was some shape to it. It described a journey of the body as well as of the mind. Having once again failed to find the Kremlin ('I've traipsed around Moscow thousands of times and never once seen it') this Muscovite attempted to travel by train to the suburb of Petushki, where his girlfriend and son both lived. He bribed an equally tipsy ticket inspector with a gram of vodka per kilometre and passed station after station but, unsurprisingly, fell into a drunken stupor and ended up back in the stagnation, ugliness and violence of Moscow.

But it was a very articulate stupor. One moment Venya was mourning the terrifying hours between dawn and opening time, the next describing how he lost a job as a cable-layer after sending a graph delineating his drinking habits to Communist headquarters in mistake for one of the high-minded socialist pledges his bosses expected, the next holding reproachful conversations with his guardian angels, the next wondering why his fellow-citizens had such 'vacant, bulging eyes', the next recalling nightmares of being attacked by workers with hammers and peasants with sickles. It all ended badly, as it was bound to do, with Venya relating his own meaningless murder by thugs as at long last he reached the Kremlin. 'Why, why?' he repeated as he died, a lost man to the last.

And the conclusion? 'All Russia's finest sons, the people she really needed, drank like fish,' said Venya, 'because they were honest enough to know they couldn't relieve the people's suffering.' Quietly, incisively, and with a dignity that belied his slovenly looks, Courtenay made me feel the waste. I feel it still.

ART

Nobody can have expected a ninety-minute play for three male characters by an obscure French-Iranian to have run for over seven years in the West End, getting through twenty-six cast changes in the process. But actors from Roger Allam to Jack Dee, Stacy Keach to Richard Griffiths, Judd Hirsch to Reece Shearsmith to Warren Mitchell ensured that Yasmina Reza's *Art* achieved just that.

Mark you, Reza was fortunate in her original British cast. Tom Courtenay was Serge, an earnest dermatologist who had splurged 200,000 francs on a painting that appeared simply to be a large white rectangle. Albert Finney was his best friend Marc, an extroverted engineer whose reaction to the canvas was to chortle with derision. And Ken Stott was Yvan, who was something small in the stationery business and, though he didn't fully realise it, something even smaller in the hearts of Serge and Marc.

Some thought Reza was using a painting that, at first glance, might have been titled The Triumph of Washing Powder or The Thoughts of a Polar Bear in order to mock the pretensions of modern art. In a particularly disgraceful review *The Guardian's* Richard Gott attacked *Art* as 'old-style fascist theatre, sly, slick, self-indulgent and passionately anti-intellectual', pandering to deeper prejudices in a way not seen 'since the palmy days of the Third Reich'. For him, its mindset was that of the Nazis' notorious exhibition of so-called degenerate art in 1937.

True, the first-night audience laughed when Finney's Marc stared at the painting and, in a desperate attempt to be polite, declared it looked 'expensive'. Likewise when Stott's Yvan agreed that it was 'shit'. And no doubt later audiences came out with their own philistine guffaws, at least in the play's early stages. But how could a responsible critic fail to recognise that Reza – herself of Jewish stock, as the translator Christopher Hampton pointed out in an outraged retort to Gott – was actually writing about the nature, the strains, the limitations, the politics of friendship?

The painting exposes the fault-lines within a seemingly solid relationship, bringing out tensions that, all unacknowledged, are already festering inside

it. Marc feels that Serge has squandered a small fortune on rubbish and, since he's always fancied himself his old friend's teacher, interprets this as a rejection of himself. Serge finds Marc patronising, domineering, smug, boorish. Marc thinks Serge treacherously trendy. For Serge, it becomes a case of love me, love my painting. For Marc, it's almost a matter of destroy your painting and love me. The quarrel escalates. By the time a raging Marc leaps for his throat Serge has said unforgivable things about him, his wife, everything. A disagreement about art is threatening to go nuclear.

Reza has deftly raised issue after issue well before the play reaches an ending that should satisfy those with a regard both for friendship and, with the painting looking eerily beautiful, for abstract art. To what extent does caring for a person mean refusing to resent the slow, subtle changes that occur in all relationships, male and female? To what extent should one tolerate alien tastes and offputting opinions? To what extent must one try to adjust one's own beliefs to someone else's, perhaps even telling fibs in the process?

Myself, I saw three different casts during *Art*'s long life and was struck by the shifts of character, the changes of sympathy and the rebalancing of the play itself that occurred. There were even times when the most peripheral character seemed the most central. Not that his supposed chums cared when he expressed them in an agonisingly funny monologue about his impending marriage, but poor, weak Yvan had rather more serious problems than either – and here he was, the bewildered piggy-in-the-middle, caught in the increasingly vicious crossfire as he tried to make peace between them.

Still, a hard-won peace did come, which is one reason why so acerbic a piece was categorised as a comedy. That seemed to irk Reza when she received a Best Comedy award in London, since she rather gracelessly muttered that she thought she'd written a tragedy. Actually, she'd created a tough-minded yet hilarious play in the tradition of her compatriot, Molière: a minor classic that posterity may see as a major one.

THE ICEMAN
COMETH

ALMEIDA THEATRE, LONDON, APRIL 14 1998

Four critics, including myself, called him 'mesmeric' or 'mesmerising', two 'spellbinding', two 'electrifying'. Those of us who were growing resistant to Hollywood stars who crossed the Atlantic, often bringing little more than glitter to the London stage, had to concede that this time our cynicism made us look shallow. And the universal welcome given to Kevin Spacey's Hickey in Eugene O'Neill's *The Iceman Cometh* had major consequences, with the Oscar-winning actor relocating in Britain, restoring the Old Vic's fortunes as its director, becoming an influential voice in the British theatre and, in 2010, being rewarded with a CBE.

All because of a performance in Howard Davies's revival of a play widely regarded as impossibly ungainly. It's not just that *The Iceman* runs over four hours but that it's wilfully, crazily repetitive. When one of the original American producers suggested cuts, telling O'Neill that the idea that mankind is wedded to its 'pipe-dreams' was repeated eighteen times, the dramatist's answer was that eighteen was wholly deliberate. Indeed, the figure is an underestimate, for there are sixteen desperate drinkers in the bar that's run by the ironically named Harry Hope, all with pipe dreams or self-serving delusions they can't cease parading.

But Spacey made the impossible probable and the ungainly riveting. Hickey is the alcoholic who always comes to celebrate Hope's birthday in that Bowery tavern, a dismal dive based on the last-chance saloon in which O'Neill himself had lived, drank and attempted suicide in 1912, the year when *The Iceman* is set. But this time he's on the wagon and forces unwanted doses of reality on its topers: among them Hope himself, whose myth is that he's mourning the wife he loathed; Jimmy Tomorrow, a journalist who dreams of resurrecting his dead career; and Pat McGloin, who was expelled from the police force for corruption but imagines he'll regain his job. He'll relieve them of fantasies that, he thinks, are rotting

their minds more cruelly than Hope's brackish whisky – and then, like him, they'll find peace.

Hickey is actually a salesman and, as Spacey played him, could have sold anything from encyclopedias to snake oil to belief systems. Such were his skills that today he'd be successfully running encounter groups or an evangelical cable channel or a sinister new cult. Joshing, eyeballing, taking his victims by their shoulders and stroking them like some fundamentalist healer, refusing to rise to their taunts or buy their excuses, Spacey radiated laid-back charm and smiling self-belief; yet there was a coldness behind the affable grins, a hollowness inside the steel, an unease below the confidence, a danger that surfaced when he outed himself as the most destructive pipe-dreamer of all. For Hickey also has a myth, which is that love drove him to murder the poor, suffering wife who always forgave his drunken escapades. In fact it was a tormented mix of guilt and hatred.

It was a subtle performance throughout and towards the end remarkably so. Spacey allowed himself a long, long silence, one not demanded by O'Neill's garrulous and over-controlling stage directions, as his Hickey observed the drunks, took pity on their illusions, and let them retreat back into their protective life-lies and then into an uproariously coarse drinking spree. It was a touching yet terrible moment and would surely have been approved by O'Neill.

Though the play was first performed to mixed reviews in 1946, and not generally acknowledged as a masterpiece until a decade later, when a cast led by Jason Robards Jr showed that its relentless repetitions gave it its power, O'Neill actually wrote it as war came to the Europe of 1939. 'Jesus, the incredible, suicidal capacity of men for stupid greed,' he wrote in one letter and, in another, 'only pessimists are not morons and only a blithering near-sighted idiot could desire to live very long in the future'. But can we acknowledge and act on truths as harsh as that? No, denial is our lot: the melancholy conclusion of *The Iceman* and, in 1998, the production that took Spacey to London and then Broadway.

MNEMONIC

The Salzburg Festival is as famous for its opera as the city is for its churches, winding streets and von Trapps, but every so often it stages a dramatic marvel that contains no singing at all. And what sticks most in my memory is *Mnemonic*, the hugely inventive play given its world premiere by the British company Théâtre de Complicité, or Complicite as it renamed itself, in a shabby ex-cinema in a Salzburg side street.

In 1991 hikers were walking through the melting snow of a Tyrolean mountain some two hours drive from Salzburg when they found the perfectly preserved corpse that was to give the play its centre. Who was 'the Iceman', as he became called? A music teacher who had gone missing in our era? No, he was 5,200 years old and had perhaps been a shepherd, a shaman, a merchant or, more likely, a villager escaping violence down below. After all, he was wounded, was carrying an axe and a bag of herbal remedies, but was starving. He had gone to sleep, collapsed, or been struck, dying in the terrible cold.

Whatever the answer, the Iceman gave Complicite the chance to explore ideas galore, as did the modern story that accompanied the company's quest to comprehend him. In this, a young man desperately tries to contact the girlfriend who has walked out on him, while she traverses Europe in hopes of finding the father she never knew. The questions raised by these interlocking tales ranged from the elusiveness of our origins to the intricacies of cultural identity, from the weight of history and the prevalence of violence to what, with Austria and Italy squabbling about the nationality of a body found somewhere between their current frontiers, one might call modern tribalism.

Sounds portentous or pretentious? That wasn't the view of the British critics, who gave *Mnemonic* their Best Play award when it came to London later in 1999. Indeed, some of them hailed the piece's revival in 2003 as the finest work of a touring company that had been founded in 1983 by Simon McBurney and two friends when they were studying in Paris under the great teacher of movement, mime and multipurpose theatre, Jacques

Lecoq. Though its base became London, its name signaled both a defiantly un-British style and a determination to ask its audience to be complicit in its creations. For McBurney, its artistic director, 'the imagination is a muscle and needs exercising'.

Those dramatic exercises have been remarkably various, for Complicite is also noted for what one influential admirer, Nicholas Hytner, has called its 'insatiable intellectual curiosity and ceaseless experiment'. The company has staged Shakespeare, Dürrematt and Beckett, but also seemingly unstagable stories by writers who aren't household names in the English-speaking world: Daniil Kharms, a Russian absurdist who died in a Stalinist prison; Bruno Schulz, a Polish Jew murdered by an SS officer; the Swede Torgny Lindgren. It has confronted its audiences with a Tokyo full of strange, night-time terrors in its adaptation of Haruki Murakami's *The Elephant Vanishes* and, in the multi-award-winning *A Disappearing Number*, with the career of the untutored Indian maths genius, Srinivasa Ramanujan. At the time of writing Complicite hadn't yet staged its promised version of *The Battleship Potemkin* in Trafalgar Square, but you wouldn't bet against that happening.

The only constant in the company's work is spareness of décor combined with a belief that intricate and often intense effects can be created by simple props and the actors' own bodies. In its adaptation of John Berger's tale of a French peasant woman, *The Three Lives of Lucie Cabrol*, the performers became birds, branches, anything, everything, while a hip-bath became a coffin and then a bloody tank in which actors became slaughtered pigs. Similarly, McBurney's production of *Mnemonic* somehow convinced you that a collapsed chair was part of a glacier, then the doomed Iceman.

It was a piece in which there was purpose in every minor event, every supporting character: Jewish-Americans on a pilgrimage to Auschwitz; a London minicab driver from Greece who plans to move to Australia and hopes to end up in one of those Californian ice pods that promise eternal life. Myself, I left that Salzburg theatre imaginatively rewarded, visually feasted – and mentally enthralled by a piece that had much to say about personal and collective memory, roots, heritage, migration, relocation and the chronic confusions of our painfully restless era.

THE LADY IN
THE VAN

QUEEN'S THEATRE, LONDON, DECEMBER 7 1999

If you called Alan Bennett the bard of isolation, the laureate of frustration and private agony, he'd probably not demur. Certainly, he's regularly written about marginalised people – from Kafka to the exiled Guy Burgess to the stricken loners in the monologues he called *Talking Heads* – and once confessed that 'the prevalence of the damaged and disabled' in his work 'says something about me'. Here was Nigel Hawthorne as the king in his *The Madness of George III*, strapped into what looked like a primaeval electric chair and wailing out impotent commands as boiling wax was poured onto his head. There was Maggie Smith as the vicar's wife in *A Bed Among the Lentils*, escaping from her hearty husband into alcoholism and the arms of an Asian shopkeeper.

But Dame Maggie gave an equally fine performance as the batty outsider, the genteel vagrant Bennett dubbed 'the lady in the van'. As with many of his characters – he once ruefully said his theatrical imagination was 'pretty limited' – Miss Shepherd actually existed. Indeed, she invaded Bennett's outer and inner space for fifteen years, getting him to help push her battered old van, which had been attacked by vandals while it was parked on the street, into the mini-driveway in front of his London house in 1974. And she stayed there until she died in 1989, occasionally emerging to make a complaint, share a crazy aperçu, or simply fill Bennett's tiny garden with a stench he compared to 'the inside of someone's ear' and she blamed on an infestation of cheese-bearing mice.

Bennett didn't intend to write about Miss Shepherd before or immediately after her death. But then he remembered he'd promised to contribute something to *The London Review of Books* and put together a memoir from his diaries and the bizarre political pamphlets she'd written in expectation of becoming Prime Minister. He made 'one or two stabs' at turning this into a play but without success until he had the idea of turning himself into two characters: 'There was one bit of me (often irritated and resentful) that had to deal with this unwelcome guest camped literally

on my doorstep, but there was another that was amused by how cross this eccentric lodger made me and that took pleasure in Miss Shepherd's absurdities and outrageous demands.'

So there were two Bennetts talking, arguing, bickering onstage: one dealing with Miss Shepherd, puzzled neighbours and the chilly 'carers' who sometimes intruded; the other narrating, ruminating and worriedly examining his own liberal conscience. This added conflict and moral clout to the play, but didn't distract from its central character. Smith took great pains with her make-up, showing Bennett the ulcers she'd incorporated in her grey, mottled legs 'with the relish of a beggar on the streets of Calcutta'. And her Miss Shepherd exuded a crackpot hauteur from inside a grimy face, withered cheeks and eyes that bulged beneath a baseball cap or a khaki helmet whose side flaps fell down to a fetid brown overcoat. 'My wardrobe's driving me mad,' she said in an incongruous Mayfair voice, oblivious to the fact that her madness was driving her wardrobe.

Madness? Well, pretty nearly. Here was a woman who could suddenly announce that she'd seen Nikita Khrushchev being kidnapped in a nearby street, or met the Virgin Mary outside the local post office, or wonder if the toad that had wandered into the van was in love with one of the slugs inside, or ask Bennett to write to the College of Cardinals asking them to elect a very tall Pope and give him a crown made from very light plastic, or decide to form a party called Fidelis, move her van to Downing Street and hold Cabinet meetings inside. The danger, of course, was that Miss Shepherd would emerge looking merely ridiculous or become the sort of 'lovable' eccentrics the English supposedly enjoy.

That wasn't the case, because Smith unsentimentally caught what made Miss Shepherd obnoxious – in Bennett's words, her 'persistent refusal to take into account the concerns or feelings of anyone except herself' – and what made her pitiful. As the dramatist discovered, she'd been an ambulance driver in the war, a novice nun and a promising musician who had suffered a breakdown, perhaps because of a traffic accident, perhaps because her religious order had denied her access to a piano. Who knew?

And who knew or knows the truth about her unpaid landlord? Was Bennett a bit of a saint? A man too timid or weak to say no? A parasitical writer observing a likely subject? Or (something emphasised as the play progressed) a guilty son compensating for putting his mother in an old folks home and not visiting her enough? The questions thickened, adding depth to a hugely entertaining play.

HAMLET

LYTTELTON, NATIONAL THEATRE, LONDON, SEPTEMBER 5 2000

To be yet not to be. To be a theatre critic is to be asked regularly who was the best Hamlet ever and not to be able to answer. Myself, I've reviewed some thirty-five actors and actresses in the part, seen several more, and read how it was played by Gielgud, Olivier, Barrymore and that strange, haunted brother of President Lincoln's assassin, Edwin Booth. My mental files include baleful Nicol Williamson, self-mocking Ben Kingsley, mad Mark Rylance, grieving David Tennant, noble Ralph Fiennes, bookish Peter Eyre, grave Alex Jennings, heroic Toby Stephens and others whose very variety emphases that a 'complete' Hamlet is an impossibility. After all, who can be loving, callous, fastidious, coarse, contemptuous, considerate, vindictive, prudish, indecisive, tough, philosophic, violent, non-violent, melancholy, resilient, vulnerable, detached, humorous, aristocratic, demotic, articulate, self-hating and much else, including a demanding stage director and critic of acting?

Hamlet is Dr Jekyll and Mr Hyde, in Ophelia's view the expectancy and rose of the fair state but in the words of the very appetising, upstanding and clean D.H. Lawrence, 'a repulsive, creeping, unclean thing'. He's a success, for he gets his man in the end, and a terrible failure, for he leaves behind eight corpses, including his own, where there was meant to be one.

In our era Jonathan Pryce and Stephen Dillane, Rylance and Tennant, have all been fine if partial Hamlets. And Simon Russell Beale was just that when he brought an unusually sweet yet unsentimentally conceived prince to the National Theatre after a tour in which he'd attracted much praise but occasional scepticism. 'Tubby or not tubby' ran a regional headline in a discourteous reference to Russell Beale's somewhat squat figure. But the history of acting is packed with thespians who defied their physical limitations to make audiences believe they were taller, shorter, stouter or slimmer than they were. Russell Beale is as much a shapeshifter as Kean in the 1800s or Judi Dench now and his Hamlet seemed as noble of bearing as Ophelia says he is of mind.

Did he play down the prince's cruelty, his spasmodic recklessness? Yes, that may have been what made Russell Beale's Hamlet incomplete. Indeed, one critic said he was 'too nice' for a man who wanted to consign his usurping uncle to eternal damnation. Yet he had many more important qualities: incisive intelligence, a knack for seeing through others' pretences, self-knowledge, self-doubt, wry humour, a sense of the absurd, natural dignity, moral disgust, humanity, vulnerability, deep melancholy and, perhaps above all, a capacity for affection that events at Elsinore were conspiring to thwart. If there was a particular emphasis, it was sorrow for the loss of a potential wife and for not one but two much loved parents.

Though the performance never strained for surprise, there was a strikingly fresh moment in Gertrude's chamber, when she and Hamlet's father's ghost both touched the agonised prince. All three members of the family that Claudius had destroyed seemed to be embracing in forlorn, hopeless tribute to what could and should have been. And when Hamlet dispatched Ophelia 'to a nunnery', it wasn't just because she was inadequate to his needs. It seemed that he wanted to protect her from the depravity and corruption he saw all around and feared might be infecting himself.

John Caird's production was very much centred on the personal, actually cutting out Fortinbras and, with him, the play's political aspects. I minded this less than most of my colleagues, because Shakespeare dealt so cursorily with the supposed threat to Denmark from Norway that you feel it barely interested him. In any case, the effect was to concentrate even more on Hamlet – the longest part in Shakespeare, with 1,507 lines in all – and his tortured sensibility. And with Russell Beale in the role, who could complain? We had only to listen his careful, sensitive handling of the 'to be' speech, unforgettable in its yearning for an impossible peace, or hear the depth of the stoicism he ended up expressing to Horatio, to know that here was an actor and a Hamlet with that rare thing: soul.

THE FAR SIDE
OF THE MOON

NEWCASTLE PLAYHOUSE, APRIL 12 2001

It was nicely timed, being forty years almost to the day since the Soviet astronaut Yuri Gagarin had become the first person to orbit the Earth. Robert Lepage was appearing in his own touring production of the one-man show he himself had devised about the space race and the subjects it suggested to him. *The Far Side of the Moon* was a piece – 'play' didn't sum up a performance using words, music, mime, film, puppetry, visual games galore – that involved desperate dreams and crushing reality, rivalry and loneliness and reconciliation, on personal as well as global as well as astral levels.

We'd come to expect that sort of feat from the French-Canadian auteur, but not always in so concise a form. Lepage made his name with epic pieces that ranged across histories and cultures and lasted for five, six hours or more: *The Dragons' Trilogy*, about the Chinese presence in his native Quebec City, or *Seven Streams of the River Ota*, which involved Hiroshima, the Holocaust, the AIDS pandemic, and much else that had caused pain and division in the twentieth century. *Far Side* played for 140 minutes and was sufficiently engrossing to seem shorter.

Lepage was onstage throughout, playing two brothers whose mutual antipathy has increased with their mother's death. André is a successful TV weatherman who smugly spouts practical information about meteorological matters from beside a huge map of North America. And Lepage had only to remove his goatee and supercilious sneer to become Philippe, a shy, unworldly fortysomething still hoping to get a PhD for his thesis on the impact of space exploration on popular culture.

Their nervy little war, waged over issues like the future of their mother's goldfish, was deftly and often hilariously observed. Here's André, who has the slickness and savvy that win fame and fortune in the contemporary West. Here's hapless Philippe, who plans to beam a video of his apartment into space, thus interesting extra-terrestrials in our world and his own forlorn existence.

Philippe is also obsessed with Russian pioneers: a nineteenth-century engineer who wanted to build a lift to the Moon; Alexey Leonov, the first man to walk in space, whom he tries and (characteristically) fails to meet in Moscow. He's an oddball and loser, yet also a visionary with the soul his brother lacks. And somewhere there, Lepage suggested, is a parallel with the American and Soviet space programmes. One overtook the other but radiated efficiency, not romance.

That claim seemed dubious. So, perhaps, did the suggestion that the siblings represented two sides of Lepage himself: the showman who has created spectacles for the dauntingly competent Cirque du Soleil and the experimental director whose *Seven Streams of the River Ota* opened unfinished and in chaos at the 1994 Edinburgh Festival. And was Philippe a clone of the teenage Lepage, a reclusive boy who was bullied because of his alopecia and had a nervous breakdown? Well, maybe.

What's certain is that in *Far Side* his imagination liberated and invigorated the audience's own. Philippe falls asleep in the laundromat where he's glumly washing old clothes, slips through the machine's glass door like Lewis Carroll's Alice, and is transformed into a spaceman, while that door becomes his helmet, a clock, a plane's porthole, a fishbowl, the mouth of a brain-scanner, the entry to the womb and the Moon whose elusive 'far side' gives the show its title. Likewise with an ironing board, which reappears as a table, gymnasium apparatus for the narcissistic André, and a dummy transformed by a medal-encrusted uniform into a Russian hero.

It could have been tricksy or distracting. Instead, the swiftly changing images added to the evening's momentum while enriching key events, as when a cannily placed mirror left Lepage's Philippe soaring, spiralling, flying in space to the accompaniment of Beethoven's Moonlight Sonata. And that upbeat ending seemed to endorse and celebrate the dual reapprochment we'd just witnessed: between those very different brothers and between Americans and Russians, who met and shook hands in the Apollo-Soyuz mission of 1975.

'More than any other practitioner I can think of, he makes the theatre a thrillingly contemporary, imaginatively elastic, consistently surprising, delightful and, above all, playful place to be,' wrote one senior British critic. 'A marvel, like discovering the party conjuror is a real magician,' added another. Yes, surely only Simon McBurney's Complicite can compete with Lepage when it comes to creative curiosity and exhilarating invention.

THE LIEUTENANT
OF INISHMORE

OTHER PLACE, STRATFORD, MAY 11 2001

It was the strangest curtain call I've seen, with the cast slithering as they tried to stay upright in stage blood that threatened to reach their ankles while stage limbs and severed torsos were littered behind them. But then Martin McDonagh's satire on Irish terrorism was itself a gruesomely, wickedly, gloriously unusual piece. After all, you don't often find a health warning outside the auditorium saying 'please be aware there are scenes of extreme violence and very loud gunshot noises – please contact a member of staff for further information', as happened when Wilson Milam's production transferred from the RSC's smallest Stratford theatre to the Barbican Pit in London.

Actually, the RSC might have added 'you'll probably be laughing too much during the extreme violence to hear the loud gunshots' and provided a staff psychiatrist to help those who felt guilty at doing so. McDonagh's great strength, most daringly evident in *The Lieutenant of Inishmore*, is to expose human callousness in ways that are engrossing, entertaining and often hilarious. His is the most distinctive English-speaking voice to have emerged in recent years. That explains why he's received four Tony nominations, including one for *The Lieutenant*, and one Olivier award, for a play that, unusually, he set outside Ireland: *The Pillowman* in 2003.

McDonagh is a Londoner but comes of Irish stock and reacts to his roots in the spirit of Synge. Indeed, *The Lieutenant* is set, surely deliberately, in the same Aran Islands that gave his predecessor his inspiration and, as several critics remarked, it blends the toughness of Tarantino with the vision of *The Playboy of the Western World*. Like that play, it proved controversial, too. The National Theatre and the Royal Court rejected it before the RSC staged it, and the commercial managers refused to transfer it from the Pit to the West End, maybe because they felt that, with 9/11 having occurred between its Stratford and London runs, it treated terrorism too derisively.

But it was a basically moral derision that marked the play, distinguishing it from both Tarantino's movies and the earnest plays about terrorism that 9/11 would spawn. It begins with dopey Donny and dim Davey worriedly cradling a black cat whose brains are seeping out, maybe because of a collision with Davey's bike. It is, they believe, the adored pet of Padraic, who is Donny's son. And Padraic is a psychopath who was rejected by the IRA as too violent, joined the INLA, and is in Belfast, bombing chip shops and, as we see in the next scene, pulling the toenails from a pusher whose sin was to sell drugs to Catholic rather than Protestant children.

What to do? Donny and Davey decide to break the bad news gently, phoning Padraic to tell him that Wee Thomas is 'poorly' and desperately applying black polish to an orange cat in crazed hopes of deceiving him. The young terrorist tearfully leaves his upended torture victim and hurries home to a very mixed reception. He's rapturously received by the sixteen-year-old tomboy who hopes to form an INLA splinter group with him and is preparing for that day by shooting the eyes out of cows. But he's also the intended victim of three INLA men, who have tired of his attacks on the dope pushers who actually fund their campaign and, it turns out, have used Wee Thomas to lure him into a trap.

What follows is as bloody as it's bizarre. Donny and Davey find themselves sawing up the corpses of three blinded INLA men and then of Padraic himself, Donny wearily complaining that he can't be expected to chop up his own son and Davey replying 'well, I'm not doing all the work'. That's characteristic of a black comedy in which everyone spouts lines that grotesquely underreact to the situation. They variously sing rebel songs, worry that too much murder may put off tourists, declare that the Guildford Four should have been proud to have been wrongly convicted of terrorism, argue about whether the IRA offers more opportunities for travel than the INLA, accuse Oliver Cromwell of cat massacre, and earnestly debate the legitimacy of their own feline killings: 'is it happy cats or Ireland free we're after?'

Perhaps McDonagh's play was self-indulgent in that it left you feeling that the INLA was so confused, so inept, so inane it would implode before its bombs and bullets did their unholy work. But his chosen form, a sort of comic Grand Guignol, surely permitted such exaggeration. And behind the exaggeration was a truth: there's a mindset in which sentimentality and brutality coexist, along with patriotic platitudes, a twisted reading of history, and a terrible indifference to human pain. That mindset was McDonagh's target – and he hit it with a vigour that still leaves me boggling.

IPHIGENIA IN AULIS

LYTTELTON, NATIONAL THEATRE, LONDON,
JUNE 23 2004

Does it matter when 'classic' plays are wrenched from their original periods by directors trying to emphasise their topicality? Yes, if the loss is greater than the gain, as it was (for instance) when Jonathan Miller reduced *The Tempest*, which at its deepest level involves evil and forgiveness, into a parable about colonalism, with the spirit Ariel transformed into the future ruler of Prospero's island, a Jomo Kenyatta clone complete with flywhisk. But to reject updating *per se* is wrongheaded, since the Elizabethans often dressed ancestral characters in costumes of their own era, and pretty pointless, since most 'classic' productions are now performed out of period.

And as Katie Mitchell's production of one of his lesser-regarded tragedies confirmed, there's no more contemporary dramatist than Euripides, who died in 406 BC. He knew the terrifying power of unreason as we now see it embodied by crazed cults, feral children, nationalist demagogues and their followers. Think of the ultra-rational Pentheus's murder by rampaging maenads in *The Bacchae*. He knew that wrong breeds wrong and that injury brings disproportionate retaliation. Think of how Medea reacts to Jason's rejection by murdering their children. He knew that, if endangered or mistreated, people can behave like monsters. Think of how Orestes and Electra, threatened with execution for killing Clytemnestra, take hostage their cousin Hermione, who only wants to help them, and vow to burn her alive.

Above all, think of Euripides's scepticism about war and the forces that encourage or exploit it, prime among them gods or supposed gods that variously seem whimsical, petty, vindictive, malicious and cruel. Think of how Athene, who helped the Greeks destroy Troy, is so offended by Ajax that she promises to drown them as they return home. And perhaps *The Trojan Women*, with its massacres and atrocities, was Euripides's reaction to the transformation of Athens from the exemplary city he had celebrated in *Suppliants* and *Andromache* into the imperialist bully that murdered the men and enslaved the women of Melos, which wanted to stay neutral in the Peloponnesian War.

Certainly, Euripides felt at least as cynically about Athens's conflict with Sparta as Mitchell clearly did about the invasion of Iraq in 2003. Ever the angry outsider, he went into voluntary exile and didn't live to see the war lost or *Iphigenia* staged. Mitchell was obviously aware that Agamemnon's arrogant vow to conquer an offending city for no wise reason and punish 'effeminate barbarians' had a certain resonance as Iraq disintegrated. But her concerns transcended the particular, as she showed by relocating the play in the 1940s and using the punchy but faithful translation Don Taylor published in 2000.

The setting appeared to be a requisitioned mansion – pock-marked walls, bustling aides, neon lights, metallic noises offstage – in which Ben Daniels's shilly-shallying Agamemnon was having second thoughts about sacrificing his daughter Iphigenia, which Artemis had demanded as the price of wafting his becalmed and fretful army from Aulis to Troy. But it was too late. His wife, Kate Duchêne's grandiose Clytemnestra, was already arriving with piles of luggage, the baby Orestes and Hattie Morahan's sweet, guileless Iphigenia, having been tricked into thinking the girl was marrying Achilles.

Mitchell transformed the chorus of local women, whom Euripides did indeed show lauding Greece's glamorous heroes, into a happily gushing fan-club complete with autograph books. But soon they were puffing nervously on their cigarettes, dropping their handbags, scuttling about in dread and, as if to display their resilience, updating a choric dance into a fox-trot. They'd seen Menelaus, husband of the enchantress whose abduction was the *casus belli*, force Agamemnon to go through with the sacrifice. They'd seen an affronted Achilles offer to protect the girl, then heard how he participated in the killing. Above all, they'd seen Clytemnestra fragment and Iphigenia recover herself.

Duchene, so assured at first, argued, pleaded, battered helplessly at barred doors in her desperation to reach her doomed daughter, and ended up not only abject, rain-soaked and bedraggled but fully motivated to commit the murder Aeschylus dramatised in his *Oresteia*. With Morahan arriving with her white wedding dress, and meekly going to her death in a little girl's vest and pants, this was heart-rending stuff, but also brain-teasing, even mind-blowing. Here were 'great' public men deceiving others and themselves, presenting expediency as military duty and the 'stinking breath of self-interest' as moral necessity, and generally exposing themselves

as opportunistic, hypocritical and everything we fear modern leaders have been and are.

Since the original *Iphigenia* was posthumously staged and possibly unrevised, not all the surviving text may be Euripidean. Yet Mitchell kept us believing in both the dubious and the authentic, even in Iphigenia's mutation from a frightened child into the princess who bravely embraced her fate. An innocent young woman showed up the slippery men around her, patriotically giving her life to a cause that, in itself, seemed as questionable as any today. And a tense, powerful, brilliantly imaginative production left us with paradoxes that cross the aeons.

JERUSALEM

For Jez Butterworth 2009 was as tremendous a year as it was for Mark Rylance, who played an anarchic maverick, a wild man of the Wiltshire woods, in the dramatist's ironically titled *Jerusalem*. For one leading reviewer the play was 'an instant modern classic' and the performance 'one of the greatest I have ever witnessed' – and he was only a little more enthusiastic than his colleagues, most of whom splashed out critics' stars like fairy gold.

But Butterworth's 2009 had already started strongly, with his *Parlour Song* touchingly yet comically defining suburbia as a mix of the boring, inane and quietly desperate. Who could forget Toby Jones as a woebegone husband nerdishly practising tongue movements to the sound of an erotic tape in forlorn hopes of reviving his sexless marriage? So it was already clear that the dramatist was back on the form that had won him recognition in 1995 at the age of twenty-six with *Mojo:* a macabre comedy about turf wars in Soho whose cast of dimwits, crazies, icy opportunists and overgrown, underachieving kids left you feeling the Medici had got entangled with The Gang That Couldn't Shoot Straight.

But *Jerusalem* was the clincher: a companion-piece to *Parlour Song* that opened with a fairy appearing beneath a tacky English flag to recite Blake's great poem and proceeded to show its author's dismay at a very contemporary disaster. What are the bureaucrats, the lookalike housing estates and (not least) the confused and alienated country people themselves doing to our pleasant pastures and mountains green?

At the stage's centre was an American-style trailer, surrounded by trees and discarded furniture, and at the centre of Ian Rickson's energy-packed production was Rooster Byron: a Romany who survives largely by selling his rare blood to a local hospital, a one-time biker and stuntman, a charismatic shaman, a curser of magnificent curses, a teller of tall tales, and a man very clearly born out of his time. Imagine Merlin or even King Arthur reincarnated as a troll, or think of a mix of the Pied Piper and Falstaff, and you've at least some of the character that Rylance powerfully yet entertainingly created.

I say troll and pied piper, because Butterworth didn't sentimentalise Byron. No wonder, really, the authorities aren't enchanted with a misleader of youth whose retinue of bucolic losers and rustic oddballs depend on him for drugs, raves and the fun that's patently missing from their lives. There's even a suggestion that this aging lord of misrule has sex with underage girls. And yet you felt Byron is making a chaotic last stand against a world represented not only by the council killjoys planning to bulldoze his caravan and build drab little houses in his druidical copse but by the spurious St George's Day fete in the village nearby: brewery-sponsored Morris dancing, 'meditation cave', dancing dog display and so on.

If he was your near neighbour you'd wish him evicted, maybe noting that his advice to his six-year-old son includes 'lie, cheat, steal' as well as 'don't listen to no one or nothing but what your own heart bids'. But maybe you'd mythologise his memory. Certainly, Rylance made him captivating, even mesmeric, from the moment he doused his hangover with a mixture of stale milk, raw egg, half a pint of vodka and a sprinkling of speed. Yes, Byron is a fighter, a bruiser, maybe a burglar – and the shapeshifting actor who had once played a slim Olivia and a flighty Cleopatra magically acquired all the gristle and bulk that implied – but he also has the wit and imagination to enchant you with unbelievable stories that, somehow, you believe.

Did Byron have an affable chat with the forty-five-foot giant he met near the Little Chef off the A14 and hear how he built Stonehenge? Was he kidnapped by Nigerian traffic wardens in Marlborough town centre, escaping after a week-long hunger strike had made him thin enough to get up a chimney? Was he born with a bullet between his teeth? Of course he did and was. Yet behind the swagger, the pride, the defiance of this titanic anachronism there was a hint of vulnerability, a touch of desolation and, when he was with his boy, genuine tenderness. There, everywhere, Rylance brilliantly embodied what Butterworth's marvellous play made clear: the remnants of an old, ribald, pagan England are sinking under the weight of twentieth-century 'progress', and there's nothing anyone can do about it.

FURTHER READING

GENERAL AND BACKGROUND:

The Oxford Illustrated History of Theatre edited by John Russell Brown (Oxford UP 1995)

Theatre by Robert Cohen (Mayfield 1981)

World Drama: from Aeschylus to Anouilh by Allardyce Nicholl (Harrap 1976)

The Empty Space by Peter Brook (McGibbon and Kee 1968)

Dramatic Theory and Criticism: Greeks to Grotowski by Bernard F. Dukore (Holt, Rinehart and Winston 1974)

The Cambridge Companion to Greek Tragedy edited by Pat Easterling (Cambridge, 1997)

Greek Tragic Theatre by Rush Rehm (Routledge 1992)

Greek Tragedy by Edith Hall (Oxford 2010)

The Dramatic Festivals of Athens by Sir Arthur Pickard-Cambridge (Oxford 1988)

The Medieval Theatre by Glynne Wickham (Weidenfeld and Nicolson 1974)

Early English Stages by Glynne Wickham (Routledge 1980)

Shakespeare's Theatre by Peter Thomson (Routledge 1983)

The Shakespearean Stage 1574-1642 by Andrew Gurr (Cambridge 2009)

Shakespeare's Plays in Performance by John Russell Brown (Edward Arnold 1966)

The French Stage in the 17th Century by Thomas E. Lawrenson (Manchester UP 1957)

Theatre in the Age of Garrick by Cecil Price (Blackwell 1973)

Theatre in the Age of Irving by George Rowell (Blackwell 1981)

Our Theatres in the Nineties by Bernard Shaw (Constable 1932)

Around Theatres by Max Beerbohm (Hart-Davis 1953)

Changing Stages: A View of British Theatre in the 20th century by Richard Eyre and Nicholas Wright (Bloomsbury 2000)

An Introduction to 50 Modern British Plays by Benedict Nightingale (Pan Books 1982)

The Theory of the Modern Stage edited by Eric Bentley (Penguin Books 1968)

State of the Nation: British Theatre Since 1945 by Michael Billington (Faber 2007)

Post-War British Theatre by John Elsom (Routledge 1976)

Post-War British Theatre Criticism by John Elsom (Routledge 1981)

Curtains by Kenneth Tynan (Atheneum 1961)

Tynan Right and Left by Kenneth Tynan (Longmans 1967)

Anger and After by John Russell Taylor (Methuen 1962)

The Second Wave by John Russell Taylor (Methuen 1971)

The Unfinished Hero and Other Essays by Ronald Bryden (Faber 1969)

Peter Hall's Diaries: The Story of a Dramatic Battle edited by John Goodwin (Hamish Hamilton 1983)

The Royal Court Theatre by Philip Roberts (Routledge 1986)

One Night Stands: a Critic's View of British Theatre from 1971 to 1991 by Michael Billington (Nick Hern Books 1993)

The Full Room: an A to Z of Contemporary Playwriting by Dominic Dromgoole (Methuen 2002)

My Life in Pieces by Simon Callow (Nick Hern Books 2010)

Politics, Prudery and Perversions: the Censoring of the British Stage 1901-1968 by Nicholas de Jongh (Methuen 2000)

A Critical Introduction to 20th-Century American drama: three volumes by Christopher Bigsby (Cambridge 1982-85)

The Collected Works of Harold Clurman: Six Decades of Commentary on Theatre, Dance, Music, Film, Arts and Letters edited by Marjorie Loggia and Glenn Young (Applause Books 1994)

Automatic Vaudeville by John Lahr (Knopf 1984)

Fifth Row Center: a Critic's Year on and off Broadway by Benedict Nightingale (Times Books 1986)

Broadway Babies Say Goodnight by Mark Steyn (Faber 1997)

ORESTEIA (458 BC)

Aeschylus and Athens by George Thomson (Lawrence and Wishart 1941)

Greek and Roman Actors edited by Pat Easterling and Edith Hall (Oxford 2002)

Aeschylus by Gilbert Murray (Oxford 1940)

The Stagecraft of Aeschylus by Oliver Taplin (Oxford 1977)

HAMLET (1601)

Shakespeare & Co by Stanley Wells (Allen Lane 2006)

On Actors and Acting by Peter Thomson (Exeter 2000)

Shakespeare's Theatre by Peter Thomson (Routledge 1983)

Shakespeare's Advice to the Players by Peter Hall (Oberon Books 2003)

Shakespeare for All Time by Stanley Wells (Macmillan 2002)

EASTWARD HO! (1605)

Ben Jonson by Ian Donaldson (Oxford 2011)

Ben Jonson by David Riggs (Harvard University Press 1989)

THE CID (1637)

Pierre Corneille: Politics and political drama under Louis XIII by David Clarke (Cambridge University Press 1992)

Pierre Corneille by Alain Niderst (Fayard 2006)

TARTUFFE (1669)

The Theatres of Molière by Gerry McCarthy (Routledge 2002)

Molière by H. Ashton (Routledge 1930)

Molière: A Theatrical Life by Virginia Scott (Cambridge University Press 2000)

PHÈDRE (1677)

Jean Racine by Geoffrey Brereton (Cassell 1951)

The Life of Racine by Mary Duclaux (Unwin 1925)

Racine by Lucien Goldmann translated by Alastair Hamilton (Rivers Press 1972)

La Vie de Jean Racine by Francois Mauriac (Librairie Pion 1928)

Jean Racine by Jean Forestier (Gallimard 2006)

THE BEGGAR'S OPERA (1728)

John Gay by Phoebe Fenwick Gaye (Collins 1938)

Life and Letters of John Gay by Lewis Melville (Daniel O'Connor 1921)

HAMLET (1742)

Garrick by Ian McIntyre (Allen Lane 1999)

David Garrick and the Birth of Modern Theatre by Jean Benedetti (Methuen 2001)

The Masks of Hamlet by Marvin Rosenberg (University of Delaware Press 1992)

The Player Kings by Richard Findlater (Weidenfeld and Nicolson 1971)

THE SCHOOL FOR SCANDAL (1777)

A Traitor's Kiss: The Life of Richard Brinsley Sheridan by Fintan O'Toole (Granta 1997)

Richard Brinsley Sheridan: A Life by Linda Kelly (Sinclair-Stevenson 1997)

THE MARRIAGE OF FIGARO (1784)

Beaumarchais by Maurice Lever (Farrer, Strauss 2009)

Beaumarchais and the Theatre by William D. Howarth (Routledge 1995)

MACBETH (1785)

Mrs Siddons: Tragic Actress by Yvonne Ffrench (Verschoyle 1954)

Look to the Lady: Sarah Siddons, Ellen Terry and Judi Dench on the Shakespearean Stage by Russ Macdonald (University of Georgia Press 2005)

The Player Queens by Richard Findlater (Weidenfeld and Nicolson 1976)

The Masks of Macbeth by Marvin Rosenberg (University of California Press, 1978)

ROMEO AND JULIET (1813)

The Life of Robert Coates by John R. and Hunter H. Robinson (Low, Marston and Co 1891)

THE MERCHANT OF VENICE (1814)

The Flash of Lightning: a Portrait of Edmund Kean by Giles Playfair (William Kimber 1983)

Edmund Kean: Fire from Heaven by Raymond Fitzsimmons (Hamish Hamilton 1976)

The Player Kings by Richard Findlater (Weidenfeld and Nicolson 1971)

Shylock by John Gross (Chatto and Windus 1992)

THE GOVERNMENT INSPECTOR (1836)

Gogol: the Biography of a Divided Soul by Henri Troyat (Allen and Unwin 1974)

Gogol: A Life by David Magarshack (Faber 1957)

Gogol and Turgenev by Nick Worrall (Macmillan 1982)

MACBETH (1849)

The Shakespeare Riots by Nigel Cliff (Random House, 2007)

Mr Macready by J.C. Trewin (Harrap 1955)

Edwin Forrest by Richard Moody (Knopf 1960)

THE BELLS (1871)

Henry Irving, the actor and his world by Laurence Irving (Faber 1951)

Henry Irving by Edward Gordon Craig (Dent 1930)

Sir Henry Irving: A Victorian Actor and His World by Jeffrey Richards (Hambledon and London 2005)

A Strange Eventful History by Michael Holroyd (Chatto and Windus 2008)

The Player Kings by Richard Findlater (Weidenfeld and Nicolson 1971)

A DOLL'S HOUSE (1879)

Ibsen by Michael Meyer (Hart-Davis 1967)

Henrik Ibsen by Robert Ferguson (Richard Cohen Books 1996)

Ibsen: The Critical Heritage edited by Michael Egan (Routledge 1972)

Ibsen and the Theatre edited by Errol Durbach (Macmillan 1980)

IOLANTHE (1882)

Gilbert of Gilbert and Sullivan by Andrew Crowther (The History Press 2011)

Gilbert and Sullivan by Michael Ainger (Oxford, 2002)

Gilbert and Sullivan Opera by Audrey Williamson (Marion Boyars 1982)

LA DAME AUX CAMÉLIAS (1891)

Duse: A Biography by William Weaver (Thames and Hudson 1984)

Eleonora Duse: In Life and Art by Giovanni Pontiero (Verlag Peter Lang, 1986)

GHOSTS (1891)

Ibsen by Michael Meyer (Hart-Davis 1967)

Henrik Ibsen by Robert Ferguson (Richard Cohen Books 1996)

Ibsen: The Critical Heritage edited by Michael Egan (Routledge 1972)

Ibsen and the Theatre edited by Errol Durbach (Macmillan 1980)

THE IMPORTANCE OF BEING EARNEST (1895)

Oscar Wilde by Richard Ellmann (Hamish Hamilton 1987)

The Life of Oscar Wilde by Hesketh Pearson (Methuen 1946)

Oscar Wilde by Sheridan Morley (Weidenfeld and Nicolson 1976)

Oscar Wilde on Stage and Screen by Robert Tanitch (Methuen 1999)

Forewords and Afterwords by W.H. Auden (Faber 1973)

THE SEAGULL (1898)

Chekhov by Henri Troyat (Dutton 1984)

Chekhov: the Critical Heritage edited by Victor Emeljanow (Routledge 1981)

Chekhov on the British Stage edited by Patrick Miles (Cambridge 1993)

Letters of Anton Chekhov translated by Michael Henry Heim with Simon Karlinsky (Bodley Head 1973)

HAMLET (1899)

Sarah: the Life of Sarah Bernhardt by Robert Gottlieb (Yale UP 2010)

Sarah Bernhardt and Her World by Joanna Richardson (Weidenfeld and Nicolson 1977)

Sarah Bernhardt by Maurice Baring (Davies 1933)

The Masks of Hamlet by Marvin Rosenberg (University of Delaware Press, 1992).

PETER PAN (1904)

J.M. Barrie: the man behind the image by Janet Dunbar (Collins 1970)

J.M. Barrie and the Lost Boys by Andrew Birkin (Yale UP 2003)

THE PLAYBOY OF THE WESTERN WORLD (1907)

J.M. Synge by Eugene Benson (Macmillan 1982)

The 'Playboy' Riots by James Kilroy (The Dolmen Press 1971)

JUSTICE (1910)

John Galsworthy's Life and Art by James Gindin (University of Michigan Press 1987)

John Galsworthy by Catherine Dupré (Collins 1976)

PYGMALION (1914)

Bernard Shaw: The Pursuit of Power by Michael Holroyd (Chatto and Windus 1989)

Bernard Shaw by Hesketh Pearson (Collins 1942)

Shaw: The Critical Heritage edited by T.F. Evans (Routledge 1976)

Mrs Pat by Margot Peters (Knopf 1984)

LA RONDE (1921)

Schnitzler's Century by Peter Gay (Allen Lane 2001)

Hauptmann, Wedekind and Schnitzler by Peter Skrine (Macmillan 1989)

Arthur Schnitzler by Martin Swales (Oxford 1971)

The History of Schnitzler's Reigen by Otto P. Schinnerer (Publications of the Modern Language Association of America vol 48 1931)

Schnitzler, Hofmannsthal and the Austrian Theatre by W.E. Yates (Yale 1992)

THE PLOUGH AND THE STARS (1926)

Seán O'Casey: A Life by Garry O'Connor (Hodder and Stoughton 1988)

Seán O'Casey: Writer at Work by Christopher Murray (Gill and Macmillan 2004)

Seán O'Casey, Modern Judgements edited by Ronald Ayling (Macmillan 1969)

Mirror in My House: the Autobiographies of Seán O'Casey (Macmillan 1956)

THE WHITE GUARD (1926)

Is Comrade Bulgakov Dead? by Anatoly Smeliansky (Methuen 1993)

Mikhail Bulgakov: a critical biography by Lesley Milne (Cambridge 1990)

JOURNEY'S END (1928)

No Leading Lady by R.C. Sherriff (Gollancz 1968)

PRIVATE LIVES (1930)

Present Indicative by Noël Coward (Heinemann 1937)

A Talent to Amuse by Sheridan Morley (Pavilion Books 1985)

Noël Coward by Philip Hoare (Sinclair Stevenson 1995)

BLOOD WEDDING (1933)

The Theatre of García Lorca by Paul Julian Smith (Cambridge 1998)

Federico García Lorca by Ian Gibson (Faber 1989)

A Companion to Federico García Lorca edited by Federico Bonaddio (Tamesis 2007)

Lorca: Living in the Theatre by Gwynne Edwards (Peter Owen 2003)

WAITING FOR LEFTY (1935)

Clifford Odets, American Playwright by Margaret Brenman Gibson (Atheneum 1981)

MURDER IN THE CATHEDRAL (1935)

The Making of T.S. Eliot's Plays by E. Martin Browne (Cambridge UP 1969)

T.S. Eliot: an Imperfect Life by Lyndall Gordon (Norton 2000)

OKLAHOMA! (1943)

Rodgers and Hammerstein: A Fact Book edited by Stanley Green (Lynn Farnol Group, 1980)

Somewhere for Me: a Biography of Richard Rodgers by Meryle Secrest (Bloomsbury 2001)

Richard Rodgers by Geoffrey Block (Yale UP 2004)

THE GLASS MENAGERIE (1944)

Tom: the Unknown Tennessee Williams by Lyle Leverich (Crown 1995)

The Kindness of Strangers by Donald Spoto (Methuen 1985)

Tennessee Williams by Ronald Hayman (Yale UP 1993)

MOTHER COURAGE (1949)

Brecht on Theatre edited by John Willett (Eyre Methuen 1978)

Brecht in Context by John Willett (Methuen 1984)

The Life and Lies of Bertolt Brecht by John Fuegi (Harper Collins 1994)

Brecht by Ronald Hayman (Weidenfeld and Nicolson 1983)

Brecht: a Choice of Evils by Martin Esslin (Eyre and Spottiswoode 1959)

THE DEEP BLUE SEA (1952)

Terence Rattigan by Geoffrey Wansell (Fourth Estate 1995)

Terence Rattigan: The Man and His Work by Michael Darlow and Gillian Hodson (Quartet Books 1979)

The Rattigan Version by B.A. Young (Hamish Hamilton 1986)

THE CRUCIBLE (1953)

Arthur Miller by Christopher Bigsby (Weidenfeld and Nicolson 2008)

Timebends by Arthur Miller (Grove Press 1987)

Arthur Miller: A Life by Martin Gottfried (Faber 2003)

WAITING FOR GODOT (1955)

Why Beckett by Enoch Brater (Thames and Hudson 1989)

Samuel Beckett by Deirdre Bair (Cape 1968)

Samuel Beckett, the Critical Heritage edited by Lawrence Graver and Raymond Federman (Routledge 1979)

Casebook on Waiting for Godot by Ruby Cohn (Grove Press 1967)

Beckett by A. Alvarez (the Woburn Press 1974)

Beckett in Performance by Jonathan Kalb (Cambridge UP 1989)

LOOK BACK IN ANGER (1956)

A Better Class of Person by John Osborne (Faber 1981)

Almost a Gentleman by John Osborne (1991)

John Osborne by Alan Carter (Oliver and Boyd 1969)

Osborne by Martin Banham (Oliver and Boyd 1969)

THE QUARE FELLOW (1956)

Confessions of an Irish Rebel by Brendan Behan (Random House 1965)

Joan's Book by Joan Littlewood (Methuen 1994)

Brendan Behan: Man and Showman by Rae Jeffs (Hutchinson 1966)

My Brother Brendan by Dominic Behan (Frewin 1965)

A LONG DAY'S JOURNEY INTO NIGHT (1956)

O'Neill by Arthur and Barbara Gelb (Cape 1962)

O'Neill: Son and Artist by Louis Sheaffer (Paul Elek 1974)

Selected Letters of Eugene O'Neill edited by Travis Bogard and Jackson R. Bryer (Yale UP 1988)

THE BIRTHDAY PARTY (1958)

The Life and Work of Harold Pinter by Michael Billington (Faber 1996)

Conversations with Pinter by Mel Gussow (Nick Hern 1994)

Pinter in the Theatre compiled by Ian Smith (Nick Hern 2005)

Pinter the Playwright by Martin Esslin (Methuen 2000)

Pinter: A Collection of Critical Essays edited by Arthur Ganz (Prentice-Hall 1972)

A RAISIN IN THE SUN (1959)

Collected Essays by James Baldwin (Library of America 1998)

BEYOND THE FRINGE (1961)

Beyond the Fringe and Beyond by Ronald Bergen (Virgin Books 1989)

KING LEAR (1962)

Threads of Time by Peter Brook (Methuen 1999)

Theatre at Work edited by Charles Marowitz and Simon Trussler (Methuen 1967)

Paul Scofield by Garry O'Connor (Sidgwick and Jackson 2002)

The Masks of King Lear by Marvin Rosenberg (University of California Press 1972)

OTHELLO (1964)

Olivier by Anthony Holden (Weidenfeld and Nicolson 1988)

Laurence Olivier by John Cottrell (Weidenfeld and Nicolson 1975)

THE HOMECOMING (1965)

The Life and Work of Harold Pinter by Michael Billington (Faber 1996)

A Casebook on Harold Pinter's The Homecoming edited by John Lahr (Grove Press 1971)

Conversations with Pinter by Mel Gussow (Nick Hern 1994)

Pinter in the Theatre compiled by Ian Smith (Nick Hern 2005)

Pinter the Playwright by Martin Esslin (Methuen 2000)

TWANG!! (1965)

Bart! by David Roper (Pavilion Books 1994)

SAVED (1965)

Edward Bond by David L. Hirst (Macmillan 1985)

Bond: A Study of His Plays by Malcolm Hays and Philip Roberts (Eyre Methuen 1980)

Contemporary Theatre: a Selection of Reviews edited by Geoffrey Morgan (London Magazine Editions 1968)

Playwrights' Theatre: the English Stage Company at the Royal Court (Pitman Publishing 1975)

LOOT (1966)

Prick Up Your Ears by John Lahr (Allen Lane 1978)

The Orton Diaries edited by John Lahr (Methuen 1987)

ROSENCRANTZ AND GUILDENSTERN ARE DEAD (1967)

Double Act: A Life of Tom Stoppard by Ira Nadel (Methuen 2002)

Conversations with Stoppard by Mel Gussow (Grove Press 1996)

Tom Stoppard's Plays by Jim Hunter (Faber 1982)

A DAY IN THE DEATH OF JOE EGG (1967)

Feeling You're Behind by Peter Nichols (Weidenfeld and Nicolson 1984)

THE LAWRENCE TRILOGY (1968)

D.H. Lawence: The Life of an Outsider by John Worthern (Allen Lane 2005)

D.H. Lawrence: Triumph to Exile (vol 2) by Mark Kinkead-Weekes (Cambridge 1996)

The Priest of Love by Harry T. Moore (Heinemann 1974)

D.H. Lawrence: the Man and His Work The Formative Years 1885-1919 by Emile Delavenay (Heinemann 1972)

Apprenticeship by Peter Gill (Oberon Books 2008)

HAIR (1968)

Joe Papp: an American Life by Helen Epstein (Little, Brown 1994)

PARADISE NOW (1969)

Acting Out America: Essays on Modern Theatre by John Lahr (Penguin 1972)

OH! CALCUTTA! (1970)

The Life of Kenneth Tynan by Kathleen Tynan (William Morrow 1987)

Kenneth Tynan: A Life by Dominic Shellard (Yale UP 2003)

The Diaries of Kenneth Tynan edited by John Lahr (Bloomsbury 2001)

A MIDSUMMER NIGHT'S DREAM (1970)

Peter Brook by Michael Kustow (Bloomsbury 2005)

Threads of Time by Peter Brook (Methuen 1999)

Shakespeare Our Contemporary by Jan Kott (Methuen 1965)

ABSURD PERSON SINGULAR (1972)

Alan Ayckbourn: Grinning at the Edge by Paul Allen (Methuen 2001)

Conversations with Ayckbourn by Ian Watson (Macdonald Futura 1981)

Alan Ayckbourn by Michael Billington (Methuen 1983)

JOSEPH AND THE AMAZING TECHNICOLOUR DREAMCOAT (1972)

Andrew Lloyd Webber by John Snelson (Yale UP 2004)

Sondheim and Lloyd Webber: the new musical by Stephen Citron (Chatto and Windus 2001)

NOT I (1973)

Beyond Minimalism by Enoch Brater (Oxford UP 1987)

Why Beckett by Enoch Brater (Thames and Hudson 1989)

Billie Whitelaw ... Who He? By Billie Whitelaw (Hodder and Stoughton 1995)

THE MISANTHROPE (1973)

The Theatres of Moliere by Gerry McCarthy (Routledge 2002)

Moliere: A Theatrical Life by Virginia Scott (Cambridge University Press 2000)

SIZWE BANSI IS DEAD (1974)

Athol Fugard by Dennis Walder (Macmillan 1984)

Notebooks by Athol Fugard (Knopf 1984)

The Dramatic Art of Athol Fugard by Albert Wertheim (Indiana UP 2000)

A Night at the Theatre edited by Ronald Harwood (Methuen 1982)

Theatre Quarterly: Special Feature on the Theatre in South Africa (vol 28 1977)

NO MAN'S LAND (1975)

The Authorised Biography of John Gielgud by Sheridan Morley (Hodder and Stoughton 2001)

Gielgud: A Theatrical Life by Jonathan Croall (Methuen 2000)

Ralph Richardson by John Miller (Sidwick and Jackson 1995)

The Life and Work of Harold Pinter by Michael Billington (Faber 1996)

Conversations with Pinter by Mel Gussow (Nick Hern 1994)

Pinter in the Theatre compiled by Ian Smith (Nick Hern 2005)

MACBETH (1976)

Shakespeare On Stage by Julian Curry (Nick Hern Books, 2010)

The Masks of Macbeth by Marvin Rosenberg (University of California Press, 1978).

Judi Dench: with a crack in her voice by John Miller (Weidenfeld and Nicolson 1998)

PLENTY (1978)

About Hare by Richard Boon (Faber 2006)

Writing Left-Handed by David Hare
(Faber 1991)

SWEENEY TODD (1979)

Stephen Sondheim by Meryle Secrest
(Knopf 1998)

*Sondheim and Lloyd Webber: the New
Musical* by Stephen Citron (Chatto and
Windus 2001)

THE ROMANS IN BRITAIN (1980)

Brenton the Playwright by Richard Boon
(Methuen 1991)

QUARTERMAINE'S TERMS (1981)

An Unnatural Pursuit by Simon Gray
(Faber 1985)

NOISES OFF (1982)

Writing on Theatre 1970-2008 by Michael
Frayn (Faber 2008)

TOP GIRLS (1982)

*The Cambridge Companion to Caryl
Churchill* edited by Elaine Aston and Elin
Diamond (Cambridge UP 2009)

*About Churchill: The Playwright and the
Work* by Philip Roberts (Faber 2008)

Churchill: The Playwright by Geraldine
Cousin (Methuen 1989)

FOOL FOR LOVE (1983)

The Cambridge Companion to Sam Shepard
edited by Matthew Roudane (Cambridge
2002)

GLENGARRY GLEN ROSS (1983)

David Mamet in Conversation edited by
Leslie Kane (University of Michigan Press
2001)

David Mamet by Christopher Bigsby
(Methuen 1985)

*The Cambridge Companion to David
Mamet* edited by Christopher Bigsby
(Cambridge UP 2004)

DEATH OF A SALESMAN (1984)

Arthur Miller's Death of a Salesman by
Enoch Brater (Methuen 2009)

Arthur Miller by Christopher Bigsby
(Weidenfeld and Nicolson 2008)

Timebends by Arthur Miller (Grove Press
1987)

Arthur Miller: A Life by Martin Gottfried
(Faber 2003)

LES MISÉRABLES (1985)

Les Misérables: From Stage to Screen by
Benedict Nightingale and Martyn Palmer
(Carlton Books 2013)

Les Misérables: History in the Making by
Edward Behr (Pavilion Books 1996)

**ENTERTAINING STRANGERS
(1985)**

Edgar the Playwright by Susan Painter
(Methuen 1996)

DANCING AT LUGHNASA (1990)

*Brian Friel, Essays, Diaries, Interviews
1964-99* edited by Christopher Murray
(Faber 1999)

Brian Friel in Conversation edited by Paul
Delaney (University of Michigan 2000)

The Cambridge Companion to Brian Friel
edited by Anthony Roche (Cambridge
UP 2006)

The Achievement of Brian Friel edited by
Alan Peacock (Colin Smythe 1993)

DEATH AND THE MAIDEN (1991)

Ariel Dorfman: an aesthetics of hope by
Sophia McClennan (Duke University
Press 2010)

**THE NIGHT OF THE IGUANA
(1992)**

The Kindness of Strangers by Donald Spoto
(Methuen 1985)

Tennessee Williams by Ronald Hayman
(Yale UP 1993)

AN INSPECTOR CALLS (1992)

Priestley by Judith Cook (Bloomsbury
1997)

J.B. Priestley the Dramatist by Gareth Lloyd Evans (Heinemann 1964)

THE WEXFORD TRILOGY (1993)

The Art of Billy Roche: Wexford as the World edited by Kevin Kerrane (Carysfort Press, Dublin 2012)

ARCADIA (1993)

Double Act: A Life of Tom Stoppard by Ira Nadel (Methuen 2002)

Conversations with Stoppard by Mel Gussow (Grove Press 1996)

Tom Stoppard's Plays by Jim Hunter (Faber 1982)

OLEANNA (1993)

David Mamet in Conversation edited by Leslie Kane (University of Michigan Press 2001)

The Cambridge Companion to David Mamet edited by Christopher Bigsby (Cambridge UP 2004)

A MONTH IN THE COUNTRY (1994)

Helen Mirren: The Biography of Britain's Greatest Actress by Ivan Waterman (Metro Books 2003)

Turgenev: His Life and Times by Leonard Schapiro (Oxford 1978)

The Gentle Barbarian: the Life and Work of Turgenev by V.S. Pritchett (Chatto and Windus 1977)

Gogol and Turgenev by Nick Worrall (Macmillan 1982)

MOSCOW STATIONS (1994)

Moscow Stations: a Poem by Venedikt Yerofeyev, translated by Stephen Mulrine (Faber 1997)

THE ICEMAN COMETH (1998)

O'Neill by Arthur and Barbara Gelb (Cape 1962)

O'Neill: Son and Artist by Louis Sheaffer (Paul Elek 1974)

Selected Letters of Eugene O'Neill edited by Travis Bogard and Jackson R. Bryer (Yale UP 1988)

THE LADY IN THE VAN (1999)

The Lady in the Van by Alan Bennett (London Review of Books 1990)

Untold Stories by Alan Bennett (Faber 2005)

Alan Bennett: In a Manner of Speaking by Daphne Turner (Faber 1997)

FAR SIDE OF THE MOON (2001)

Robert Lepage: Connecting Flights in conversation with Remy Charest (Methuen 1997)

IPHIGENIA IN AULIS (2004)

Euripides by C. Collard (Clarendon Press 1981)

Ironic Drama: A Study of Euripides's Method and Meaning by (Cambridge UP 1975)

Euripides by Gilbert Murray (Oxford 1946)

INDEX

254